BEYOND THE ECHO

Sneja Gunew is currently senior lecturer in literature and women's studies at Deakin University, Victoria. Born in Germany, Sneja was educated in Australia, Canada and the UK and has long been committed to multicultural writing. At present, she is on the advisory editorial boards of *Hecate, Outrider* and *Australian Feminist Studies*. She has published widely, with her latest book (in preparation) theorising the impact of non-Anglo-Celtic writing on Australian culture.

Jan Mahyuddin lives in Wollongong, NSW, and works part-time with TAFE and other teaching institutions as a teacher and course writer in women's education. Jan has been involved in community education in the Riverina area where she scripted and produced dramatic readings of Italo-Australian writings. She has also worked as an EFL teacher in Athens, Greece, and has recently had her first short story published.

BEYOND THE ECHO

Multicultural Women's Writing

Edited by Sneja Gunew & Jan Mahyuddin

University of Queensland Press
ST LUCIA • LONDON • NEW YORK

First published 1988 by University of Queensland Press
Box 42, St Lucia, Queensland, Australia

Typeset by University of Queensland Press
Printed in Australia by The Book Printer, Melbourne

Distributed in the UK and Europe by University of Queensland Press
Dunhams Lane, Letchworth, Herts. SG6 1LF England

Distributed in the USA and Canada by the University of Queensland Press,
250 Commercial Street, Manchester, NH 03101 USA

Creative writing program assisted by
the Literary Arts Board of the Australia
Council, the Federal Government's arts
funding and advisory body.

Cataloguing in Publication Data

National Library of Australia

Beyond the echo.

 1. Australian literature — Women authors. 2. Australian
literature — Minority authors. I. Gunew, Sneja. II.
Mahyuddin, Jan, 1948–

A820.8'09287

British Library (data available)

Library of Congress

Beyond the echo.

 1. Australia— —Literatures. 2. Literature— —Women
authors. I. Gunew, Sneja Marina, 1946- .
II. Mahyuddin, Jan (Janet), 1948- .

PN849.A952B4 1988 808.8'9994 87-5951

ISBN 0 7022 2085 X

This book is dedicated to the pioneers:

Anna Couani
Lolo Houbein
Antigone Kefala

To find our measure, exactly, not the echo of other voices . . .

A. Kefala, "Thirsty Weather"

Contents

CONTENTS

CONTENTS

Part III: "English plus . . ."

Acknowledgments

We would like to thank the following people for their help in bringing this anthology before the public:

Judy Barber, Bev Bartlett, Anna Couani, Antigone Kefala, Maria Koundoura, Lee McKay, Karen Pantony, Marko Pavlushin, Reg Gorham, June Veale, Jan Wapling, Sue Wilson.

Particular thanks to D'Arcy Randall, our editor at UQP.

Stories and poems in this collection have appeared in the following: Lily Brett — all poems from *Poland and Other Poems* (Melbourne: Scribe, 1987); Ana Irene Cummins's "Communion" in *The World is Round* (Melbourne: Sybylla Press Migrant Women Writers' Group, 1985); Anna-Maria Dell'Oso's "English as a Sekon Langwidge" in *Good Weekend* (October 17–18, 1986); Margaret Diesendorf's "Taronga Park Zoo" in *Quadrant* (June 1977); Sarah Dowse's "Marginalia" in the *Age Monthly Review* (October 1984); Chitra Fernando's "The Other Country" in *Looking For a Way Out* (Sydney: Sea Cruise Books, 1988); Ursel Fitz-Gerald's "Diary?" in *Mattoid* 22; Angelika Fremd's "Mother" and "Love" in *Sickness & Other Benefits*; Silvana Gardner's "The Assyrian Princess" and "Peas Make the Man" in *Westerly* 2 (June 1985); Zeny Giles'

"Telling Tales" in *Miracle of the Waters* (Penguin: 1988); Jeltje's "Jeltje" and "colonialism" in *Living in Aboriginal Australia* (Melbourne: Collective Effort Press, 1988); Antigone Kefala's "The Wanderer" in *Kunapipi* (1987); "Family History" in *Kunapipi* 8.1 (1986) and "Suicide" in Australian Arts, *This Australia* (Summer 1986/87); Sue Kucharova's "The Headlines That Never Made It" in *Hecate* XI.2 (1985); Ruby Langford's "My Names" in *Don't Take Your Love to Town* (Ringwood: Penguin, 1988); Uyen Loewald's "The Gecko Cure" in *Family Circle* (August 12, 1983); Haitho Massala's "To Pethi Mou" in *Mattoid* 23 (no. 3, 1985); Sophie Masson's "The Tiger" in *Emu* (Melbourne: 1983); Olga Novak's "Wrong Accent" in *Migrant* 7; Denise Pochon's "Reluctant Degustatrice of an Aussie Pie" and "The Definite Article" in Jordan, *Impromptu* (Melbourne: Neptune Press, 1985); Rosa Safransky's "Bonjour Brunswick" in *Australian Short Stories* II (Melbourne: Pascoe Publishing: 1985); Olha Terlecka's "Tell Me a Fable" in *Across the Stepping Stones* (Melbourne: Our Front, 1984); Ania Walwicz's "dad" in *Directions* 2.1 (March 1986); and Beth Yahp's "Kuala Lumpur Story" in *Overland* 107.

Introduction

"To find our measure, exactly,
not the echo of other voices . . . "[1]

This is not a collection of migrant women writers, since
some of the contributors are second or third generation
Australians. The voices of those labelled "migrant" have
long echoed in Australia but have been confined to
sociology and to oral history. In other words, they have
functioned as case studies or as "evidence" for what has
been perceived as the "problem" of being a migrant, that
is, of not being a product of an Anglo-Celtic culture. It
has not simply been a matter of coming here from
somewhere else, so much as declaring the contents of
one's cultural baggage: language, family rituals,
religion, etc.

On the one hand, the writings in this collection ques-
tion and gently parody entrenched versions of
"Australia" and, on the other hand, offer new
"Australias". They are also concerned with *writing*
rather than *speech*,[2] that is, they are not asking to be
read as though they constitute the supposed authenticity
of speech which is embedded in the processes of oral
history or the case studies of sociology. These writings
address other writing which already circulates within
and beyond Australia. This anthology offers *some*

women, writing from a diversity of non-Anglo-Celtic backgrounds, a place from which to speak and be heard. Its making is an act of positive discrimination.

"Positive discrimination", as a term, may have more currency in the bureaucratic structures of our public institutions than in the literary world. But, as an action, it has developed, in the last decade or more, into a powerful strategy of confrontation and resistance to racial and gender bias and inequity in every aspect of our society, including the public arenas of writing, publishing and reading.

To describe the making of an anthology as an act of "positive discrimination" is, quite deliberately, to position this particular text in relation and opposition to some prevailing and much-contested notions about reading, writing and criticism: namely, that a text can be produced and received *as if* outside any socio-political context; *as if* the text itself, and those involved in the process (writer, reader, and particularly here, editor) were free from any considerations of class, race and gender, of subordinate or dominant cultures, of political, or indeed, rhetorical positions.

Ours is a society in which the detrimental, and sometimes brutal, effects of overt racial and sexual discrimination can readily be discerned anywhere from playgrounds to prisons (and all this in spite of ten years of legislation, policies and programs promoting equity across the social spectrum). Hence, an anthology of writings by women in more than one language cannot exist, however, as if only to pleasure "a general reader". It cannot exist as if, in contemporary Australian society, it had no rhetorical position, no potential for *use* as a political object which may disrupt the thinking "in terms of images of homogeneity and national identity" [3] that, at its crudest, creates discriminatory attitudes and

behaviours. If, as Barthes has said, "literature is what gets taught",[4] then a measure of the success of this anthology may well be *not only* the breadth of its general readership, but also its use as a *resource* in the curricula, syllabi and programs of our educational institutions.

To suggest that a text has a use is, of course, to place ourselves at odds with views of "literary quality" and the social significance of a text as able to be determined from some undeclared (but somehow universally known), unified (but always apolitical), value and culture, class, and gender-free position.

Whose "sensibility"?

Since the rationale for this anthology was to collect some of the writings of women from non-Anglo-Celtic backgrounds, the overt emphasis on gender and culture may be seen by some as adding to intolerance and divisiveness. We prefer, however, to see this project as an act of rendering visible, in positive ways, a difference which has existed covertly in the selections and exclusions which have, so far, comprised the many compilations of Australian literature.

It is not possible for us as editors, therefore, to offer *either*: "it has been chosen because it meets the standards of the best stories, at least in the eyes of this editor . . ." [5] *or*: ". . . if you join the lines of association, the outer and inner connections of all these [stories], you have a picture of the Australian sensibility . . ." [6] as any kind of guide to our own editorial position. (Both statements were made in introductions to two collections of short prose published in the last few years in Australia.) For we have several positions from which we must ask: Whose sensibility? Whose Australia? Whose "best"?

Why women?

For us, the question of whether women write differently
from men may best be answered through culture rather
than nature, since the latter is only accessible through
the former. How bodily differences are textually
measured is once again a point of debate, but not in the
simplistic terms that characterised an earlier era which
reduced women's writing to biological essentialism.[7] In
more recent work, the body, too, is perceived as acquir-
ing meaning through cultural inscriptions.[8] For exam-
ple, the basic fact that most women menstruate signifies
very differently in a range of cultures; so the question of
gender differences may be re-posed in material terms,
that women write differently because they live differ-
ently as women. At the outset, they are assigned a place
to write which differs from that given to men. So that,
for example, women's traditional association with the
private domain of the family and home is reflected in the
publishing field by having their texts marketed as and
confined largely to diaries, journals and auto-
biographies. In addition, as De Beauvoir taught us,
women *learn* to be women and femininity itself is
constructed differently across cultures. Imagine the
various culturally-determined responses to that simple
question: What makes a real woman? That it may be
posed as a question rather than as an assertion already
marks a step forward.

Whose Australia?

For both of us, unquestioned assumptions about unity,
identity and "sensibility", risk negating the diversity of
human and social experience to a point of absurdity —
and even offence; can lead to a statement such as this:
"Australia appears to be still a robustly hedonistic
society, but perhaps through art . . . together with the

cultural modification which comes subtly from travel, design, cuisine, we will add sensuality to the robust hedonism." [9] It must be easier to leave unquestioned a dominant cultural position, for surely only an unexamined, dominant "we" could so totally exclude the social significance of the enormous "cultural modifications" made to Australian society by the *presence* of generations of immigrants who have travelled *to*, and not simply *away* from, this country.

There are two very seductive positions that a dominant culture can take, quite without seeming to, in relation to other cultures. One assumes that the dominant culture is a "no-culture", that other cultures are more real, better, in their differences (this is a version of A.A. Phillips's cultural cringe); the other assumes so much and so complacently the dominant culture as given, that contact with "other cultures" is but to add a little cosmopolitan polish and style (travel, design, cuisine . . .). Both positions function as denials of the dominant culture's own ethnicity, and cultural heritage; both selectively plunder "other" cultures, but permit no essential changes to their own position. ("Real Australians" travel, are occasionally expatriate, but never emigrate.) Both positions encourage a view of Australian culture as unified, not diverse, and as something to which others must assimilate.

Culture, however, is made up of many strands which include not only language but also many other elements comprising ways of perceiving social existence. The term "multicultural" is the most recent in a long line of terms denoting otherness: New Australian, reffo, wog, migrant, ethnic. Its current meaning has little to do with the experience of actual migration, though it is often reduced to that, to being a remedial term suggesting that those who belong to the multicultural world have problems with language, employment, etc. What multi-

cultural usually refers to is non-Anglo-Celtic, that is, Australians from the UK and Ireland are not designated as part of multiculturalism, nor are they perceived as partaking of ethnicity. Instead of indicating a deficiency in English (a minus), non-Anglo-Celticism should be seen as English plus, the plus referring to varying awareness of languages in addition to English. Inevitably, because positioned differently, those multicultural perspectives on living in Australia as a non-Anglo-Celt differ from traditional views of being Australian.

Australian concepts of identity have long struggled with defining themselves against Britain and America, and it is only recently that "male" and "white" have been acknowledged to be fundamental attributes of this mainstream notion of what it means to be Australian. We, modestly, from our dual cultural positions suggest that Anglo-Celtic also be added to this list. Our position is dual in the sense that one of us derives from an Anglo-Celtic and Protestant background and, although marginalised as a woman in this society, is not doubly marginalised as a non-Anglo-Celt. The other editor, of German-Bulgarian extraction, is consequently aligned with the women writing in this anthology, but it has taken her a long time to begin to unravel the complexities of being coded a woman and an "ethnic" within Australia.

Whose "best"?

The fact of this anthology presumes that for many women writing from multicultural, non-English-speaking backgrounds, places from which to speak have been absent; or subsumed in an often common assumption that such places are, and always have been, universally available to any member of a society. By providing

a specific and exclusive space which discriminates *for* multicultural women, this anthology is a sister activity to those confronting such common assumptions in social areas as broad as education and employment, the law and welfare.

As a declared political strategy, positive discrimination creates a rhetorical position from which the previously absent refuse to be spoken about, and instead write experiences, needs and desires directly. The strategy does more than encourage points of equal access to a mainstream society — it re-presents (re-positions) in such a way as to irrevocably challenge a view of any society as whole, unified, indivisible, and consistently equitable and a view of any text as "good", "better", or, universally "best".

In some ways, what appears in this anthology is "self-selected". Contributions came in response to a general advertisement asking for poetry and prose in English by "multicultural women writing". The umbrella term, "multicultural", and the statement that it might be possible to publish some pieces in both English and other languages, offered sufficient definition for some one hundred contributors to forward to us more than three hundred pieces of work. Approximately half of the writers who sent in their work have been included in this volume. A few sent in a manuscript with a note attached: "I don't know if I fit . . . but . . .", displaying a healthy ambivalence towards the limitations of tags and labels. One Aboriginal writer chose to forward material and part of her work is included here.

Inevitably in this volume there are gaps and silences. The way in which the word was spread (through advertisement in national English-language newspapers, some of the ethnic press and radio, and various writer's groups) no doubt discriminated for those who saw and

heard it. The request for material in English discriminated against those who do not write in English, and had no access to translators. There are other silences, related most directly to the length of time non-English speaking cultural groups have "settled" here. The more recent the settlement, the fewer writers seem to be offering material for publication. Hence, perhaps, the scarcity of non-European contributors.

Also, inevitably, the anthology reflects a process of selection by its editors. We looked for writing which went beyond recording and reflecting experience, beyond historical, journalistic modes. We looked for writing conscious of crafting and making, of reconstructing image and experience in words. We looked essentially for writing which realises the power inherent in taking charge of the word on the page. We wanted to show, as effectively as possible, that non-Anglo-Celts contribute to literature as well as to oral history and sociology. These writers are engaged in writing rather than confession, writing which addresses other writing here and elsewhere.

While this anthology can offer a place for participation, it cannot claim to "represent" the state of multicultural women's writing in Australia now. (It can't, indeed, claim to represent the state of anybody's art.) Rather, here, forty-eight women have the opportunity to "re-present" image and experience, to write not with "the echo of other voices", but beyond that echo.

Notes

1. Antigone Kefala, "Thirsty Weather", *Thirsty Weather* (Victoria: Outback Press, 1978), p. 8.
2. For a discussion of the distinction between speech and writing see Sneja Gunew, "Ania Walwicz and Antigone Kefala: Varieties of Migrant Dreaming", *Arena* 76 (1986), pp. 65–80.

3. Judith Brett, "Cultural Politics and Australian Literary Magazines", *Outrider* 1.2 (December, 1984), p. 95.
4. Quoted in T. Eagleton, *Literary Theory: an Introduction* (Oxford: Blackwell, 1983), p. 197.
5. Don Anderson (ed.), *Transgressions* (Ringwood, Victoria: Penguin, 1986), p. viii.
6. Frank Moorhouse (ed.), *The State of the Art* (Ringwood, Victoria: Penguin, 1983), p. 5.
7. For a brilliant and witty summary of this fallacy see Mary Ellmann, *Thinking About Women* (London: Virago, 1979).
8. For an excellent example of the new ways of conceptualising bodies, see the recent Australian film *Landslides* by Sarah Gibson and Susan Lambert, which draws on the work of the Australian feminist philosopher Elizabeth Gross. See also *Australian Feminist Studies*, 5 (November 1987).
9. Frank Moorhouse, *The State of the Art*, p. 3.

Part 1: "Writing, rather than confession . . ."

Concrete poem no. 3: Camouflage

thalia

⁀ℊ : *Camouflage (in shorthand)*

Taronga Park Zoo

Margaret Diesendorf

1 Butterfly Fish

One day
looking deep
into the blue waters
of the Pacific Ocean,
the butterfly saw
a creature of fabulous
beauty.
Urging to join
such an exquisite
member of his race,
unknown among his mates
on terra firma
and in the air,
(clearly an unique specimen)
he dived in,
this second Narcissus,
and was instantly transmuted
by some mischievous
marine deity
into a fish,
the golden wings
now beating the waves
as fins.

2 Moray Eels

Some look as if weary
of living too long
in confined spaces,
their earthly bulk dulls
in grey flounces
strange to one another
as they wind about
the one low
grotto pillar
which simulates
their coral reef home
(and — for the beholder —
cuts them to pieces);
their mouths droop
as if with a last
gasp for air.

The tiny misplaced eyes
glitter rarely,
at what entrancing
fish-discovery,
what daring small prey
advances?
From what faint ray
of hope . . . for freedom?

3 Turtle

Coming up for air
 the giant turtle — front
flipper extended — shapes
 despite his bulk . . . an angel.
Perhaps his comparative gastronomic
 innocence & great age add substance
to this fair, immaculate image.
 The strong shield excites
a dream of stout St Michael;
 the darkly masked head
of a famed black knight;
 I gaze at him
with growing admiration
 (the flow of 175 000 000 years
fixed in his lazy stance),
 then drop my own visor
to brood (like him?) in precambrian
 silence on the Creation's
uncomprehended primal reason:
 on principle & paradigm.

4 Goldfish

The goldfish
(l'a ula-ula)
light up the deep;
one flips about
nervously
and twists
as if
he were struck by
dolorous tic,
should he have kissed
in mistake
some sea monster's lips?
or should this be
an ula-way of feeding?
frustration at broken tryst?
Perhaps he is simply needing —
a marine psychiatrist

To Trap a Big Saltwater Crocodile

Jo Jarrah

Ernest Hemingway and Gengis Khan and six million dollar flight simulators honing in. The National Emergency Squad and the National Bank and the National Image converging on some sharp-toothed, salted dragon of the north, indecent pink meat rotting in her gut.

> *A lot of exotic plants have been brought here and they've escaped out of gardens.*
> *They will come to people's soft fruit trees and they will do considerable damage.*
> *Do they widdle on you?*
> *No, they're very well behaved in that matter.*
> *Do they eat you?*
> *?*

Write to Bat Watch, write to Fruit Watch, write to Night Watch. Watch them go to trap a big saltwater crocodile, and afterwards, because we're brave, we'll celebrate with steak and beer, and an international side street with stalls from thirty ethnic groups, not counting ours, of course. Qantas air crew in a cabaret, puffed pride like cookbook water wings. They dance in tiny tinfoil compartments when you lift the lid. The shearers click, the main event, and offer you a taste of fresh jumper, still warm from the sheep's back.

> *Do you hate dry rot more than you hate rising damp?*
> *We've been told we have dry rot. The salesman tells us that if we cover it with aluminium cladding, it will stop.*

In the bus, her mane moves in front of me, garlic sheathed, a solid horse-hair block, her curls and rolls

immovable since Warsaw, World War 2. I try not to look for small things moving, resist the urge to pick at the thick edge of coloured clay setting out from just behind her ears to hold her face, her whip red mouth, her kohl-daubed eyes. Still slit, hooded eyes. An old, old, croc.

If the rain hits the top of a mud-brick wall, it deteriorates very rapidly.

Do they mean the rain or the wall?

The Wanderer

Antigone Kefala

The river
moved further away
in the heat of the road
shimmers of water
towards the horizon.

The salt
which they gave him at home
he would place on his tongue
to taste his own roots
and draw comfort.

The world
made of a matter that never
forgets, a symmetry so exact,
fatality at the heart
of each thing.

The front room

Irene Vlachou

The front room is unbelievably crowded & the coffee's cold. The solutions are simple if you're into them & I expect no-one is anymore; tidy up & stick the cord back into the jug, fold up this shirt & that skirt & put them in the cupboard with one heaped teaspoon of coffee & not too much sugar.

She said if she'd wanted a linear society she'd have moved to a paranoid city in Europe with tight security & cruise missiles in the backyard.

So the front room's a mess. And she continues to live in the land of opportunity where she has this bit of space to call her own; an illusory few centimetres not yet claimed by the superpowers. Anywhere else she'd know it's an illusion which is why she's living in Australia, because it's an enormous myth & she believes in myths.

If I stopped to think about it, about how we're obsessed with a National Identity in the era proceeding the holocaust, I might agree with her.

She doesn't talk a great deal, her words are always clipped & curt & when she was younger she failed everything at school because she couldn't structure her thought processes. As a result no-one will give her a job. And she's obsessed with space, the bit that's hers, the cracks in the wall waiting to be polyfillaed, the sheets of paper she draws on daily, the hundred or so dope seeds she's planted, hoping they won't be stolen, & one way or another she doesn't care what her pictures look like & won't be smoking her plants but they'll make enticing gifts.

Her space isn't the purely physical or material or

10

esoteric & that's what's lovable about her, the way she can adapt to her environment. If cracks remain in the wall — they make decent homes for spiders, & spiders need somewhere to live, eviction being an ideological consideration when ideological considerations are in shreds. At least ideology is an alternative to buying polyfilla. At least alternatives still exist.

She is mourning the demise of the family. Once she could rely on the family absolutely, once she had a suitably neurotic relationship with her mother & father & sister & .4 brother, but they started discussing the war & she gave a very emotional speech on the irresponsible foreign & domestic policies of the superpowers & they said really honey, don't be so gloomy when you could be looking for work. So she never went back. This suits her, in a way. She didn't really get on with any of them but at least they gave her unconditional love. Where else on earth is she going to find unconditional love? To mourn her loss & indulge her insecurities she wears hecate blacks & wonders about a post holocaust society & the expanded role of rejuvenated cockroaches. It was already difficult getting the landlord to fumigate but who in their right mind would go near an unrecognisable & grotesque army of creepie crawlies armed only with a thong & a spattering of anger? What if their vengeance was greater than ours?

We talked about the family once, about the importance of dethroning the patriarch & she said, my mother knows I can't give up cigarettes. There's something ticking over explaining the concern of mother in her powerlessness but she retorts, bullshit, what would she know, dad left years ago & mum's been denying her valium addiction ever since & is so consumed with guilt that really, sometimes I just want to scream at her & say

it's not your bloody fault if I haven't done it a thousand times.

Occasionally she notices her rootlessness, the one produced by her mother because her father had pissed off, & she goes along to job interviews knowing that no-one will employ her.

If only, she says, if only I wasn't defined by the sort of work I do so that when I'm not working I'm not defined at all, which should be ideal but it's not. I get moody, I sleep in till midday & run around at night cleaning up or watching Plan 9 from Outer Space except, of course, when there's only shit on t.v & then I go out.

She's very lucid sometimes. She's very cheerful, fussing over her clothing, should she wear black jeans or grey & some time she must wash a few tops for such celebrated occasions. Oh, there'll be lots of people there from different walks of life, real heterogeneous splendour, real variety united by a common concern. Disarmament, no less. On goes the make up, applied liberally & enthusiastically. The hair teased, The tone gushing. She's talking ten to the dozen, about shopping & the film she saw at the Valhalla last night, about the excitement of driving over the Harbour Bridge, about her latest drawing & why she doesn't like it. She says, self criticism does me the world of good, gets me into practice for criticising others. I say it's good to see so much life in you, you must really believe in this. She says, it's great, I can go to the pub afterwards & not feel guilty.

There's a waning light around me, It's quiet. Tomorrow I'll get a job, I'll buy the *Sun Herald* & make enquiries & wear presentable clothes to the interview & say the right things. Something's sure to turn up. Tidy up afterwards & make a hot cup of ~~coffee~~ herbal tea. Organisation is such fun. I endeavour to be a less moody person & kinder to my family, they can't help their

stupidity. This room suits me but I must clean it up &
rearrange the t.v so I have a better view from every
angle. And watch less garbage. Time will be of great im-
portance when I start this new job. Next week. I'll see
the sunrise. And drink less. No more paralytic discus-
sions on anything 'specially Godzilla vs Megalon or even
Destroy all Monsters. If I can't be sober then I can't be
anything, all it takes is a bit of willpower. To destroy all
monsters & not think it's my fault. Like that song baa
baa black sheep have you any wool, one for the monster
& one for the dame, and one for the little boy who's
lonely & lame.

So I ask her, what are you going to do? What about,
she says, rearranging the furniture & I am momentarily
distracted by her painstaking efforts at applying
polyfilla on some cracks in the wall.

Pages Volantes

Francoise Chaimbault

In French *voler* means to be scattered away by the wind, to fly and to steal.

> . . . blank pages, gaps, borders, spaces and silence, holes in discourse; these women emphasize the aspect of feminine writing which is the most difficult to verbalize because it becomes compromised, rationalized, masculinized as it explains itself. . . . If the reader feels a bit disoriented in the new space, one which is obscure and silent, it proves perhaps, that it is women's space.
>
> Xavière Gauthier[1]

Monday

Found yesterday this several-years-old poem:

Do you hear
The wind in the branches
Near you?
Do you see
The sky
Getting very dark
Above you?
Do you feel
The cold
Getting inside
Of you?
Put your thoughts away
For you will soon go away.
Hear the wind
See the sky
Feel the cold
For the last time.

Don't be afraid.
She will take you
By the hand
Very gently
She will get inside
Of you
Very slowly.
For the last time
Hear the music
PLAYING LOUDLY
ON-THE-TAPE-RECORDER
And look at the painting
In your favourite corner.
Now lie down.
You see
No more you hear
The wind
No more you see
The sky
No more you feel
The cold
For she has started
To enter you
Keeping you warm
And your pain away
What
No regret?
With Her you have to go
That is the price
You have to pay.
Her name?
Death, my Lovely![2]

Wednesday

Mary Fallon's poetry is MIND BLOWING. I read her book[3] in the bus yesterday and found myself flat on my back several times. As I read, her words, without any punctuation, took hold of me and wouldn't let go. Images started coming to my mind, like shooting stars, in all directions. I felt dizzy and the traffic noise was not distinguishable any more from the inner symphony of her poetry, which went from Chopin, to Bach, to Tchaikowsky.

"Why does she keep rubbing salt on her wounds?" (As if I did not know that when we have someone in our head, in our heart, in our body, wanting to extirpate him/her is wanting to commit suicide.)

And then, progressively, she became the winner of this inner *corps à corps* (body-to-body). Transcending her pain, she gave birth to this beautiful poem[4], which unfolds before our amazed eyes like a giant flower.

Friday

Coffee, Cinzano, Cigarettes.
— Another day of the three C's. (Not in that order.)
(How penetrating is Marguerite Duras, who spoke of *les moments troubles et opaques des femmes*, women's opaque and troubled moments.) [5]

Saturday

Migraine!
Another "leap from the mind to the body"?[6]

Sunday

Worked in the garden all day. It was so cold! I wish summer would be here, although it is so humid in Sydney! *Ou sont les étés d'antan* (Where are the summers of yesteryear?) like this particular one when I was 11 and living in the country in France.

I remember how hot it was, in that small village of the Loire Region. Outside, it was like if the blazing sun had melted in the golden fields of wheat — waiting to be harvested — in sharp contrast with the flat blue steel of the sky. But then, at night, we used to go for long walks, in the paths across the fields, my mother and I.

I remember how strange our voices sounded. I remember how our physical appearances were different from the ones we were accustomed to see during the day, everything taking another dimension: our gestures, our voices and how the physical and psychological awareness of the other was intensified. I remember how blissfully happy I was.

Tuesday

Yesterday was D. Day: the day of the presentation of our paper for the course "Ideology and Art". Contrary to what I thought, it went very well, and like Avril (I always call her "April") had said, it has been good for me to speak in front of an audience.[7]

Robin, outrageously, but very wittily, spoke of women's graffiti (being a nurse, no wonder she seemed to be so familiar with all these orifices). Unfortunately, this was not that well received by the audience, which worried us all.

Anna was there, impassive (were her students going to

be as good as she thought they were?), surrounded by a friend who looked very feminine and French (with her beret and her delicate dress) and a single father who found MY talk very interesting!

Linda also was listening very attentively and seemed to be pleased by it all but looked a little bit puzzled and confused in the end, when confronted with the cake (decorated with cunts).

Our presentation was titled "The Art of a Woman is her Living", and . . .

* * * * *

Katia has just interrupted me to tell me what she wants the little mouse to bring her for her fallen tooth;[8]
— A big yellow car like the one in the toy shop window.
— But, Katia, it's too big (and too expensive, think I), the little mouse will never be able to carry that.
— Yes, she will. Because when she brings big presents to the children there is a big rat (she shows me with her hands how big) which helps her!

Thursday

All I experienced about the difficulties in writing because of my interruptions, because of my doubts, it was all there, expressed by someone else who had gone through it before me.

I remember having written for my presentation, taking as a starting point Michelle Cliff's writing: "Our silences originate in interruption and our silences lead to interruptions." [9]

"I always wanted to write — but was too involved in my dual role of wife and mother, which I tried, of course, to play to perfection: one day, I kept thinking,

when the children are at school, I will have the time and energy to write.

"That day has come.

"But when I sit at my desk during the day, in the complete silence of the house, I feel very restless, finding it hard to concentrate. So, I create my own interruptions: I water the plants, tidy up the house, put one more load in the washing machine.

"Although these activities alleviate the feelings of guilt for not doing housework, I still feel disconnected, *mal dans ma peau* (ill at ease under one's skin) — especially if it is early in the morning.

"I have been so interrupted — by the children during the week, husband, children and visitors during the weekend, that I cannot concentrate when these conditions of interruption are not there any more."

And I concluded by saying:

"Unfortunately, women cannot easily unlearn the role which has been imposed on them by society because if they do not choose self-sacrifice — as they have been conditioned to do by our patriarchal society (which depends on their very sacrifice for its existence) — it revives thousands of years of guilt and self-doubt, thus keeping women's creativity and therefore, women's identity in control."

Tillie Olsen speaks of "habits of years" and of "the cost of 'discontinuity' ".[10]

She quotes Virginia Woolf who called women writers the "Angel of the house"[11], and Adrienne Rich expresses her conflict between her duty to husband and children and her desire to write.[12]

And, still, as Sue Bellamy says, "Feminist Creativity is not merely pleasing form or subjection to style — it is a releasing of suppressed energy".[13]

Friday

Bleu, Blanc, Rouge.
Today is Bastille Day.
Today is

Blue
Like the warmth
On my skin
Of the winter sun
Red
Like the wine
I'm drinking
And my thoughts
In the garden
White
Like this page
The moving shades
Of branches
And of leaves
Sounds of birds
In the trees
Their liberty
How I envy
The fresh air
The burning sun
On my skin
How contradictory
Soothing talk
Of that bird
Near me
And suddenly
The silence . . . The silence . . .
Please, please, talk to me

Friday

All week I have been writing in the morning. Doors closed, windows closed, curtains closed. The silence of the house does not inhibit me anymore. My *womb-house*, as I call it when it is cold outside and warm inside with the heater on. I write. About everything and about nothing; sheer pleasure of putting one's thoughts on paper — fully aware of the difficulties I would encounter if I wanted to have it published.[14]

And if by any chance I were successful and would have public recognition, that would be the end of my privacy. I should be prepared to have my female body and my female soul dissected and crushed under the sharp criticism of (mostly male) critics and reviewers.

And do not forget that
"A man's book is a book. A woman's book is a woman's book."[15]

Epilogue[16]

"Ecrire, c'est devenir, mais ce n'est pas du tout devenir ecrivain. C'est devenir autre chose." To write is to become; but it is not at all to become a writer. It is to become something else.[17]

"I know that when I write there is something inside me that stops functioning, something that becomes silent. I let something take over inside me that probably flows from femininity. But everything shuts off — the analytic way of thinking, thinking inculcated by college, studies, reading, experience. I'm absolutely sure of what I'm telling you now. It's as if I were returning to a wild country. Nothing is concerted. Perhaps, before everything else, before being Duras, I am — simply — a woman . . ."

Marguerite Duras[18]

1. X. Gauthier, "Exiset-t-il une écriture de Femme?", in *New French Feminisms*, ed. E. Marks and I. de Courtivron (Amherst: University of Massachusetts Press, 1980), p. 164.

2. In "Parole de Femme", Annie Leclerc argues that men are terrified by death, that they see it as a defeat, and asks: "But who has set himself up as judge of the monstrousness of death? How and in the name of what can we, who are mortal, qualify death as monstrous? And this is where greatness (mens' greatness that is) is meant to lie?" *(New French Feminisms, p. 84.)*

3. M. Fallon, *The Sexuality of Illusion* (Glebe: Working Hot, 1984).

4. In "The Laugh of the Medusa", Hélène Cixous explains that poetry involves gaining strength through the unconscious. (*New French Feminisms*, p. 250.)

5. Marguerite Duras interviewed by Michele Manceaux in *Marie-Claire*, 1977.

6. See also Moira Gatens, who discusses the so-called, mind-body problem (first explained physiologically and psychoanalytically by Freud, who described it as a ". . . mysterious leap from the mind to the body") in terms of "a leap from one kind of discourse, say the analytical to another, the physiological".
 M. Gatens, "A Critique of the Sex/Gender Distinction", *Beyond Marxism*, ed. J. Allen and P. Patton (NSW: Intervention Publications, 1983), p. 148.

7. See Hélène Cixous' comment on the difficulty that women have in speaking in public — especially in front of a male audience, who understands them only if they use masculine language. This is almost impossible for women, Cixous goes on, for "her speech, even when 'theoretical' or political, is never simple or linear or 'objectified', generalized: she draws her story into history". (*New French Feminisms*, p.251.)

8. French children are not as poetically rewarded as the Anglo-Saxon children when they lose a tooth. Instead of a fairy bringing them money, it's a little mouse which brings them a little present, which she leaves while they sleep, under their pillow.

9. Michelle Cliff, "The Resonance of Interruptions", *Chrysalis* 8 (Summer 1977).

10. Tillie Olsen, *Silences* (NY: Seymour Lawrence, 1978), p.39.

11. Ibid, pp.33–34.

12. Adrienne Rich, *On Lies, Secrets and Silences* (NY: Norton, 1979), p.43. She goes on to explain that when you succeed in writing, "It is an extremely painful and dangerous way to live — split between a publicly acceptable persona, and a part of yourself that you perceive as the essential, the creative and powerful self. Yet also as possibly unacceptable, perhaps even monstrous." Ibid p.175.

13. Sue Bellamy, "Women cannot paint — They can only consolidate" in *Mejane* 4 (September 1971): 12.

14. In *Are Women Writers Still Monsters*, Christiane Rochefort reports that after de Beauvoir's novel *La Femme Rompue*, she was said by a (male) critic to be an "old woman", that the quantity of whisky that Francoise Sagan absorbed was carefully measured . . . and that Marguerite Duras, coming out of a clinic after a breakdown, was tor-

tured by a reporter about how she felt and if she was as inspired as before, and if she was not frightened by the blank page. Christiane Rochefort herself was described by a (male) journalist as being ugly and frustrated after her first book was published. *(New French Feminisms*, p. 183.)

15. Ibid.
16. I owe to Anon. (*Jenny, My Diary,* Penguin, 1983) the format of this essay; to Adrienne Rich (*On Lies, Secrets and Silences*) the style. Except for some (amateurish) poems, the whole diary has been written for the purpose of this essay.
17. Gilles Deleuze
18. Duras, *Marie-Claire*.

Shadow 1

June Factor

And still they come to wonder at her smile
(tremulous mouth across the flickering years),
to watch the soft convulsions of her walk.

Fixed in celluloid aspic, she mimes
her heart's long hurt dispassionately, alone.
And still they come to wonder at her smile.

Her eyes cast down, the net of hair drawn tight
catches the indrawn breath of those who come
to watch the soft convulsions of her walk,

to taste with salty lips the apple flesh
that's gnawed and nibbled silently. Storms rage,
and still they come to wonder at her smile,

while privately each watcher counts the cost,
subtracts the dues demanded by the heart
to watch the soft convulsions of her walk,

elusive shadow on the cave's blank wall.
Who can remember back before the dark?
And still they come to wonder at her smile,
to watch the soft convulsions of her walk.

You Don't Whinge

Inez Baranay

Part 1: "How lucky you are"

"Australia is beautiful sure everything's easy, you can have everything if you work, you can get by easy if you don't work. But it hasn't got. You know. There's nothing spiritual."

"Australia is where people are coming to now, like once they would all leave. Something is really happening here. You can feel it. Everything's coming together and its very positive and very spiritual. New age consciousness is really growing here. This is the most spiritual country of the future. We have chosen to be here to be part of that."

"I been to Australia a lot before. I thought I'd check it out as a place to live, work here. It's a beautiful easy country. But it's *too* good you know. What do I miss? *Energy*. I like Australian girls. Australian girls got soul."

"You Australians don't know how lucky you are and you're giving it all away."

"Darling don't you notice as soon as you get back to Australia you notice how most people are ugly, you see crowds and no-one's really good-looking and mainly they're ugly. Over there you just sit and watch people go past and there are attractive and beautiful people always walking past you. Here it's so rare we go home and ring each other up: guess what I saw an attractive person today."

"Think of all the places people have come from to live in Australia. Except the aborigines of course. But

25

everyone has come from somewhere else for a purpose. It's the only country everyone who lives in has *chosen* to live in."

"Australia is people who can't make it anywhere else."

"I've lived in this country for six months now and I tell you I have never seen such a case of sat-upon energy. You seem to have a national conspiracy to sit on all your enthusiasm, all your vigour. If you ever really *own* the energy in this country — wow!"

"More countries should be like Australia — apathetic. Yes that's the greatest thing we've got going for us here — our apathy. Say to America: help yourself, build your bases, take the minerals, fuck you, we don't give a shit, we're right. We should let China and Russia build their bases here next to each other and let them destroy each other in the desert, just let them leave us alone."

"Australia has no tradition but images of a fantasy tradition: boomerangs, kangaroos, the outback. That's what people know: the fantasy images, the imagined tradition."

Part 2: Childhood was black salami

We've all got a black-bread-and-salami story. Our smelly stinky reffowog lunches. All the other children have their white soft sandwiches filled with stuff we have to find out about, vegemite — peanut butter — devon, and they swap half of this for half of that. But we have coarse thick black bread with spicy garlicky sausage and we throw it away or we hide it or we eat it with shame defiance resignation we flavour it with revenge secrecy pride . . . we can't swap with them all we can do is share latvian bread polish sausage serbian pickle hungarian salami italian ham greek cheese . . .

They are soft white bland even children and *we* are black lumpy spicy prickly children we cause strange smells in your nose strange sounds in your ears and in your belly indigestion discomfort embarrassment. They are real-australians. We are new-australians, would-be australians, non-australians. At school they know we must have come from somewhere that was no good ("they're all coming over here, we're not rushing over there") at home we've come from somewhere that was better. Must have been, the way it's spoken of and not spoken of.

Not you! they say to me now, it can't have been like that for you! Not me they say because I don't have olive skin black hair sloped eyes. I have blond hair and I'd pass for white. But my name was what-was-that-again/different!? What kind . . .? and my childhood was black salami and saying to my mother aloud or not aloud oh please don't talk so loud oh please talk english please don't wave your hands about It took us longer to be proud of our mothers.

We had secret prides already along with the shames. *They* came from convicts. We came from countries with history, culture and traditions, we lost it because of Hitler. "Real-australian" becomes for us a way of saying common and mean: in the outer world australian means crass and provincial. (This is way pre-Whitlam.)

We were on our way to recreating the past. *They* worship an english queen and sing english songs. Their history is english governors and convicts who drink rum and sing horrible songs. There were explorers and kangaroos. Aborigines stood on one leg and were shot. We never see what this has to do with us and fail to learn about it. That is their history. Our history is the secret stories our parents tell and the many things they never

speak of. We came from somewhere else and something owed to us was taken away.

Mary was my friend at Sunday School and I go home with her for roast dinner. They are scottish which is english the same as irish. Roast dinner is a leg, baked veg, pudding. It is exotic, it is foreign, but I know it is normal, this is what you eat on Sundays in Australia.

When we were children our mothers travelled miles to the one place you could get real coffee real bread real sausage. Later, you can get these things everywhere (about the time we turn vegetarian and drink herbal things). An echo of this when I lived in a country town for six months in the early 70s. It was *The Last Picture Show*, the drive-in hadn't opened yet the Greeks served pies and chips in their cafe and cheese only came in blue boxes. The next year there was a supermarket and then suddenly Delicatessens, Health-Foods and Boutiques, and now farmers wives make their own pasta and grind their own coffee.

Wog food becomes exclusive food becomes trendy food becomes city food becomes food.

Food our wars their restaurants food our recipes their dinner parties food our everyday their let's try it food our peasant fare their delicious food our delicacy their stomach-turning food our pig-feed their serve to guests food we miss it they import/tax/speciality food our food their better way to have it.

Then we are thirty or thirty-five and we meet for lunch near the television station where we all work or have worked. Multicultural Television. Double-You-Oh-Gee Tee Vee.

I had my job there when I'd just come back from Europe, back to be an australian. It was a new decade and there was going to be a new australia and Multicultural TV. I worked with real-australians and the

men (don't stop me there of course men) who ran the station made policies bought programs and said what-was-what had english names and were real australians too. They made jokes like: it's now the able-bodied heterosexual white-anglo-male who's discriminated against. (What's discrimination — calling a bluff, losing?)

Wogs women abos and cripples become boards/units/projects and fat public-money salaries. And politer ways of saying it.

And the pragmatic truth is (I listened to this) all the new reffos and boat-people are a bunch of in-fighting factionalised sub-divided gang-war lot and Luigi Abdul Loh are building their own empires manipulating the divisions. And we real-australians divide and rule divide and rule as our englishness makes us so naturally able.

So you can't have them running these things though they are welcome to write in or be elected to something. And we'll give them variety shows soap operas romantic movies not debates inquiries docos forums which stir up politics. Because we're not elitist, this is what they'd watch in their own countries if they could have TV usually they're illiterate and couldn't make it over there. And when the trendies switch over from the ABC we'll have the kind of good European movies that introduced us to subtitles.

But it's early days and I go about my research job and the taxi-drivers tell me what they think of coming-Soon Multicultural Television. It's them and us them and us. If it's *us* they're glad to hear what they'll be watching if they come from a country with a film industry that makes films that were in the package that the buyer liked that won't stir up politics. If it's *us* the taxi driver stops the taxi in crowded Parramatta Road so overcome with emotion because not only do I now know about

Oum Khalsoum I promise he'll see her on TV and the date. If it's *them* the driver says with some belligerence "they should be learning english shouldn't they" and I say "not all australians speak english as their first language" really believing this, believing *in* this, "not all australians have english origins" and he stops the car in the middle of the crowded Harbour bridge he doesn't want to drive me any more. I feebly resort to "They'll learn english from the subtitles."

So, this lunch that day, a few years later, a few years ago. We have shrugged off our disillusionment with multicultural TV, we've got other things on our minds. Though remember we did think at the time at last at last this is us and for us and made for us to do.

It is a beautiful day so lunch is al fresco, smoked turkey and salad on rye, looking at the glittering harbour of the best city in the luckiest easiest country in the world. B. had been asked to write about growing up migrant so let's remember what we're here for and she takes up her pen. And we all go "black bread and salami" and laugh because that's the only way a migrant childhood story can start.

Food, and names. How some of us and our sisters got their names changed to real-australian (ie., english) names that could be said. Who we know who had to change to a real-australian (english) name to get ahead and has one name at work and with real-australian friends and one for the family. The shortened anglicised version some of our parents changed to. And now some people are changing back or digging up names from foreign great-uncles to change to.

We had this topic with a real-australian friend some years ago, the way *they* refused to say our names and our friend cries: "But we had no references!" and we say: lazy, just lazy. Resistant. Children who have not

been told they have no references have no trouble, they say it right. Sue Kay Lyn Ann Jill etc never watch for those who try to make sure they get it right those who get it right at once those who never get it right. We've all got a name that matters to us.

We envied your exotic names says another real-australian friend, the liar. Retrospect changes things retrospect over espresso/matzo soup/cheesecake. She's told me before how she and her friends, hearing new-australian languages on the street, they'd go sneer sniff reffos why don't they go back.

None of this matters any more, that's the point I somehow want to make from all of this. None of this matters any more and it shouldn't. It's a new australia and you don't whinge. We live in a cosmopolitan city and watch american TV on satellite. Everyone's sick of fancy cooking and the debate on national identity. You travel when you can but these days on a return ticket. I love the english language and hope the world heals and renews. We forgive ourselves and forget our childhoods. I meet my friends for cappucino and some days say I'm still just trying to pass for white.

On the Way to Lodz

Lily Brett

On the way to Lodz
our tireless guide
insists we stop

at
Zelzowa Wola
Chopin's home

we see
Chopin's piano
Chopin's mother's piano

Chopin's bedroom
Chopin's mother's bedroom
Chopin's bathroom and Chopin's garden

having no
interest
in Chopin

I glare at the guide
who takes us past
Chopin's desk and Chopin's table

Mrs Potoki-Okolska
I stutter
are we going to Lodz

and again I feel
Lodz
doesn't exist

and
maybe
mother

I
will
never

touch
your
past

eventually
Mrs
Potoki-Okolska

leaves
Chopin
reluctantly

humming
La
Polonaise.

translate

Ania Walwicz

inne different to co this what is on levels krasnoludek
dwarf no not dwarf is fairy says robimy siusiu we pee
peepees weewees we wee o piss let's now translate jokes
trudno is difficult remember and what is word for this
krowa cow not same thing now think hard starannie tidy
neat accurate put across from another world kraj coun-
try don't say same mean znaczy use same letters so can
put sztuka play theatre bawimy ubaw zabawa play is not
play like english child special word for play stage english
relies few words say what neighbour relay on another
polish describe exactly in but now i less fluent forget
what say think hard about before stumble fall over
words fall over i fall over wywracam wracam come back
to before think polish words don't answer they go away
goodbye forever then see you again dowidzenia ciao
they return little letters typed in my head hidden in
drawers put away they return bit by bit ten facet fellow
painter jacek malarz pokojowy house painter is going to
paint my house renovate looking for right word page
mister right word but he doesn't come yet nie no please
come but he says no nie oh please come soon when you
can when ready when found me find znajda sierota
foundling orphan doorstep basket koszyk niemowle
baby can't speak i once did now forget forgot
zapominasz powoli slow powolnie slower slow down re-
mont i remember what renovator does what does he do
what is he going to remont renovate these words hide
then come out hide and seek where are you where they
were once arranged ready worker then retire english take

over but they're still there not used but wait to be dug
out dusty old dresses i don't wear no longer stare old
sukienka dress used to flow and now cat kot ala ma kota
ala has a cat from first grade reader come sentence first
learnt scraps rzeka river rzeczka little river flows
meander wije speak slowly please zachowa will keep to
keep treasure skarb to keep po co ci to he said what do
you need this for now wants me translate keep not lose
tongue mowa speak okno window dach roof sciana wall
paint maluje malarz painter for my house dom words
will come later first try trudno hard but not too hard
where are you words we are here czekamy we wait they
wait for me here gotowe ready for fight but awkward
not joint to join put together immediately razem
together gather to put pisarz writer says write polish po
polsku po angielsku have both keep both strata loss lost
language lost tongue pickled don't you lose this keeping
trzyma holds embrace what is embrace how do you say it
look for embrace do it i don't know how it will come
usta lips nose nos eye oko face twarz neck i touch my
neck but there is no word yet neck stick out from
shoulder for head neck came now szyja hurray hurra at-
choo apsik hrapie snores budzi wakes it will flow again
if i try to try to try out to look for to find znajduje
wracam come back to back head where everything is
these other words bit rusty brudne dirty i will clean them
polish them i will show off and you see what it's like
won't tell you anything you be on the out for bit nic im
nie powiem nic tak jak ja wtedy what is woda drzewo
maj serce bluzka palto but zegarek just sounds for buzz
my mouth moving says you don't know ha allright will
tell them will translate water wood may heart blouse
coat shoe clock watch i will speak polish on a tram and
discuss people by nasty wroga hostile giggle dirls discuss
teacher it always sounds nie dobrze not well prestaniesz

ja stop that like to have another bit more space switch to station radio wave fala stacja inna different cud-zoziemiec foreigner has some extra at back of head is another country my old words sleep wait

The Headlines That Never Made It

Sue Kucharova

The photograph her parents gave to the newspaper shows a young woman, with dark curly hair and bright smile. All the papers used the same picture, but some of them also used a diagram of where her mutilated body was found.

By the time I picked up my copy from the front garden, she was nothing more than a sensational headline; a photo for most, and a painful memory for the few. So now I am writing a story of this woman waking up in the middle of the night. Who is she going to be? Single? Married? Divorced? Living alone? Living with a husband or a friend?

She wakes up from a dream. Should the dream be a pleasant one, or should it be a nightmare? I think I'll let her dream of snowflakes, silently falling on her bare feet, covering them in a soft feathery blanket.

Now I want her to wake up. She has to. I've put an intruder in her house. Will she wake up slowly with the softness of the flakes still lingering on? With the sudden realisation that all is not how it should be? When she awakens, will she believe her senses telling her that someone else is inside the empty house?

Yes, I have decided that she will be alone, her friends have gone on holidays; her husband is on a business trip, her girlfriend just away for a few days. She wakes up to the resounding footsteps on the polished floors in an empty house. No, there is no place for carpet in this story. I want her to feel the vibrations of the wooden

floor. Whether single, married, divorced, or a widow, she will try to pretend that the steps are still part of her dream, from which she will be saved in due time.

I will, however, bring the footsteps nearer. I will make them watchful and slow, not stopping to pick up the video and the colour TV, but purposefully walking towards her bedroom.

I could let her stay in bed paralysed by fear, knowing she should move but unable to do so. Waiting for the steps to come closer and closer.

Fortunately I have already developed a liking for this woman, and I don't wish to see her getting hurt. I force her to get up, despite her jelly-like legs, and send her slowly and quietly towards the bedroom door. Step by step, she is hoping to reach it before it opens from the other side. She finally discovers an empty keyhole. What will she do next? Faint? Scream? Run out of the room and struggle barehanded with the intruder? She has no hope of winning, she never learned how to give punches, nor how to receive them.

She stands there trembling with fear. Can't even escape through the windows, trapped in a fine wire cage.

By now I really like her. I wish she would not accept the violation of her house and probably her body, in the centuries-old pattern. I do see myself as a progressive writer, after all. I place an electric iron on the stand near the door, and a streak of light from outside to make sure she sees it.

For a split second she admires the silvery light, wondering if it's coming from a full moon or a street lamp.

A few more steps outside the room, she grabs the iron and moves silently behind the door.

I know, and she knows, that the only chances of a happy ending are for the footsteps to stop, turn around,

and walk away; or for a quiet knock on the door, followed by her name pronounced in the familiar way in which lovers call, when arriving unexpectedly late at night.

However, I am not writing a TV script or a thrilling romance. The steps will slowly reach her bedroom and then stop.

She realises her only advantage comes from knowing that he is there. It is precisely this knowledge which cripples her mind and body. She hears her heart pounding like a water pump, convinced that he must hear it too, separated only by the thickness of the door.

I can't stop her from feeling scared. I can't even make her believe that it's happening. I would like her to realise that waiting turns the hunted into the hunter, and her only way to survive is to wait and act.

I am not very successful. She stands behind the still-closed door, praying silently for him to go away, feeling helpless. She wants to go back to bed, close her eyes and accept her fate. It is easier that way because it is the pattern she knows, it is the way she was taught to be. All her senses stretch to their furthermost as the door knob silently turns, one way and then another. Her breathing stops, his continues. I think she believes it now. Fixated, she stares at the movement of the slowly opening door, wanting to scream. "Get ready," I whisper. The door opens completely, protecting her from the reality of the other side.

A few moments later the figure of a man appears, slowly stepping forward in the dark. He is cautious but confident. Her lungs are about to burst, betraying her hideout. She must act fast to use the element of surprise.

She wants to wait, wait for eternity. Maybe he will not see her, maybe.

I know he holds a knife. I know he came with a pur-

39

pose. He watched her for days, waiting for his chance. He knows she will be frightened by his knife, he doesn't necessarily want to use it, he has other intentions.

I can't let him walk too far. I have to give her her last chance to act. I let him pause, making sure nothing stands between him and the bed across the room.

The same silvery streak of light which served her once already, now reveals the knife in his hand. She silently gasps, lifts her hand above her head, then pauses again.

I know he found a clear path to his target and is ready to move on.

Oh God, she is worrying about hurting him! I can't take it anymore! I push her hand violently forward, whispering in her ear, "He came with a knife in his hand. To your house and into your room." Her lungs let out the stale air with a scream. The iron in her hand finally hits the side of his head, there is not even enough time for surprise. She takes a step back and fills her lungs again. She and I hit once more. His body crumples and falls to the ground. She looks at him with disbelieving eyes, screams, and drops the iron.

I visualise the next set of headlines in the midday news. The full moon shows up behind the muslin curtain in my room.

To Virginia Cuppaidge

Jolanta Garolis

New paintings from New York
painting no. 6, Heart . . .
very feminine
expressive
virgin blue
a bit of purple tantrum
the little cloud
romantic, solid
the red triangle
heartfelt feelings
a few white arrows
piercing the heart
a very consequential thought
brown and
royal blue strip
arrested
facing the little cream cloud
some lighthearted streamers
a few exotic leaves.
that's no. 6
at Bloomfield Galleries.

10/20 Dogs Under the Bed

Rosa Cappiello

Translated by Gaetano Rando and Tony Mitchell

No breeding at all. Spoilt and stubborn, they sprawl over the beds and in the bathtub, run riot all through the house, piss and shit any old where. So what if they're expensive and sophisticated, from African and Asiatic steppes, tall and thin, slender and graceful of limb. The grace of a filly. Gets us all on heat, scrapes away the traces of rust in our joints. Actually, I told him from the start that what I would really like to do was give them a good kick in the balls and send them flying out the window. As the last wish of a condemned man I would like to see them yelp, wag their tails, foam at the mouth, those 10/20 right little sluts, fresh as a rose, pollen under their armpits, a greenhouse, a paradise on earth of erect breasts, golden ovules, ovaries opening out to the sun, the quintessence of spring bubbling up in my breast. Damn it all! It's mouth-watering, makes me foam at the mouth. When I think about it I suddenly feel young again. Jumping spryly and nimbly from flower to flower . . . naked baby, eye for the ladies, tiny wandering hands . . . I would throw them on to the floor, turn them inside out, bundles of them, whole packs in every shape and size, smell and colour, indiscriminately . . . until I pass out. Ah, I'm passing out. Hold my hands. I've never been able to control myself. Even in my youth I'd get delirious just eyeing them up and down.

Darlings, my little pudgy cream-complexioned dollies,

42

have a good feel of grandaddy, yes, that's it . . . a bit lower . . . gently, slowly, down there. Where it hurts. Or grandaddy will cry. Cry his eyes out. Boo hoo hoo. Big tears will roll down his cheeks. Visionary, senseless, bitter tears.

Not even bag-ladies dare to encroach on this territory, let alone lovely little girls! Our neighbours are a cranky lot, elderly couples perfectly content to potter round their gardens or coop themselves up in their rabbit warrens. You could die, turn into a skeleton and they wouldn't even notice. Except for the eccentric old woman who lives a hundred metres or so off the main road and has the atrocious habit of spying with a telescope from her attic on houses scattered miles away. She's the only person in the neighbourhood who owns a nag, which has a very droopy jaw but no tail or mane. Every morning at the crack of dawn she wears him out thoroughly with a long gallop. But gallop as he may she always makes him slow down when he gets near my gate. Mrs Melissa, Manning's widow. She flutters her eyelids and dilates her pupils when she stares at me. It's enough to bring on a rabid attack of the colic even in a saint. Enough to turn your stomach! A penance for youthful memories. Enough to have the few hairs I have remaining turn white. A threat to my freedom of choice. As I'm available, I'm afraid she'll cause me to capitulate. I'm almost tempted to lure her into the house on some pretext or other and whack her right into the midst of the dogs, into the pigsty, complete with turds, flies and bedbugs, I'm that depressed.

Why shouldn't I be? In my day, fathers took their sons to the best brothels to wean them and give them some practice. They assumed responsibility for the education, religious upbringing and future career of their heirs. It was a matter of family honour. Now

nobody gives a stuff about taking the same sort of care of the oldies. There's no public sexual welfare service for a start. Something along the lines of "Home Care Service". Itinerant maids fully qualified in coitus and mouth-to-mouth resuscitation. These shitheads who govern us promise us tax cuts, wage increases, more jobs, new schools, new housing, public monuments, but they don't know the first thing about the people's most basic need. To fuck! All the people have ever asked or ever wanted to do is fuck, on a full stomach or an empty one, it doesn't make any difference. Revolutions? Don't make me laugh. You don't have a revolution over a loaf of bread. Let the starving fuck, God help us, and you'll get a plenary indulgence! No need for free treasury bonds, cards or concessions. At my age you can't up the ante. The blood doesn't sing in my veins any more. Let them sing and play for evermore in the old fools' club on the rocks, in that bazaar of old tat and crumbling bones which crash out halfway through a waltz. I do not desist, I remain firm, dug in, on the defensive.

I have a reputation to maintain as an impenitent Don Giovanni. I've seen the winds of thirty-three foreign countries lift the skirts of girls; I have impregnated redheads, blondes and brunettes. I'm greedy, and choosy. I want them young, a bit on the plump side, and without any brains, but where can I find them? Over the paddocks, the swamps, the far-off sand dunes, the forest, the sea, and behind the dog-house a small emerald green hill, its slopes lined with horizontal rows of white crosses which converge in indistinct points at the summit. Up there rocks and ravens fly in a black cloud of ill fortune . . . I'm old . . . well preserved . . . withered, but sprightly, and I've never ever put on a pot belly. But increasingly more often now depression creeps upon me, with that cemetery just a gun shot away

sounding its roll call. Especially at night. Insomnia, asthma, coughing fits. When I look out the window I'm lured by bright little flames. They loom unimaginably large. You'd think I was already moribund. Joker spirits, bloody little wankers let loose in the evening to enjoy the view, the fresh air, and maybe even an orchestra of violins improvised by owls. What do I know? What would I know of life after death? I observe with dismay those luminescent plumes in the bluish haze of the swamp, perceiving them as I perceive the stars, the moon, the sky. An enchanting play of al fresco necromancy. Phosphorescent spider webs tangled in the short grass, flashes of sound darting about at the speed of lightning, and every now and then a bang. Forked shadows spit fire, male-female-soul, evil beings, bah! I hear them with these ears, see them with these eyes, swaying, joining together, dancing clumsily, separating, leaping and bowing to each other. I see spurts of gas twist and twirl, spiral upwards, lick the clouds, and romp back until they're a few inches from the ground, taking on the shape of an obscene grimace.

They call out to me, they flirt with me, give me the eye, just me. In their bad faith they recognise in me the imminent dear-departed emptied of emotion. Another puff of toxic gas makes them tumble together in a merry gymnastic display. What a higgledy-piggledy pack of bastards the dead up there! Robbers, drunkards, hell's lurid leftovers! Can't even make the effort of a tiny fractional detour to the right, towards the power lines that stretch for miles and miles along the asphalt strip of main road, towards the widow's wooden shack, softly softly zigzagging up to the attic, and poof! She'd disappear, like a roasted angel. One sticky beak less across the road. If I could get them to understand by telepathy . . . up there in that place I know. What a bargain —

hundred kilos of extra fine fat, superadhesive, guaranteed minimum waste, just the thing for eroticism, exhibitionism, togetherness. What a load it would lift from my conscience. I can't sleep. I don't get a wink of sleep at night. A strange uneasiness of unknown origin grabs me by the throat just as I'm on the point of nodding off. I get up, put on my woollen socks, shoes, beret. I rattle the lock, the door handle, then reconsider, pace up and down, up and down, trying to make up my mind . . . hours go by . . . day breaks. God I'm tired. Utterly stuffed. It's morning. I hear Josse moving round in the kitchen, swearing and yelling, more than usual. Must have changed his clothes at least seven times in half an hour. First he tries out the T shirt-pink shorts combination, then the violet. Then he ends up with the white-blue, red-brown, yellow-orange mishmash. God only knows what colour he's festooned himself in this morning. I'll lay thirty to one on our frisky four-legged friends that this morning we'll see a grand display of green and yellow in pure bilious silk, with a purple number 9 on his back. He loves his fancy dress and his strutting about even though he isn't admitted to the race.

My God. The house has been reduced to a dung heap. Curtains hanging in tatters, settees and armchairs gutted, footstools, furniture, anything that hangs down or sticks out is torn and gnawed. Not to mention that disaster of a garden running to rack and ruin back and front, ravaged with holes, burrows, bones, bits of bloody meat, rotten broken-down cages and little thatched-roofed huts, with just a few trees in the middle, a shady bell-shaped little thicket, avoided like the plague by the birds who've all disappeared in a flurry of feathers. Those dogs are driving me nuts, with their eternal barking, farting and slavering.

I'd love to go back to the time when little multi-coloured birds settled down trustingly and happily to eat out of the palm of my hand. They were so gracious about it . . . tasty and tender . . . dear little things . . . so affectionate too. I got to be very fond of them. Good taste, poetry, and culinary art was all it took. I'd got really good at roasting them on the barbecue . . . Then Josse discovered he loved pure-bred racing dogs. A sudden passion . . . a get-rich-quick scheme, a fast buck, fast as the speed of the dogs. Yep! You should've seen him and heard him talk in those days. Very convincing, and his euphoria was contagious, even if I did keep trying to ward off the evil ones, and took refuge in a barrage of refusals, retreated to my corner, hung on tight to the purse on my belt and stared pointedly at the wallpaper when he dropped hints about joining forces and savings. Brothers, partners and mates in a joint venture, for the duration. I remembered all the business ventures that had ended in bankruptcy, the great opportunities that had disappeared with the rising of the sun, the midnight flits from rented premises, the grind of starting again from scratch. Bullshit artist. One of life's losers. A right megalomaniac who gets worse as he gets older. You couldn't really take him seriously any more but his descriptions, his picaresque fantasies, the enchanting vision of the higher things of this world, capital growth, had got me under its spell to such an extent that I could feel myself quivering all over with excitement. I could feel the adulation of the masses, the stardom, being toasted with fanfares of trumpets, and admired by glittering and uninhibited high society ladies who were wild about him, and about me, poor miserable bastards, all alone without a soul in the world.

Women. Always women. Wherever there is music, ac-

tion, monopoly. Degenerate puppets. Ready to do it in our pants for a smidgeon of fun on the merry-go-round. Or even a tiny piece of love won at auction, of course, to be kept in a glass case under lock and key. I've seen far too many bashful bathing beauties, au naturel just like mother made them, twist and turn and pour out heart-felt exclamations of pleasure, dead certain they've fallen in love, declaring their fidelity beteen the sheets through every pore, who've suddenly shot through. A slight accounting error, deflation of the wallet, a diamond ring promised but not delivered, and they move on passionately and devoutly to another man who makes them a better offer. Victims of the consumer society, we must agree. All those women who feigned swoon and passion and were by me adored. What a fool. Getting done over and over again on top of such traumatic experiences. Yuck! I should go and throw myself off a cliff, if I had the guts. God help me. I'd rather write my memoirs. Or an epic poem. Revenge. Stick scurrilous verses in the style of Boccaccio up withered pussy willows turned into useless brooms put away God knows where. I wouldn't even bother to spit on them or waste a sigh on them in the light of the moon. Thus the passing of beauty is mourned. Let's get on with it, you old hags. Sure, I like the idea and I'll put it into action as soon as I get organised. Nowadays all I do is complain and grumble and spend the whole bloody day running around after the dogs. I should force myself not to think about them, egotistical bastards, couldn't give a stuff about the sacrifices we have to make to get them a pedigree. They behave like sluts and pederasts, a disgrace to the whole canine race. When in heat they're quite capable of mounting mothers, sisters, brothers and cousins indiscriminately. They're no different from those filthy monkeys at the zoo showing off behind their bars, suck-

ing up to a handful of bored chimps, out there for everyone to see, applauded by a crowd of children and adults having the time of their lives.

By comparison my senile erotic fantasies, filmed and discussed with a great show of erudition in catholic recreation centres, would pass unnoticed or at the very most look like some quite innocent pastime. I'm probably jealous. No doubt nature is kinder to animals. I should be so lucky. To wake up tomorrow in the skin of a chimpanzee tortured mercilessly, popular, petted, finally free of the angst which is the tragic fate of the thinking man. They say they're inexhaustible. Rubbish. I'd know all about that . . . half savage, half gentleman. Lovely lady monkey, let me scratch the fleas on your dainty little bottom, kiss your tiny hairy hand, but let's get on with it, the day is short. No putting on airs, no beg-your-pardons, no smooching. Only peanuts, bananas and coconuts straight from the trees, while I go through the first, second, third, fourth, on the hop, whistling a merry tune. God knows what. No sentimental romantic ditty springs to mind. In any case, there's no call for subtle preambles or even to stop and sniff them. A kick up the calloused arse and on to the next one, her face thrust into the thick foliage, paws over her eyes . . . women, women, I am yours. Ready to pack my bags and leave on the spot. Yes. Let's go. I'd love to go away. Emigrate to the darkest most mysterious part of Africa, virgin waterfalls, unexplored rivers, sun peeping through the branches, tons of ripe juicy fruit all year round, hunting deer ibex boar thrush zebra with a bow and arrow, the milk of the ass, the bread fruit, marvellous gift of God, undisturbed siestas in the shade, clear starry nights without a single damned soul around to bother you while you sleep blissfully as if in a villa with millions of millions of empty silent rooms full of

sweet sounds which rock the cradle of your dreams and give you the energy and the desire to do it, undo it and overdo it when you wake up.

I can't stand this life any more. I've had it up to here with the same old routine. Getting up in the morning. Having to set the alarm clock three quarters of an hour earlier, otherwise things get buggered up. Josse would lose all his zest and zeal if he was deprived of his early morning ration of applause and approbation, all bright-eyed and bushy-tailed in shorts and T shirt and purple rag vaguely resembling a 9 good luck charm sewn to his back, as he loads those fucking greyhounds four by four into the van to take them on their training run in the park or for their swimming lesson or to show them off to some big shot at the track. There's no denying, their pedigree is impeccable, as is their bloodline, muscles and finishing burst. Our pride and joy. A constant source of hope. If only they'd given us some satisfaction. A couple of wins in minor races, a good place occasionally, a dozen or so honourable mentions in the dog register. Not a thing. It's useless. And Josse can't be trusted. Shifty appearance. Criminal record. Five months jail for shoplifting. The news gets round. The contempt reflects badly on our dogs, makes them feel insecure, depressed. That explains their canine neurosis, diarrhoea, worms, dog flu. The few times they've been allowed to enter third rate races they've always come in at the rear of the field. It's got to stop. He's feeding me a load of bullshit. You'll see, he says, you'll see, Boris my friend, in a month's time, two at the most, we'll be millionaires. I have a hard job telling him they're dogs, not high class whores. Jeez. Same old thing every morning. Down the drive, whacks the dogs so they'll jump into the van, raises his arm, clenches his fist in a victory salute, shouting they'll win, we'll win, we'll be champions too.

Yes. Wait and see. We'll make them into chaaaampions. The punter's darlings. The poor fool still believes it. Wait and see Where's my watch? I'm sure I put it on the bedside table last night. My cigarettes? My slippers? I'm going crazy. Those dogs will see me to an early grave. I'll make them into sausages with muzzle, leash and racing colours for trimmings. I'll burn down "Josse, Boris and Dogs Pty. Ltd." lock stock and barrel.

10/20 Cani Sotto il Letto

Rosa Cappiello

Senza un briciolo di creanza, viziati e caparbi si sdraiano sui letti e nella vasca da bagno, corrono all'impazzata per le stanze e pisciano e cacano dove capita capita. Io me ne strafotto che son cani costosi e sofisticati, originari delle steppe asiatiche e africane, alti, snelli e membra slanciate, aggraziati. La grazia delle puledre femmine. Giusto per appassionarci a freddo e grattarci quel po' po' di ruggine dalle giunture. Infatti, gliel'ho detto fin dal principio che piacerebbe a me, si', prenderli a calci nelle minchie e poi farli volare dalla finestra. E come ultimo desiderio del condannato vorrei veder scodinzolare, guaire, sbavare 10/20 autentiche puttanelle, una torma di Lulù e Frufrù in boccio, fresche come rose e col fior di polline sotto le ascelle, una serra, un paradiso sulla terra di seni eretti, ovuli, ovaie schiusi al sole, tutto il fior fiore primaverile ribollire sul mio petto. Che il diavolo se lo porti! Mi viene l'acquolina, la bava alla bocca. Quando ci penso ringiovanisco d'un colpo. Vispo e arzillo salterei di fiore in fiore . . . nudo bebè, occhio assassino, manine impertinenti . . . le stravaccherei sul pavimento . . . le rivolterei dentro e fuori, a fasci, a brancate intere, d'ogni forma e misura, senza alcuna riserva . . . fino a perdere i sensi. Ohi, che svengo. Tenetemi le mani. Non mi sono mai saputo controllare. Anche da giovane cadevo in deliquio soltanto a passarle in rassegna. Tesorucci, mie bamboline ciccia e panna, pacioccate il nonnino, sì così . . . un pochetto più in basso . . . dolcemente, lentamente, in quel posto dove tiene la bua. Altrimenti il nonnino piange. Piange, piange, piange. Grosse lacrime gli scorrono giù per le

guance. Lacrime visionarie, insensate, amare. Per questi
lidi nemmeno le vagabonde si azzardano: figuriamoci le
belle bambine. I nostri vicini è gente scorbutica, coppie
di anziani felici di curarsi l'orticello e starsene rintanati
nelle tane. Potresti morire, diventare scheletro e non lo
noterebbero. Eccetto la vecchia eccentrica che abita un
centinaio di metri oltre la strada maestra e che ha il brut-
to vizio di spiare col cannocchiale dall'abbaino nelle case
sparse miglia distanti. È l'unica nel circondario a
possedere un ronzino, con tanto di ganascia penzolone,
privo di coda e di criniera. Tutte le mattine all'alba
finisce di sfiancarlo menandolo al gran galoppo. E trotta
che ti trotta, però, sempre rallenta nei pressi del cancello.
Mrs Melissa, vedova Menning. Sbatte le palpebre e
sgrana le pupille quando mi fissa. Roba da far scoppiare
una colica stizzosa persino a un santo. Ah, veramente
stomachevole! Mi fa scontare ad una ad una le rimem-
branze giovanili e incanutire gli ultimi peli che mi sono
rimasti. Minaccia la mia libertà di scelta. Essendo
disponibile, ho paura che mi farà capitolare. Quasi,
quasi l'attiro con un pretesto dentro casa e le do una
sbattuta alla presenza dei cani, in pieno troiaio, con
stronzi, mosche e cimici dappertutto, tant'è l'abbat-
timento. Perchè no? All'epoca mia i babbi portavano
personalmente i figli maschi a svezzare e impratichire nei
migliori casini. Si accollavano l'istruzione, la religione,
la carriera futura degli eredi. Ne andava dell'onore del
casato. Ora non c'è cristi ne madonne che abbiano gli
stessi riguardi nei confronti dei nonni. Innanzitutto
manca un servizio assistenza sessuale pubblico.
Qualcosa sulla fattispecie "Home Care Service". Le tut-
tofare volanti a domicilio, diplomate in coiti e resurre-
zione bocca a bocca. Le teste di cazzo al governo pro-
mettono riduzione delle tasse, incremento del lavoro e
dei salari, nuove scuole, nuovi appartamenti, monumen-

ti nelle piazze e ignorano le esigenze più semplici del popolo. Fottere! Il popolo ha chiesto e voluto sempre e solo fottere sia che avesse la pancia piena, sia che avesse la pancia vuota. Le rivoluzioni? Non fatemi ridere. Le rivoluzioni mica avvengono per la pagnotta. Date da fottere agli affamati, benedetta madonna! Guadagnerete l'indulgenza plenaria, perdio! Senza buoni del tesoro gratuiti, tessere o concessioni alla mia età le aste non si alzano; il sangue non canta. Eh già! Lasciate che cantino e suonino in eterno al club dei barbagianni sulla scogliera, quel bazar di anticaglie e di ossa porose che si urtano e si sfaldano dopo mezzo giro di walzer, io non desisto, resto fermo, puntato sulle mie difensive. Ci ho la reputazione di impenitente dongiovanni da tutelare. Io ho visto il vento di trentatrè paesi stranieri sollevare le sottane delle ragazze e messo incinte diavolette rosse, bionde e castane. Sono ingordo, esigente, le voglio giovani, cicciottelle e prive di cervello, ma dove trovarle? Tutt'intorno la prateria, gli acquitrini, lontano lontano le dune si sabbia, la foresta, il mare, e dietro il canile una piccola altura d'un verde smagliante, su pei fianchi s'arrampicano in senso orizzontale filarini di croci bianche, fino a raggrupparsi in puntini indistinti sulla cima. Lassù svolazzano corvi e cornacchie, nera nuvolagine del malaugurio . . . Io sono vecchio . . . conservato in ottimo stato . . .asciutto e scattante, e mai, mai ho messo la panciera. Eppure spesso, sempre piu spesso m'assale lo sconforto, con quel cimitero a un tiro di schioppo che lancia l'appello. Soprattutto la notte, l'insonnia, l'asma, la tosse, affacciato alla finestra mi invitano gagliarde fiammelle. Risplendono d'una grandiosità inimmaginabile se gia fossi moribondo. Gli spiriti burloni, quei fregnoni in libera uscita la sera per godersi il panorama, l'aria fine e magari un'orchestra di violini improvvisata dai gufi. Che

ne so. Cosa posso saperne dell'aldilà? Sgomento osservo quei cosi, sì, quei pennacchi luminescenti nel riverbero azzurrognolo degli acquitrini, percependoli come percepisco le stelle, la luna, il cielo. È tutto un incanto di negromanzia all'aperto. Ragnateli fosforescenti si arricciano sull'erbetta, acustici bagliori saettanto alla velocita del fulmine, nonchè dei botti di tanto in tanto. Ombre biforcute che sputano fuoco, omo-femmina-anima, malefici soggetti, bah! Li sento con queste orecchie, li vedo con questi occhi ondeggiare, allacciarsi e danzare goffamente, poi discostarsi, rimbalzare e inchinarsi. Vedo gli sbuffi di gas girare e rigirare, serpeggiare in alto, lambire le nuvole e ritrarsi tre spanne dal suolo assumendo la forma di sberleffi osceni . . . Mi chiamano, mi corteggiano, fanno degli ammiccamenti proprio a me, il sottoscritto. Riconoscono in malafede l'imminente caro estinto a corto di emozioni. Un'altra zaffata di gas tossico per far capriole e acrobazie tutt'insieme allegramente. Che accozzaglia di farabutti i morti lassù! Grassatori, beoni, luridi avanzi dell'inferno! Mica si slabbrano o si sbilanciano facendo un piccolo piccolissimo sforzo verso la destra, verso i fili della corrente elettrica visibili chilometri e chilometri lungo la striscia d'asfalto della strada maestra e insomma verso la catapecchia di legno della vedova zigzagando quatti quatti attraverso l'abbaino, cosi che paft! si involerebbe angioletto cotto a puntino. Una rompiscatole in meno dirimpetto. Se mi riuscisse farglielo intendere tramite telepatia . . . su per quel posto dove dico io, l'affare, la convenienza d'un quintale di grasso extrafine, superardente, garantito al minimo consumo e spreco, ottimo per erotismo, esibizionismo, cameratismo, lo farei con la conscienza alleggerita da un peso. Non dormo, non dormo affatto la notte. Un malessere incomprensibile, di ignota provenienza mi prende alla gola non ap-

pena scivolo nel sonno. E mi rialzo, infilo i calzerotti, le scarpe, calco il berretto, afferro il paletto, la maniglia della porta . . . rifletto . . . ritorno indietro, vado su e giù, su e giù indeciso . . . passano le ore . . . albeggia. Come sono stanco. Sfinito. Ed è mattina. Sento Josse trafficare in cucina, imprecare e urlare più del solito. Avrà cambiato abbigliamento almeno sette volte in mezz'ora. Prima, prova con l'abbinato canottiera/pantaloncini rosa, poi il grigio, poi il viola. Infine ripiega sugli spezzati biancoazzurro, rossomarrone, limonearancione e così via. Chissà di che colore s'è bardato stamattina. Ci scommetto 30 a uno, sui nostri baldi damerini a quattro zampe che stamane avverrà l'esibizione in pompa magna del verde e del giallo in pura seta sgargiante, con per giunta il 9 porporino dipinto sulla gobba . . . giacchè predilige le carnevalate e fa il civettuolo nei vortici dei fuori gara. Oh, Signore! Con la casa ridotta un letamaio. Le tendine cadono a brandelli, poltrone e divani sfondati, cuscini, pedalini, mobili, ogni oggetto che pende e che sporge lacerato e rosicchiato. Senza contare quell'accidente d'un giardino che se ne va a ramengo davanti e didietro, interamente cosparso di buche, avvallamenti, ossa, pezzi di carne sanguinolenti, gabbie e capannucce dal tetto di frasche cadenti e marcite e soltanto pochi alberi al centro del canile, un angolino di bosco a forma di campana ombrosa, evitato come la peste dai pennuti, che son fuggiti, spariti in tromba dopo averci rimesso le penne. Anche a me fanno schizzare il cervello, i cani, a furia di abbaiare, sbavare, scoreggiare. Vorrei riportare indietro le lancette del tempo. Quando gli uccelletti variopinti si calavano fiduciosi e contenti per becchettare direttamente nel palmo della mano. Com'erano graziosi . . . veramente gustosi . . . teneri teneri, carini carini . . . affezionati. Anch'io mi ci ero affezionato.

Tutta questione di buon gusto, di poesia, di arte culinaria. Non a caso imparai ad arrostirli saggiamente sulla griglia . . . Senonchè, Josse scoprì d'amare i cani di razza e da corsa. Un amore sorto all'-improvviso . . . sperando e prevedendo d'arricchire rapidamente, alla stessa velocità e sulla velocità dei cani, per l'appunto. Eh! Bisognava vederlo, sentirlo allora. Credibile da non dire, contagioso nella sua euforia, nonostante facessi gli scongiuri e rinculassi tra i dinieghi, stringendo ben bene il borsello sotto la cintola e fissando la carta da parati manco manco accennava d'unire le forze e i risparmi. Amici fraterni, compari alla ventura e soci finchè era durata. Ricordo tutte la opera-zioni commerciali finite in bancarotta, gli affaroni dileguatesi all'alzarsi del sole, gli scherzetti degli sfratti alla chetichella, gli sconquassi del ricominciar da zero . . . E un fanfarone. Un perdente della vita. Un vero e proprio megalomane che, col progredire della vecchiaia e andato peggiorando. Non era da prendere più sul serio, davvero, ma le sue descrizioni, le sue in-venzioni pittoresche, l'incanto e la visione delle solennità mondane, l'increase del capitale m'avevano stregato a tal punto che mi sentivo prudere d'eccitazione da tutte le parti. Avvertivo su di me l'esaltazione delle masse, il divismo delle tribule, gli squilli delle fanfare, l'ammira-zione di appariscenti e disinibite dame del gran mondo incapricciatesi di lui, di me, poveri minchioni trascurati, ridotti senza nessuno. Le donne. Sempre loro. Dovun-que governano la musica, la messa in opera, il monopolio. Burattini degenerati. Pronti a farci nelle brache per un zinzinello di spasso sulla giostra. E anche un pezzettino di cuore vinto all'asta, si sa, da custodire sotto vetro, chiuso a chiave con doppia mandata. Ho visto fin troppe schifiltose al bagno, come dire al naturale e come mamma le ha fatte, contorcersi e

rovesciar l'anima dal piacere e innamorate ariconvinte tra le lenzuola e ancor piu venirsene urlando fedeltà da tutti i pori, per poi squagliarsela di corsa. Un piccolo errore di contabilità, l'afflosciarsi del portafoglio, l'anello di brillanti promesso e non concesso, ed eccole passare devotamente, appassionatamente al miglior offerente. Vittime del consumismo, bisogna convenire. Lor tutte, che finsero ardori e svenimenti e che da me adorate furono. Ah, fesso. Ricascarci e ricascarci dopo siffatte traumatiche esperienze. Puah! C sarebbe da andarsi a buttare dalla scogliera, se ne avessi il coraggio. Dio me ne scampi e liberi. Piuttosto scrivere le mie memorie. Un poema, anzi. Vendicarmi. Appiccicar versi scurrili. boccacceschi su quelle malve ormai appassite. Saranno diventate degli scopini inservibili, finiti chissà dove, che non ci sprecherei uno sputo nè un sospiro al chiar di luna. Pace alla bellezza. A noi, care befane! Mi piace, sì l'idea, e in effetti la metterò in atto appena rimessomi coi nervi. Ora. non faccio che lagnarmi e mugugnare e correre da un cane all'altro. Dovrei sforzarmi di non pensarci ai cani che, oltremodo egoisti se ne fregano altamente dei sacrifici sopportati per dargli dei natali altolocati, comportandosi da vere cagne lascive e veri pederasti, scorno di tutta la specie canidi. Quando sono in calore, capaci di montare madre, sorelle, fratelli, cugini senza alcuna distinzione. Se è per questo non differiscono da quelle sporcaccioni di scimmie allo zoo nel dare spettacolo dietro le inferriate, ciucciando, leccando, leticando i favori di 2 e 3 scimpanzè annoiati, lì, a scenario rialzato, applaudite da una folla di grandi e piccini che mai si son divertiti tanto. A paragone, la mia fantasia erotica senile, filmata e commentata con grande sfoggio di erudizione nei ricreatori cattolici, passerebbe inosservata o al più al più come svaghino innocente. Bah, sarà che son geloso. È sarà la natura. Favorisce gli

animali. No, non credo a me capiterebbe mai una fortuna simile. Svegliarsi domani nella pelle di uno scimpanzè tormentato senza tregua, coccolato, conteso e libero finalmente dalle angosce e dalle tragiche fatalità intellettive. Dicono siano instancabili. Che esagerazione. Saprei anch'io . . . mezzo selvaggio, mezzo galante. Permettete leggiadra scimmieta, vi gratto le pulci dal sederino e vi bacio la manina pelosa, ma sbrighiamoci in fretta, la giornata è corta. Niente smancerie, niente cortesie, niente sbaciucchiamenti. Solo noccioline, banane e noci di cocco direttamente dagli alberi, frattando ch'io prendo e lascio di corsa la prima, la seconda, la quarta, etc, fischiettando un allegro motivetto. Non so esattamente cosa. Non mi viene in mente nessuna canzone romantica sentimentale. Tanto non occorre andare per il sottile nè soffermarsi ad annusarle. Una pedata nei calli e avanti la prossima, col viso sepolto nel fitto fogliame e la zampa sugli occhi . . . femmine . . . femmine, io sono vostro. Pronto a fare i bagagli e partire oggi stesso. Sì, andiamo. Voglio andare. Emigrare nell'Africa impenetrabile e misteriosa e la sue fresche cascate, e i torrenti inesplorati, e il sole far capolino tra i rami, e la frutta a quintali matura e sugosa ad ogni stagione e poi la cacciagione, i cervi, gli stambecchi, i tordi, le zebre presi con l'arco e le frecce, e la capanne e le amache di palme intrecciate, e il latte d'asina e l'albero del pane meraviglioso dono del buon Dio, e i sonnellini all'ombra indisturbato, e le notti stellate serene senza un'anima perduta e dannata in giro a rompere i coglioni, dormendo beato come se fossi in una villa di milioni miliardi di stanze silenziose e vacanti, ma pur piene di dolci fruscii e mormorii che cullano ninnano i sogni e danno la carica e la voglia di fare disfare e strafare al risveglio. Sì, perche non ci resisto. Ne ho fin sopra i capelli della solita

routine e della sveglia e della consuetudine di mettere l'allarme tre quartidora avanti che, sennò guai, Josse perderebbe tutta la baldanza e l'entusiamo vedendosi negare gli applausi e l'approvazione di primo mattino, quando tutto scintillante in pantaloncini e canottiera con la pezzuola porporina cucita sulla schiena carica a quattro a quattro quei fottuti cani sul furgoncino per gli allenamenti nel parco o per le lezioni di nuoto o per mostrarli a qualche commendatore dei campi di corsa . . . Non c'è paragone, hanno un pedigree impeccabile, sangue, muscoli, sprint. Nostro vanto e orgoglio, Infinite speranze. Ci avessero dato qualche soddisfazione. Una mezza corsetta vinta qua, un piazzamento onorevole là, una dozzina di osanna sul recorder dei cani. Invece nulla. È inutile. È lui, Josse, non dà alcun affidamento. Aspetto malandrino. Fedina penale sporca. Cinque mesi in prigione per aver rubato scatolami al supermercato. Le notizie circolano. E così il disprezzo punisce di riflesso i nostri concorrenti, li rende insicuri, depressi. Ecco perchè hanno la nevrosi canina, la diarrea, i vermi, il raffreddore. Le rare volte che vengono ammessi alle gare, quelle di terzordine, arrivano sempre agli ultimi posti. Basta! Bisogna finirla! Panzane mi racconta. Vedrai, fa, vedrai Boris amico mio, fra un mese, due al massimo saremo milionari. Ho un bel ripetergli, son cani, mica fior di puttane. Eh. Ogni mattina la stessa solfa. Guinto in fondo al viale, dato una pacca ai cani che saltano sul furgoncino, alza le braccia e scuote i pugni chiusi in segno di vittoria, urlando vinceranno, vinceremo, anche noi campioni diventeremo. Sì. Aspetta. Aspetta. Campioooooni ne faremo. I favotiri degli scommettitori. Povero illuso che ancora ci crede. Aspetta domani . . . ma dov'è l'orologio? Ricordo d'averlo poggiato sul comodino ieri sera. E le sigarette? E le ciabatte? Io divento matto. I cani mi sotterano prima

del previsto. Ah, ma io ne farò salsicce con contorno di mantellina, museruola e guinzaglio. Darò fuoco alla baracca "Josse, Boris & Dogs Proprietry Limited".

TV

Srebrenka Kunek

We've just heard the latest weather report which says that we'll accept all the rain we can get only if it leaves behind foreign currency as it passes through — manna from heaven. Well, that's what is going to pull us out of the dry season, that or the banning of drinking water.

As I sit on my cushion Eastern style, watching a report on the dirty Western countries and all the wonderful showers of rain they're getting, I think — better take that last lemon out of the fridge and make myself that drink — could be my last the way things are going. What with the lack of means to buy foreign goods and on top of it all this business about the rainfall, one never knows. Apart from queueing up for toothpaste, washing powder, stockings and sanitary napkins, lemons will probably be the next thing to disappear under the counter.

The news man flashes onto the screen again and continues his report on the opening of a new factory in Downtown Village. The picture of the scissors and ribbon are flashed onto the screen. Smiling faces look slightly stiff. Next report is about all the hay we're making while the sun shines, so much so that we'll even be able to export it this year. Well, at least before we import it back again at a higher price. Flashes of other economic and agricultural achievements and . . .

I get up and switch to the other channel. Must go into the kitchen and make that lemonade. Not much choice but to watch the other channel. It's the only alternative even though we watch it on a TV which has twenty-nine

channels. Smuggled it in from Germany last year. It helps having German tourists as friends.

No, I'm sick of the weather forecasts because they're talking about it all over again on the second channel.

I hear the tap dripping . . . and then it stops.

ICU

Jutte Sieverding

Your kiss was warm and dry, like a tissue that'd been left in the sun, and the boldness with which you turned me around, insisted that I go with you. Then in the field outside, with your head tilted to say something, you evaporated. I know it must have been important because all of a sudden I was hanging from a limb three storeys above the ground — only when someone came to rescue me my feet were touching the floor.

That was when they came with the green gowns. I recognised the place immediately. Who wouldn't, having worked there for ten years? How dare they! I was on long service leave. Whose dreams wouldn't be disturbed after working in this place for ten years?

I fought them. This breach of morality couldn't be let to pass without protest. Then they started the sirens in my head. And as if that wasn't enough the room they put me in was green. I've worked in all the rooms but the green one's the one I hate the most.

My first impulse was to scream, to rant, to yell "no" till I was hoarse. Instead I glared at the green-clad figure bending over me, noticed the red sauce stain and the garlic on his breath. The room beeped and hissed to its own rhythm, no distinction between day and night and even less regard for the people inside. The others didn't notice.

The ship was casting off and the sirens were getting louder. I tried to turn them into music, into the gentle strumming of a guitar. Instead a forest of metronomes, each clicking to a different time, marched toward me.

Then they began to slow, and one by one, like toys with run-down batteries, they stopped.

They gave me That Substance to eat. I smelled it immediately. I mean, having worked here, they must know I would realise. They must also know that I know what it can do. I refused to eat, but there comes a time when that gnawing in your gut overcomes reason. I knew then that it was all over, that they had me to do with whatever they pleased.

The sea storms. Salt-frosted portholes give only a hint of the moon. Black satin sheets engulf an unwilling body. Green walls close in, recede, advance. Black! That's it. In black they won't see me. In black I'll pass out of the room with the shadows. I've spent enough time on the other side of this to know.

It was hard without sharp implements to fashion a practical piece of clothing, but then, teeth were man's first sharp implements — unconfiscatable.

When they came to take the tray I melted through the door, down the corridor and up to the blue level. The day was grey on grey, almost green-grey. I must have miscalculated how much time had passed because we weren't even close to land — panic! If I was still on board when the substance wore off I knew I'd go running back to them. I've seen it happen over and over.

The world spins, blurs, refocusses. I grip the handrail, bent forward, hoping it will pass. I know they're waiting with the green room. The chestpain, the headache, I slide to the floor, curled into a ball. At least I know they can't see me, not in my black satin.

The sky streaks pink on blue. The sea still inky grey, not yet green. I peer between the railing, dare to hope for land.

To Pethi Mou (My Child)

Haitho Massala

Do yoo no sukses?
Do yoo no wot mins?
Mins yoo no hev to vork for nuthing.
Mins your choodren get edukashon
Be docters end loyers — tichas.
Mins yoo no hev to wori.
Mai dota she vork veri hart
She ticha
She studi
She get goot muni
She noo kind woomun
No hafta wayt for man
She support hesself.

"Your daughter then is successful?"

Cood be mor
but she trai veri hart.
Yes, she veri sukses
end no veri meni Griks hev choodren —
gerls —
hoo studi end ar sukses.
Thei think gerls only
to get merid.
But I sai edukashon
for mai dota important.
I no want her to be like me.
She on her on fit stend,
no wayt for man,

she do everithing
on her on.
Do yoo no sukses?
Sukses is a Grik's choodren
hoo studi
to be sumbudi —
no coll wog —
end pipel sai —
Grik end Ostralian pipel sai —
she sumbudi
she Elli's end Savva's dota
she ticha
veri smart Grik.

night

Irene Vlachou

night. it's late. it's very late. which is why the street's so empty. on sunday nights the folk all get together to watch t.v. or sing songs round the piano or take part in the ritualised events that prevent them from going out. they only go out on friday or saturday nights. sunday drives & picnics.

i take my dog for a walk in the expansive winter air that's biting a bit. i'm all rugged up. the dog grins because he's not tripping himself up in people's legs. how are they to know he's half blind? he looks youthful but he's an old man, really.

the milk bars are shut. very synchronised. when on a sunday night do as the other sunday nighters do.

a woman with platinum blonde hair & a white pleated dress staggers up to 2 swarthy latin lover-type characters. is this club 75? they leer & offer to escort her in. no thanks, i'm meeting me boyfriend inside. they follow her in anyway.

a small sign with a big ego pierces the darkness & fades out into obscurity.

a cop car whizzes by. i imagine the scene:
hey lady, it's past midnight. where yer off to?
fuck off i yell at the top of my voice, spitting it out with gusto & aggressive intent.
i'm off to rob a bank. i'm going to throw myself under the first truck that comes along. i'm going to release all the rats from the csiro labs. i'm about to commit murder. i'm taking the dog for a walk. he's happily munching on bits of take-away chicken & dropped meat pie.

in which case lady, yer asking for trouble.

shadows cling onto buildings in stucco relief. during the day the edges are hard & noisy. now they're murky yellow & subdued.

a cat slinks in an alleyway. the dog chases it & the cat stops slinking. a light mist of rain begins to fall, altering the naive timelessness of my frolic in the present. i'm stalling for time. the dog likes the rain. he rolls over & over on the wet footpath. i'll go into a shop & buy cigarettes. i'll sit down somewhere, take out my matches, light one. but i notice retrospectively that all the milkbars are shut.

rooms from another century sit on top of hi-fi & department stores & art deco cafés. the second hand shops display an affinity with lost time but are really catering to a future generation. a young, middle class world of recession dressing & idealism & gender twisting. and not a lot of money but enough to be contemptuous.

streetlamps wink at me & i wink back. after all, it's cold & wet & i'm a woman alone in the streets.

an intruder lurks in the background. the dog becomes a giant dingo & gobbles him up, reinstating him in the background where he'll remain forever. he's not the subject of my story. not tonight.

i'm still searching for the subject. it constantly eludes me. just when i think i can put my finger on it & say yes, that's it, some new explanation, some new thread of a theme pops itself into view & shatters my well being.

there's a pinpoint of light; the steadfast, immutable night light of the streetlight & the light of the car with its driver & their destination. i'd like to know where they're off to.

is this my dog's story? he's having a ball, he's yelping excitedly, immune to the crippling possibilities of at-

tacks at night. fear of time, fear of being left stranded when an idea begins to take form only to disintegrate in the transition from its source to the page.

so i stop outside a dress shop & look at the greta garbo dummy decked in a red crêpe de chine outfit & fantasise about being whimsical enough to buy it. if i saved $10 a week i could have it in 10 weeks. or splurge into my next pay packet. or be on the dole & never get past the fantasy. next door the lebanese café with mouth watering baclavas offers a fraction of the satisfaction at a fraction of the cost.

but i return to the unattainable & a scope of possibilities. black silk & diamanté. brocade shoes with tiny heels. hats with feathers, with veils. bags with intricate tapestry designs. a park. a waterfall. a woman bending over to pat her dog.

escapism, secure & transparent.

soon i'll be home, out of the wet, the cold, the deserted sunday night.

The Definite Article

Denise Pochon
To Alan Crooke

Sharing a bowl of soup,
A thick slice of buttered bread.

You proofread —
Diluted feelings
Dissected into order.

Your surgery into ambiguities
Scares me
From a question mark
To a punctilious full stop.

In the eddy of semantics
My soup syntaxed
To a quasi mess.
Cold — in parenthesis.

Ultima Thule

Aina Vavere

One after another, the lights in the small shops went
out, the doors fell shut, the keys turned. The butcher
returned the unsold meat to the refrigerators and went
home to bask in the warm glow of his wife who always
dressed in pink and argued with the children, all alike,
round and spongy, like the sausages in his shop window;
the owner of the health foods inspired by her faith took
home granules for her cat, the only living being who
awaited her (and who turned his back on the granules);
the perfumed little hairdresser in her perfumed salon
hummed a farewell tune to the working day and, with a
Mona Lisa smile, greeted the coming night. The wind
rattled the doors of the other shops which, for reasons
known only to lawgivers, remained open.

In the travel agency, Simon ordered brochures in neat
piles in the window as always when the owner had gone,
and he was left to keep the bureau open until the re-
quired hour. The various part of the world, in multi-
colour, obediently lay in his hands: white beaches for
surf-riders, white snowfields for skiers, green tropical
gardens for lovers, monuments and places of historic in-
terest for everybody. Hawaii belonged in the upper left
corner, New Zealand with the geysers and mud pools in
the middle, Japan's cherry blossoms on the right,
Europe in a pile and England, the most popular, on a
separate shelf. He had travelled as a young, promising
employee in the tourist industry; he could do it, and had
seen many of these places. Yet every so often, he was
overcome by a desire to go where no plane could take
him or to find out what no travelling brochure promis-

ed. At such times he would've liked to shout the way the spruikers did: "Dreams at a discount! Illusions half-price! Pre-prepared experiences, select to suit your taste!" He never did.

He noticed them when they stood in the middle of the room, out of the blue; wearing hats, little trilbies, such as only older immigrants still wore, suits, shiny from years of service, and ties. The storms that may have ravaged their features could not have been caused by their own hearts' tempests, only by some external calamity or misfortune.

"Can I help you?"

"We are looking for . . ."

"We want to find . . ."

"It's not so simple . . ."

"That's all right. I've plenty of time."

They sat down and told him everything.

In those days when young, they were addressed as Ansen and Redsand as was the custom in the tertiary institutes of Northern Europe, just before the Second World War put an end to this and many other customs. Young Ansen and young Redsand read philosophy in all its aspects: moral philosophy, philosophy of nature, philosophy of religion; studied ancient history and Norse language. They debated logically, wrote poems in strict measures and read them with an exquisite sense of rhythm and rhyme. In the fraternity bar, they engaged in drinking bouts and, despite the illegality of duels, perfected their fencing techniques just in case the opportunity arose to defend their own or a lady's honour. They were friends and swore to remain friends for ever.

The ultimate intellectual achievement in their circle was a poem written in such a manner that it could be read, not only the usual way from left to right, but also

from right to left; in each case, the meaning being diametrically opposite while the perfection of the rhythm and measure was preserved. The artistic stamina required was tremendous as one had to spend days on end considering the pros and cons of the chosen topic. When their poems attracted another admirer outside the circle the competitive spirit sharpened and their philosophical debates acquired new dimensions. The new admirer was a luscious Valkyrie, steins in hand, behind the counter in the bar. Enveloped in the frothy smell of beer and the smoke of cigarettes, she smiled equally sweetly at Ansen, Redsand and everybody else. Her thoughts, if any, were well hidden by the richness of her hair while her diaphanous blouse revealed the openness of her heart. When their friends admitted defeat in deciding who wrote the more perfect poems, Ansen or Redsand, they decided to ask Valkyrie to adjudicate. The theme of the poems was to be Valkyrie herself, and she also agreed to present the winner with the prize herself.

On the night of the contest, the bar was full to capacity. Valkyrie listened to Ansen's and Redsand's presentations as attentively as everybody else; while from the left, they praised her beauty and her sweetness. When the poems were read from the right, and the audience was just beginning to appreciate the delicacy of thought and subtlety of discrimination, Valkyrie gave a particularly endearing smile. Then she took two steins full of beer and emptied them into the contestants' faces and calmly pronounced that she had never heard greater shit in her life. In the confusion following Valkyrie's action, chairs and tables were overturned, candles fell from the bottles that served as candle holders, insults were hurled left and right. Later nobody could establish who had offended whom, and Ansen and Redsand fought a duel as

far as it was possible without getting into trouble with police. Before the honourable scratches could heal and their friendship dissolve, the war intervened, demolished the bar, separated them and stopped the aesthetical and philosophical debates for ever. After the war, they married aristocratic girls from impoverished families, settled in Australia and spent their days doing office work for which better-educated immigrants were found to have a particular aptitude.

Problems raised on one side of the world could not be resolved on the other side. They wanted to travel. As young men they had not had the opportunity to go to the source of all truth; to Iceland, where the perfect poetry is supposed to be chiselled in stone. They wanted to see it.

To Iceland? To Reykjavik? Of course. Yes, from London or from Copenhagen?"
Tours, didn't tours go to Iceland?
"No, sorry, no."
Couldn't he organise a tour?
"Not enough people would be interested."
They'd prefer to go with a guide, were not young any more. Complicated arrangements . . .
He would arrange everything for them, make it simple.
Wouldn't he himself, individually . . . personally like to be their guide?
Thanks for the offer, the trust, but sorry, it was impossible. He was an employee of the firm . . .
Wouldn't he like to be free? Forget the firm?

Wouldn't he? Behind the windows, moths tried to penetrate the invisible barrier and Simon noticed that a couple had succeeded and were fluttering inside. Across the small plaza, he saw late shoppers moving across

lighted squares and he wished some real ones would come and talk to him. Reason told him there was no sense in going to search dark waters and to turn stones, only because two old gentlemen, their passions spent, remembered anaemic philosophies and bar girls. Yes, he thought, the way things had been, the truth, probably was that each of them would have given his eyetooth just to be able to write a more perfect philosophical discourse or a more strictly-measured poem. Without disclosing his efforts to the other, each searched the most ancient manuscripts, sieved through the oldest information, examined long-forgotten accounts hoping to surprise the lecturers and fraternity brothers with some new hypothesis, fresh insight of a never-heard-of theory. Hadn't they cut each other's pronouncements to pieces with the sharp edges of their foils, demolished the logic of the other's argument and delighted in proving the shaking foundation of a conclusion? Didn't a small fault, detected and properly discussed, grow into an unforgivable shortcoming? Had they considered black magic and the pact with Mephisto — it would have been a theoretical one; they lacked Dr Faustus' conviction.

"Two old fools," Simon smiled in the polished glass on the desk. Tony and Tim were playing squash tonight. After, in the wine bar they'd listen to the new group, ogle the vocalist, tell the girls the latest one; Daniel would get sloshed at the junior executive dinner or later in the bed of one of his three girlfriends. Samantha had said she'd spend the evening at home as usual, when he was working late, and he didn't believe her. He could call on her after work and was surprised that this prospect neither delighted nor depressed him. He had a hunch there was a difference between a satisfying night in her bed and a feeling for which he had no words and could not describe. He'd try to talk to Louise and Leonie

at the golf club where they often discuss the finer points of the game and the exhilaration of playing a perfect game which, of course, they never did. However, both of them were too solidly built and their leg muscles were too well developed.

No, he could not possibly go.

But what about Thule? Didn't he long to reach Thule?

Even the most experienced travel agent was not expected to know every little place on the globe. He had never heard of Thule.

Wouldn't they like to tell him the names of all the places they wished to see and leave the rest to him? He, Simon, would make all arrangements.

Yes, they would do that. He should think about the trip, nevertheless. Wasn't it his duty to get to know the part of the world where his own roots were?

They were not entirely wrong. His paternal grandfather had come from somewhere in Northern Europe. Old jokers, they probably guessed it from his name.

Didn't he want to find where he stood? His place in the scheme of things? Excellence, fulfilment, the ultimate truth? They talked as if the world were a large building raised on columns supported by invisible forces, gods, ghouls. Oh, yes, Simon had met many a pedlar of truth, Ananda Marga, Kali Yuga, Jehovah's Witnesses, Christian Scientists.

Yes, he would consider that. At present, however, there was no chance of him going.

Mr Ansen gave his address, and only after they had gone, Simon realised that they, or at least Mr Ansen, lived on the other side of the town; they had come quite out of their way to see him.

In the back room on the shelf there was a world atlas, not a very detailed one, nor of the latest edition. They

were not supposed to consult it in front of the clients; that could make them suspicious of the agents' knowledge and experience. In it, Thule appeared as a small speck far inside the polar circle in Greenland, so far, that most likely, only a few Eskimos pitched their tents there. No tourist route to there. The old gentlemen must be playing a trick on him, wanted to test his geography. Who could tell, and who cared anyway? Simon locked the bureau and went straight home.

In a few days, he had put the itinerary to Iceland and Reykjavik together as far as he could do it without including Thule, and made a note to refer back to them. After a few more days, he realised that they had not come back. He could mail the itinerary but he liked the idea of talking to them again, if for no other reason than just to show that he understood their joke. When a week later he could not find an Ansen at the given address in the telephone book, Simon got into his car. Cursing his idea as ridiculous and capricious, he drove to the suburb miles away.

The house was old — in a district where once wharfies lived, and where now industrial complexes were taking over — wedged in-between modern edifices, deciduous elms, hidden behind runners and creepers and weeds, two feet tall on either side of the footpath. A young woman with a baby on the hip was talkative and helpful. She had never heard of a Mr Ansen. When two men from inside the house, and an old woman across the fence, joined in, it became clear that second to the last owner of the house had been a Mrs Ansen, and that that was long ago. The old woman who claimed to have lived here for sixty years swore she had never seen a Mr Ansen. Simon was satisfied that his idea to come searching for Mr Ansen had been a silly one, a whim, a mistake.

Two days later, against his earlier decision to forget about Mr Ansen and Mr Redsand, he was sitting in the public library and, with the help of the most desiccated young woman he had ever met, trying to find out more about Thule. Thule: the administrative centre of North Greenland, six hundred inhabitants, founded in 1910 as a trading post with the Eskimos, since the Second World War, American airforce base. What did the old gentlemen want there? More interesting were the facts that Thule was the name given by the Romans to the northern-most point they had reached sailing along the British coast. Variously conjectured to be the Shetlands, Iceland, the northern point of Denmark or some point on the coast of Norway. Simon recalled Hagar, Vikings with horned hats and maidens with breastplates. His helper didn't find it amusing; Sandwich Bay in Africa had also been referred to as Thule, the Thule of the Southern hemisphere. Simon wondered how a young woman could be so flat and have such enormous grey eyes. Her skirt was long and her stockings black, but she could as well have worn no clothes. Simon was used to undressing a woman at first sight if he so wished, and he saw her body bare and cool under the grey skirt. And how could she keep all these facts in her head? Had she grown up squeezed in between the heavy volumes on the shelves? He noted all the information and felt well armed to show his clients that he was on a par with them and, appreciated their wit. This feeling helped him to ward off the emptiness that had crept into his relationship with Samantha.

He would never argue that it was not his fault. The same thing had happened with Rowena, Anne, Cherry, Catherine. It was the same — whether they invited him to their flats where they had first class hi-fi, good wine in the fridge and concealed lights, or they came to his —

the result was the same. After a few exciting encounters, they became good friends and gradually drifted apart. He always allowed them to make the final decision and to think that he was a true gentleman; they never heard him whistle quietly to himself as he left. He waited for the next, the next, and the next encounter hoping that the time would come when he would want to stay. He did not really want to escape, on the contrary, he longed to stay and all he wanted was to know why he would stay.

It was nothing unusual for people to call at the travel agency, to request information and never to come back. Why should Mr Ansen and Mr Redsand be different from any other casual caller? Simon put an ad in the paper and nobody responded. Nobody came, even though he kept the door open past the closing time.

Only because the bureau was quiet and he had nothing to do, did he lift the receiver and dial the embassies of the Scandinavian countries, one after another. Weren't Ansen and Redsand Scandinavian names, even though they could just as easily belong to half a dozen other nationals from half a dozen other countries around the Baltic? His inquiry was unusual, he acknowledged it, but could they perhaps help? They suggested he contact social clubs of the respective countries. There he'd find almost everyone he was likely to look for. Yes, there were several Ansens on the members list, a Mr Redsand they could not trace. However, neither the young diplomat Ansen, nor the car manufacturer's representative, nor the glass importer Ansen had inquired about a trip, and most certainly not a trip to Iceland. No, they were not interested. Simon contacted all other North European clubs and societies but found neither Mr Ansen nor Mr Redsand.

He invited his kind helper from the library to dinner,

and after several refusals, looking as if she feared drugs in her coffee, she accepted on the condition that they eat somewhere near the library and insisted that her mealtime was one hour and no longer. How unusual she is, Simon thought with his eyes on her while they ate their self-serve schnitzel. He marked coolly her smooth long hair tied back in a pony tail and the small cork-screw curls at the ears, the high collar of her black jumper and necklaces and bracelets of what looked like grey stones. She looked at him with neither curiosity nor indifference, just a steady gaze like a confident girl in a TV ad. They talked of the tourist attractions of the far North, of fishing, glaciers, thermal pools, black beaches of lava sand, Aurora Borealis, things he had read about in tourist books and brochures; touched on the history of the country, the ancient crafts of the people; noted in passing the society where myths and legends were as alive as in Iceland, if not more so. He had read that Icelanders were great believers in the supernatural, telepathy, dreams.

Did she believe in these things?

There was nothing to believe or not to believe, they simply were there, and a steady gaze.

Simon of the working hours argued with the Simon of the night. During the day he promised to meet friends, to play squash, to go to the wine bar; when evening came, he met her for an hour of schnitzel and claret. After, she left him under the oleanders at the corner of the library. I want her in my arms he thought to himself, I want to possess her secrets, her scrutinising gaze. I want to climb the stairs to her flat, to see where she slept and ate and dreamt. They should be lying together in her white bed, it must be white, and go down together to the black seabed of lava sands.

After several hesitant one-hour meals, he asked:

"Tell me about the other Thule?"

"What other Thule?"

"The one that is neither in the Shetlands, nor in Iceland, nor Norway, nor Sandwich Bay."

Certain, she smiled at him and made his heart race. Her voice was deep and throaty as he had noticed on their first meeting.

"You don't believe in it."

How could he believe if he did not know, and felt that from those grey eyes and the grey stones he would believe anything. He didn't dare to move for fear that it might break her steady gaze or startle her into changing the topic. She's flat and thin and cold; but I'm all yours, just tell me. She looked at him the way women look when they are about to reveal secrets you can only dream of.

I want to know about the back to front poetry, the acme.

> He, he only
> Who has far travelled,
> Has far and wide travelled,
> Knoweth every
> Temper of man,
> If he himself is wise.*

Her voice made the shelves with the glasses and the counter with the food spin and the lights wink.

"And?"

"And what?"

"And now backwards, please."

Why did he think she had recited it forwards? It may have been backwards, upwards, downwards as well as crossways.

*"The Havamae" or "The Odin's High Song", in *The Literature and Romance of Northern Europe* W. and M. Howitt, (London, 1852), p. 52.

Which was it? And which was the right way?

She was not sure. Why didn't he try himself? He might find his own right way.

This was crazy.

"And about the writing in the stones?"

"Runic stones?"

He didn't know what they were called.

"Yes, there you could read the design of all things, the destiny of love and lust, of fulfilment and void, courage and dissolution." *He would find his answers there too . . .*

Why? Why pick on him? Who said he was looking for answers?

. . .his acme.

With the last remnants of reason, he asked why she thought that her truth was more truthful than anybody else's truth and, as she left him under the oleanders, she said that for him it should be.

To fill in time between customers, Simon started to work out a detailed itinerary to Thule. One would have to take a ship from Copenhagen to Godtháb, the capital of Greenland, or a plane to Sondre Stromfjord, and in either case, transfer to one of the wide-body helicopters that made occasional flights to Thule. In winter, it would not be possible to get there without long delays en route (due to the weather conditions).

On the third night after waiting in vain for her under the oleanders, he went into the library to look for her. She had said her name was Edda, just Edda. He walked from one counter to the other, up and down the stairs, past subdued voices among shelves. Her voice in his head drove him on to ask:

Edda? Where did she work?

"Edda? What Edda?"

He didn't know.

Was he sure she was an employee of the library?

"She seemed to know everything."

"Perhaps she was someone who came into the library, just a user of the library?"

"She seemed to understand."

"Maybe a student, well versed in her topic. Many students spent days on end in the library."

In the canyons of books, he whispered: "Edda, where are you? Answer me," and scampered on when people turned their heads.

His world became unstable, he could no longer perceive it through only sight, sound or smell. He had a vague feeling he had to start to build it again from square one, and had to incorporate in it things as yet unknown: the trolls, ghouls, gods and shapeshifters she had talked about. He developed a habit of going for walks at night. Foggy and damp evenings appealed to him most. As he walked streets, squares, plazas and gardens changed dimensions, moved away from him, dissolved, re-emerged or ceased to exist. Things and places changed into ideas, dreams became concrete. Now and then he dropped in at the bar or a cafe near the library, asked if a girl called Edda had been there. When he met colleagues, he mentioned the names Mr Ansen and Mr Redsand in case they had heard from them. They hadn't.

At the police in the missing persons file, they had no record of a Mr Ansen, Mr Redsand or anybody by the name of Edda. He insisted that three people could not possibly disappear in a place with less than one million inhabitants or live there unaccounted for.

They could've been visitors. Was he sure they were permanent residents?

He wasn't sure.

When Simon bought a hat, a trilby which did not suit

him at all (and his friends told him so), he explained that he was getting ready for a trip to Europe, the very far north, in fact, and the weather there was cold and foggy even in the middle of summer.

Jeltje

(for W. Les Russell)

Jeltje

I, Jeltje, from the blood-soaked cities
 of Northern Europe
came to this land, to hear a bird sing
(from the tops of my roof!)
and hang out my washing in sunny skies.

my parents brought me here as a child.
away: from the acid rain
away: from the black skeletons of
 bombed inner cities,
away: from the endless pounding of
 factories, polluting
the rivers and streams.

in some rivers, you couldn't count
 1 (one!) fish.
I, Jeltje, from the European cities
where the parents of school-age children
now hang themselves from home
 light-fittings,
or turn their garages into gas-chambers
(for themselves)

I have come to my senses in Aboriginal
 Australia,
in time to learn new words:
 tarwan (pronounced "dar-win"): black bream
 nanagi (pronounced "na-na-gi"): sea-fish

marndtja (pronounced "marn-dja"): fish,
from the High Country
jaronboa (pronounced "yorn-boa"):
murray-cod or 'big feller'
murroanba (pronounced "morrum-buh"): perch.

Part II: "What makes a real woman . . . ?"

Concrete poem no. 2: Tides

thalia

 : *Woman (in shorthand)*

My Names

Ruby Langford

I was called after my great aunt Ruby. In the mission photo, she's standing beside her identical twin, Pearl. They're dressed in Victorian fashion, high collars and pinched waists. Their dresses are white. Ruby and Pearl are black.

When I was six, Mum left us. My sisters were four and two. The person who took over our mothering was an Aboriginal clever man, Uncle Ernie Ord. He's telling us our totems. He says my totem is a willy wagtail, he says I'll always know if there's trouble because the wagtail will warn me. Many years later I'm living in Alexandria. There are sparrows and crows here, also a rain bird calls out when it's going to rain. There are no wagtails. One day I hear a wagtail outside my window. That afternoon I hear my brother is dying.

After Mum left, Dad took us to stay with Aunty Nell and Uncle Sam in Bonalbo. I am nine years old. Aunty Nell has boiled up flour bags and made our pants. Our dresses are made of cheesecloth, starched. Also the rag hats. It's my job to damp the starched clothing down, I hate it. I shinny up the tree outside our bedroom and hide in the leaves. Uncle Sam is calling me. Everything's quiet in the house. "Where's the Big Noise?" he calls. I start to sing. I'm singing as loud as I can.

I am in high school, thirteen going on fourteen. My best friend is Olga Olive. She's the only girl in her family and one of her brothers Bruce, races us home from school. He can always outrace us, he belts us on the head with his father's newspaper to make us run faster. Sometimes Olga and I climb a tree and hide till he goes

past. I'm so so good at climbing Olga calls me *rangi*, short for orangutang. "Hey Rangi," she calls, "give me a leg up, here he comes." We're quiet as mice till he goes past.

Ruby Anderson. My maiden name. I had a bad crush on a boy called Reggie Gordon who called me Ando all the time instead of Ruby. I got my first proposal when I was fifteen years old. It wasn't from Reggie but from Mervyn Kenny, a boy I called pug mug because of his nose.

I'm fifteen now. I finished high school and I'm working for a family called the Bulls. Their farmhouse overlooks Gorge Creek. I clean the house and look after two little girls. At weekends I borrow the chestnut pony and ride home singing "Yippi Hi Oh, Yippi Hi Ay". When I come to our gate Uncle Sam is on the back steps. "Hey mother, here comes our little heifer who works for the Bulls," he calls.

At Christmas, Dad arrives at Uncle Sam and Aunty Nell's. He's taking my sister Gwen and me to Sydney. Our younger sister Rita stays, she's too young. We get to Redfern and my stepmother, Little Mum Joyce, takes me to Bracks and I'm put on as an apprentice trousers machinist. My best mate is Betty Williams. On Sunday nights we go to the dance at the Ironworkers Union, down in Sussex Street. When we're broke we borrow money from Dad. He keeps the money in a big old woman's handbag in the wardrobe; he doesn't believe in banks. "Come on Andy," says Betty after we've borrowed a pound. "Let's go Willy," I say. Off to the dance. We weren't wallflowers for long.

I had my first three kids with Sam Griffin but I didn't change my name. Bill, Pearl and Dianne are Andersons, named after me. The next three I had with Gordon Campbell, Nobby, David and Aileen. They're registered

in his name. Then I married Peter Langford (Chub), and Ellen and Pauline were born. Now I'm Mrs Langford. My only legal name change. Later I had Jeff, my youngest, with Lance Marriot, who took on all my kids and loved them all. But I stayed Langford, by now things were complicated enough.

You can think of me as Ruby Wagtail Big Noise Anderson Rangi Ando Heifer Andy Langford. How I got to be Ruby Langford. Originally from the Bunjulung people.

Telling Tales

Zeny Giles

Mikhali, his brother-in-law Pericles and his daughter the teacher, sit on deck chairs near the Olympic Pool eating the last of their chocolate hearts. Since Mikhali's wife has gone back to the motel to rest, he and his brother-in-law have become unusually talkative.

"Do you know what they do," Mikhali complains to his daughter. "They line up at the Baths at six thirty."

"But if they get here first Dad . . ."

"Listen, listen while I tell you," he interrupts. "They pay their money, they go inside, they take their towels and the towels of their friends — one, two, three — sometimes four, and hang them over the doors of the cabins."

"And they are all the sunny ones," confirms Pericles. "We haven't had a cabin in the sun since we arrived here a week ago."

"And I'll tell you what else they do," says Mikhali. "See that tall bossy one over there holding the blue towel. She ordered me out of the place because it was time for the women to swim alone. But I got back at her the next day. I said to her, 'You see how crowded we are in the mixed pool, why don't you go now to the pool where the women are swimming alone?' "

His daughter is surprised to hear him confronting strangers in this way.

"And there are women who stand too long in front of the spurting water," says Pericles. "Three minutes it says on the signs and then another should come."

"Perhaps they don't read English, Theo Pericles," she says to her usually gentle uncle.

94

"Surely one of their compatriots can tell them," says Pericles speaking with even more feeling. "They stand, they swim, they drink, while the rest of us wait. They want too much."

"That's right," says Mikhali. "The women want too much."

She knows as she listens to her father that he is thinking not only of the women in the pool, but of her mother, his wife, who is in her sixties has insisted on a bank account of her own.

"But they will wreck things for themselves — especially the young ones. What man wants to marry today when the girls give them everything?"

Pericles nods, thinking of his own son, almost thirty and still unmarried.

Another Greek, a man from Samos in his middle fifties, pulls over his deck chair and joins in the discussion. "You're right, compatriot. And I can tell you that if I had what the young men get today, I would never have thought of marrying." He puts down his belongings on a nearby table, offers his cigarettes to the others, then lights one for himself.

"And if they do marry," says Mikhali, "how can they stay married? As soon as there's a fight, they decide to split up. Nobody needs anybody any more. The women earn as much as the men."

"Do you see how these women fight to get the higher wages?" says the man from Samos.

The woman sits back and watches them. She is Australian-born. Her spoken Greek is not fluent but she can follow their conversation and she continues to be amazed by their list of grievances and the vigour of their resentment.

"Women want power," says Mikhali, "and they will not be satisfied until they hold it in their hands. You

know the story of the king who loved his wife and wanted to give her a special gift?"

The men move their chairs closer. Mikhali's daughter leaves hers where it is, but listens carefully.

"If you want to give me a really special gift," the woman said to her husband, "let me rule your kingdom for just one day." The king told her that this was impossible, but she kept on at him with the same request, over and over, until the king, being a good man and loving his wife very much, said to her at last. "For one day, because I love you so much my dear one, you may rule my kingdom." She kissed him — making a great show of how much she appreciated the love he had shown her, and what does this woman do on her first day of ruling? With the help of the high executioner, she cuts off the head of her husband the king.

"But wait," says the woman, beginning first in Greek and finding her lack of fluency a burden, protests now in English. "What of all the kings who had their wives put to death? What of Henry, the English king?"

But they are not listening. They are bent on establishing the depravity of women. She sits back, comforting herself that she is witnessing male prejudice, as if in some experiment.

"I will tell you a better story," says the man from Samos. He lights another cigarette, pausing for effect. His wife has come now from the change room and sits beside him. "Kalimera," she says to them and the Australian-born woman knows that she is Greek born and judges that she will give no support in pleading the cause of women. She sits arranging her hair with a hand mirror and a comb and completing her hair, begins to rub cream into her skin. The Australian-born woman turns away to focus again on the men waiting for the story to begin.

There was once a merchant who could not get on with his wife. She was a great trouble to him. Even though he bought her a house where she could live alone, she would still come to pester him. So he determined to do something about it.

A powerful wizard lived on the other side of the island. People said he was as old as the mountains and as crafty as a fox. The merchant decided to visit him.

"What do you want my man?" asked the old wizard.

"I want you to get rid of a woman for me."

"Ah, so you want me to kill your wife."

"Sh —" said the merchant, fearful that someone might hear.

"Well, what will you give me for that piece of work?"

"I will give you a bag of silver."

"I have no use for silver."

"Then I will give you a bag of gold."

"I have no use for gold."

"What on earth do you want me to give you?" said the merchant, desperate in case the wizard would not help him.

"You are a landholder?" asked the old magician. "You grow olives?"

"Yes, I have terraces of olive trees."

"And you press the olives into oil?"

"I make the finest oil on the island."

"To get rid of your wife," said the old wizard, "you will need to bring me a year's supply of your best olive oil."

"I will bring it. In a day's time, I will bring it."

"You do not try to bargain, merchant. You must be a very wealthy man."

"This woman has caused me much worry. I will be pleased to pay to be rid of her."

"Listen to me merchant. Listen and hear what I will do for you and for all the men on our island. Bring me five years' supply of oil, and I will not only remove your wife, I will get rid of all the women on the island."

The men began to clap. It is a great story. A great story.

The Australian-born woman cannot believe her ears. She will have to recount this tale to her feminist friends at school.

The wife of the man from Samos, has only now put her mirror and her jar of cream back into her toilet bag. She turns to her husband and says. "Come Spiro. It is time we went back to have lunch."

"Ah yes, I had forgotten," says the man from Samos. "Do you know what we will eat today? Some smoked fish we bought from a compatriot in the town and some of our broad beans. We grew them in our garden. You have never seen such broad beans — big, but not dry"

"Do not begin boasting about your garden Spiro," his wife interrupts. "It is time to go."

"Be quiet, woman!" her husband shouts at her, and then he stands and raises his hand as if it strike her.

The Australian-born woman is furious. Do something, she signals to the other woman. Don't take this from him.

But the Greek woman does nothing and her husband, still holding up his hand, punctuates each word he says with a thrust of his fist towards her. "Don't you forget. I have brought the olive oil."

The men are laughing now — delighted by his wit as well as his demonstration of strength.

His wife continues silent, but as he stands, still threatening, she takes their two towels and hangs them on his upraised arm. She leans across and takes the rest of his belongings from the table and standing as tall as her husband, puts his cloth hat on his head and his packet of cigarettes and his lighter into his bathrobe pocket. "Come now, Spiro," she says smiling. "Until you learn to look after yourself, you'd better keep your olive oil for your salad."

The Assyrian Princess

Silvana Gardner

The Brisbane River is not the Euphrates nor does it resemble a tiger, even in floodtime. The inhabitants are Brisbanites not Ubaidians, but the force which controls human reincarnation is not responsible for relocations, which belong to another department in the Great Cosmos, just as a different section takes care of milleniums. Both of these illustrious organisations are beyond my understanding.

I can't promise familiarity with human reincarnations, either, except my own, and even this is a continuing trial and error which baffles my current existence.

Peculiar associations with objects were the first links to partially jolt my memory to another life, possibly in Assyria. Rather than *partially* I should say *fragmentedly*, for I don't know who my parents were, what I did, where I lived or what my name was, except that I was a princess. What else can one expect after five thousand years of milling through fire, earth, air and water? The elements have a way of pounding brain cells, leaving atoms with weather-beaten corners of strange photos, visual remains haphazardly collaged to what the eye sees and records in its present life.

You don't believe me?

How do you explain, then, the first link was the laboratory?

Squatting at the end of George Street, Gardens on the left, Brisbane River on the right, the Physiology

Building was a ziggurat when I started work in the morning.

When I went home in the evening, it became the building it was supposed to be. Each day I went to work, CLICK, ziggurat in the morning, Physiology Building at night.

Forget about my present life as a laboratory assistant. One optical atom records a fortress in Mesopotamia. It's all very well to say *imagination* . . . but the building never became anything else but a ziggurat. It never was a pyramid, a castle or a fifty-storey executive building. This proves a definite link on top of all the others which enrichened my life with all kinds of possibilities not to be shared with others. The law of Karma implies anonymity, otherwise nothing will be gained from the privilege of remembering. Worse still, the flowering of all memories will be blocked, and the mind will play confused tricks, maladjustments, frustrations that, in the midst of a modern young woman's contemporary life crowded with current issues, there will be disconcerting flashbacks to the Tower of Babel, an altar, sacrifices, libations and sanctuaries. The people I work with are Vets. My boss is a Vet who likes Gilbert and Sullivan. Enough said! No link whatsoever between "The Mikado" and an Assyrian princess. He confided he has an affinity with "The Pirates of Penzance". I was tempted to share my affinities but my mind went blank. A warning, for sure.

You may think it grandiose of me to connect an earlier life with royalty, but everyone admits I look incongruous as I scrub the congealed animal blood out of test tubes. They say (sometimes kindly, sometimes not) that my deportment is royal. My secrecy is severely tested

There is another laboratory assistant who stole my

white laboratory uniform so that she, too, could look royal. She thought she was Nefertiti, because of her nose. But it's not reincarnation with her, since the current make-up strongly advertises a beauty such as the Egyptian queen's. Possibly all the women in Brisbane think they are Nefertiti when they buy cosmetics with her face on the brand. Reincarnations are never as obvious as this. There's a difference between wishful thinking and a genuine reincarnation, as it happened in my case.

This does not infer I think washing pipettes or cleaning rat cages beneath my station. I'm philosophical about it. It's my karma. I just do everything royally. Especially when the laboratory sink is filled with forty test tubes caked with animal blood, clotted milk and foul-smelling chemicals, especially when some nitwit pulled the plug the day before and there was no overnight soaking. You can't give yourself airs doing a job like mine, handfuls of rat shit will guarantee it!

The window immediately above the repulsive sink faces the river and I can do the wash-up without looking, staring instead at the water till I'm hypnotised by the Tigris tinged with blood, the red flux merging with clear water to ensure animal sacrifices haven't been wasted: the battle *will* be victorious . . .

The blood is the strongest link. As a true Assyrian princess, the sight of blood never offends me. Nineveh flows with blood. We worship its redness. Sometimes we drink it.

The ziggurat houses sheep, specifically kept for the letting of blood. It's true I only watch (you've got to be a graduate to do it) but I know how the syringe can easily be a dagger, skillfully poised to slit the ewe's jugular vein. Not a deep cut. Not deep enough to kill. Just a nick to allow the ruby red fluid to collect in a phial. I

love to feel its warmth. The Sedimentation Rate of Platelets is a ruse for a pagan sacrifice. The déjà vu feeling is so strong I once ruined a whole experiment by not hurrying to my boss with the fresh blood. It coagulated before he could add his chemicals to keep it flowing.

He's displeased with me. Says a laboratory assistant can't afford to be a dreamer and even though he understands how a woman could be disturbed by the sight of blood, I should concentrate on my job or else get out. Little does he know . . . AND I'm not dreaming! The fragments of an earlier existence come upon me uninvited, although it's peculiar they are so clear when blood is drawn.

Despite the clarity of the sacrifice, the sequence of events is disjointed. First the sacrifice, then the boss going mad at me, then the cymbals . . . it's impossible to deal with rapid changes with aplomb. I can only apologise and promise to concentrate next time. Royally, of course.

Another link is the pot plants. I have a mania for hanging baskets whose health is fortified with fresh blood. They don't want me to bring them in the laboratory.

They'll make the brick walls look nice, I tell them and withhold the booming voice calling out *hydroponics* the minute I was born. Absolutely not, my boss orders. He worries there won't be enough blood left for his pecadillos. I've seen him throw out one hundred mls. the morning after being out late the night before. Another temptation to reveal all. The Laws of Karma are tough.

Since I do not trust reincarnations completely (I'm not a fool) and find it safer to stick with the commonplace of my current life, I go about my business with the mundaneness of any employee, feeling jubilant on pay days.

They talk a lot about sex at morning tea. I don't know

what they talk about at night since I do not mix with them. They've tried to involve me with group outings after work but somehow I'm not attracted to the idea. I overheard a girl say: *who does she think she is?*

It must be my royal demeanour which prompted a laboratory attendant (ranks are important in the ziggurat), a youth, to refrain from telling what he did with two girls, locked in a motel bedroom, for three days at Surfers. He'll wait for me to leave before he'll tell the rest of the group. The cheek of him! He obviously doesn't know anything about Babylon. How I would love to tell him of Assyrian sexual practices. *Ménage à trois*? Kindergarten! I could tell him a few things about spring festivals after the lion hunts that would make him blush with embarrassment. Let him see a prudish lab assistant . . . he is too unimportant to break my karma.

There's a new Vet joining the staff next week. Everyone nubile is excited at the prospect. There's much speculation about his appearance. I'm not interested and go about collecting blood, staring through the window to see more of what happened thousands of years ago. I must have been devoted to the priesthood. I smell incense instead of sour milk.

It would be rare for the new Vet to come down to the dungeon where I work. His specialties involve him on the mezzanine floor. But there he is, behind me, as I wash test tubes. How long has he been assessing my arse?

He's dark, like a Bedouin. He's wearing shorts which accentuate his skinny legs covered with lots of black hair. He would be the type whose back is covered with hair like fur. An animal. There's a saying that someone can be so ugly that they're wearing the seven sins. He's wearing the seven sins.

He's using his rank to impress me. I'm not impressed.

He leaves. I'm convinced he's come down to see what I look like. He's probably investigated all the female staff to see what's available. What is he expecting? He'll always be a desert merchant, never a priest with seven sins.

There are lions in the hills today. Assurbanipal is going hunting. One minute I'm a princess, the next a lioness. Several sheep are sacrificed for the hunt. Ishtar is a moody goddess. The Bedouin Vet comes down again.

I've been trying to remember who you remind me of, he says as he stands at the door with bleating sheep behind him. Nefertiti? I suggest, privately sneering at his crude attempts at courtship.

No, someone more ancient. The Egyptians came much later than the Assyrians. (He has a genuine copy of an Assyrian frieze where Assurbanipal smites the Elamites.) He talks and talks about Assyrian culture. About Semiramis and her famous hanging gardens. I'm impressed, even though I'm not registering his words.

It's as if I'm being turned into a statue. The final chiselling, the final chip of alabaster falls when the camel driver tells me Stalin was called the Assyrian and I remind him of an Assyrian princess carved in stone.

This is where my reincarnation ends. There will never be any more pictures of the other life. The princess has been terminated. Gone with the elements down the plughole, the water drowning any memory she would've liked to enlarge.

The sheep are poor animals molested everyday. One saving grace is that I mustn't have been too wicked a princess, otherwise karma would have seen me an incarcerated sheep. I would have known what it's like to be bled dry, let alone slaughtered.

And who was the Vet who knew me from ancient Assyria?

I never saw him again.

I continue to wash stale blood from test tubes. One day I will wash human blood in a different life. The Laws of Karma are merciless.

Suicide

Antigone Kefala

This timelessness
that rises out of the earth,
the rocks, the sea,
envelops us, tantalising,
a familiar yet forgotten scent
that tries to wake
lost images in the deposits
of our mind.

This silence,
the ease that fills the trees,
a promise of such bliss
of self-forgetfulness.

The Case of the Vanishing Princess: Sally's Tale

Patricia Pengilley

This event took place in 1947.

Dad says that ever since my Aunt Kitty started stirring the family for stories of the British Raj, everyone has been bitten by a bug — to search for old paraphenalia and become maudlin with wornout tales and family memorabilia.

To anyone who says to me, "Have you started . . .?", I laugh and say "Me? Hell . . . don't ask me to write . . . never could . . . can't spell . . . can't compose . . . can't formulate . . . literary moron!"

"Dictaphone it," said Aunt Kitty.

Damn! That old bird never lets up. Damn! For an attack of archaeological-family-blues was coming on. To be honest, Dad's tale of the family rubies really got to me. Why has he been so secretive about it all these years?

So here goes — dictaphone. Well this is typical . . . typical . . . I always do things differently . . . never could be the same as everyone else in our family. I mean . . . to begin with . . . I look different. "They" were all fair . . . brown-haired . . . blue-eyed . . . English-bound. Me? I'm dark. And never hankered for the white cliffs of Dover. If Chinese women had their feet bound up, our Indian-born English families had their minds bound up . . . trussed-up like mummies

with bandages stamped . . . Rule Brittania. All born bleating "Home Sweet Home". Home being England.

Well, about 1947, the family was planning to migrate; planning "TO BE OR NOT TO BE . . . THAT IS THE QUESTION". Of course, the real question was: TO BE WHOM BLOODY WHO?

I had just sat for my Cambridge School Certificate. I told you, we were English-bound. Dad was some big nob in the Telegraph Service in Bombay at the time. Well, most of the kids were pondering what they were going to do next, school, thankfully, being over. Hell, I hadn't got there — yet. I wasn't even sure how someone as dark as me was going to get into bloody white Australia.

This realisation had hit me hard that December. These days, this sort of experience is poetically described as a moment of truth; I would say my moments of truth have been ghastly dilemmas.

And this is how it all started. One night, I had planned to meet Wendy, my friend, in a Cinema Ice-cream Parlour. A new kind of peach melba was the "in thing". Later we were going on to a cocktail party at Lulu's home to celebrate the end of school and exams. And well . . . her parents were out.

I can remember I had borrowed Mum's black dress and her high-heeled shoes. By hitching the dress up with a silver belt, pulling the bodice out over my boobs, making sure my bare shoulders were showing, I felt cute, grown up. I was sure the dangling silver earrings from the bazaar gave me a touch of class. Every time I think of those earrings I can feel the damn things pinching. I was sick-to-death-of-being-going-on-seventeen, the youngest in the class.

I was eating a peach melba, hopefully in a seductive fashion, when an ape of an English sailor came barging

in, breath stale, bulging with alcohol and made some suggestive propositions. Coolly, I swirled the high stool around and turned my back on him. Actually, I was feeling pretty scared and wondering if I had overdone the growing-up bit. And I began to regret borrowing Mum's things without asking her, especially when a group of watching soldiers sniggered.

"Tart," the sailor snarled behind me. "Tart . . . dirty *Chee Chee** . . . Go back to the gutter!"

Suddenly I was mad . . . mad with rage. Didn't know I had it in me to be so angry. I was sick of these morons in the forces pretending the war gave them the right to everything, so I just turned around, faced him, toppled the remaining ice-cream down his tropical uniform and jumped on his toes. That tactic had been tried out on me in my last netball match, and I had been longing to do it to someone ever since. To my surprise, he squealed like a village pig, his eyes popping open like press studs coming apart . . . snap! I hadn't meant to hurt him so much. Oh God, of course, I'd forgotten about Mum's high heels. He had begun to look as if he would punch my nose and some of the fellows started to hold him down and shout: "Get! *Chee-Chee*."

I didn't wait. I meant to walk out slowly, swinging and twirling my bag. I would have liked to have been able to drawl out something like: "Come up and see me sometime. Cry baby!" like a Mae West film, but I tripped on the broken heel and hobbled out. Curses! When I got out in the street I ran, just in case they were all after me. You never know with these things. Fortunately, I bumped into Wendy. She was getting out of a tonga. So I pushed her back into the seat and yelled, "*Juldi Juldi** tonga-wallah . . . drunken sailors in bar!"

Chee-Chee: Colloq. Half-caste.
Juldi: hurry (Hindi)

Well, that was a mild exaggeration, but I thought that would satisfy Wendy and get the tonga moving. "We'd better go straight to Lulu's," I told Wendy.

"What's the matter Sally?" Wendy was peering at me through her thick glasses. "You look strange . . . awfully . . . cheap. Your make-up is streaming everywhere. Wouldn't your mother mind you wearing so much?"

I mumbled something about Mum and Aunt Betty being away for a few days, and only Dad and I were at home for the time being.

I mopped up my face, let the belt out a little, covered my shoulders and decided Wendy was a prude about some things.

"Wendy", I said eventually, "why the hell is *Chee-Chee* such a dirty word?"

Wendy looked solemn, owl-like, as if she was answering a question in the Cambridge School Certificate. "Sally, why do you always use such bad language? I suppose the British would rather half-and-half babies never happened. And if 'it' happened, why throw 'it' into the gutter? And Indians, high-class, self-respecting Brahmins, would say: "leave it in the gutter!' I guess we have to decide now to be either English or Indian, Sally. Well, that is what Dad says. And I agree with him. This is not the time for in-betweens. Mum says there ought to be a separate state for the Anglo-Indians." And so she went on and on.

So I was an in-between, gutter scum. I had become miserable; it was worse, I told myself, than the fate of a Jew. I mean a Jew even in a concentration camp was a JEW. This is . . . nothing . . . Even Wendy called it . . . IT.

When we arrived at Lulu's, we had to settle the tonga-fare. Wendy was very meticulous about such matters, and never let anyone get away with a thing, which was a

pity for this left me short of money. I had to keep enough for a tonga home and I was supposed to supply the cigarettes for the party. Lulu's cousin, Phil, was teaching us how to smoke, properly. I mean we were accustomed to puffing away like blasted steam trains behind the lavatories. So telling Wendy not to wait for me, I sneaked around the corner, still hopping from time to time, and tried to negotiate the sale of a few cigarettes out of a packet. The old man in the wayside shop was not having any and offered me beadies instead. Beadies are smokes for coolies, made, I swear, from tobacco scraps and bits and pieces scooped off the floor of a tobacco factory and rolled into leaves. I took them for a joke. Decided Lulu would look a treat, smoking a beadie in her mother's elegant sitting room.

When I eventually got into the place, there were about seven girls sitting around brandishing ghoulish-looking cocktails. There was Lulu, her cousin Phil, Shanti (my best friend), Wendy and a couple of ring-ins. Shanti was looking unhappy. She was an Indian Christian and very upright. Lulu meanwhile had started to mix a cocktail for me, in a very sophisticated way. Her sister had an American boyfriend and she kept on and on, quoting his recipes. I knew Shanti's parents wouldn't approve and Shanti cared; I knew mine wouldn't approve and I didn't care a . . . a . . . a dime, or, so I told myself.

"Let's make whoopee," gurgled Lulu, sounding like the cinema. She had been unable to find the tomato juice for the Bloody Marys, so she was toppling raspberry fizz into glasses. I guessed Lulu's mother had left out the fizz as a suitable drink for her daughter's party.

"While parents away
children will play!"

cooed Phil. She had brought out a gigantic cigarette holder and wanted to know who had the fags.

I felt damn foolish but admitted I had brought beadies. There was a strangled silence. Shanti glanced at me horrified.

"Beadies!" Lulu sounded shrill.

"What a joke," said Wendy, trying to help. She didn't look as if she thought it funny. The cocktails were doing something to her weak eyes. They were flying in all directions, out of control.

"Sally's always up to something, just for a lark." Everyone agreed it was a lark, except Shanti.

So Phil tried to pop a beadie in her holder. This brought on a kind of group hysteria especially when Phil sprawled on a settee like an Empress Josephine. "Someone told me opium is injected into beadies," she said mysteriously.

Lulu had talked about the adventurous who were going places: England, Canada, USA. Her sister was going to be a GI bride.

I didn't want to admit we may be migrating to Australia. "What will you do with your colour?" I could hear Phil say, looking all innocent and doe-eyed.

So I said, "I think I'll stay . . . why not? I have roots in India. Guess? One of my Indian ancestors was a princess!"

That stopped all the "aside" conversations. No-one, but no-one, talks about their Indian ancestors. A princess! Everyone ogled a bit; even Wendy's eyes momentarily stopped wandering. Shanti sipping lemonade remarked: "You're all crazy tonight. I think we should go home before Lulu's parents come back."

Her commonsense annoyed me. She was supposing the princess to be the offspring of a Bloody Mary and a smelly beadie.

"Let's go when I'm finished," I said. Holding the glass in one hand and the beadie in the other, and forgetting about the terrible taste of the beadie, I felt . . . like . . . a . . . princess It was not . . . bad . . . not bad . . . at all.

"Remember how my Aunty Kitty got to Australia? She sold a ruby necklace. I believed it belonged to the family. You see Great Grandpappy married a young Coorg princess and a prince gave her the rubies, a dowry, naturally. Aunt Kitty always said the rubies were a gift of a prince."

I was fibbing like mad, making up the story as I went along. At that time, I wasn't sure about the rubies, everyone had been so damned secretive then. I didn't really know much about our families or anything, so I thought I was doing rather well, until Phil burst out laughing. "You're joking, you must be! We all know none of our parents can face up to an Indian in their midst so they invent a princess, like a fairy story. Like fairy stories the princess vanishes away . . . phoo . . ." and she blew an imaginary candle out and upset her cigarette holder.

"What a scream," said Lulu for the umpteenth time. She seemed to have gotten into a groove, except this time she made it sound really sad as if she didn't want Phil to elaborate too much, in case she had to banish a beautiful princess.

"Sh! Sh! Sally, you're er-er . . . allowed a v . . .vanishing princess," said Wendy who really was slooched. Her eyes were now glued into a cross-eyed position.

"Children . . . we better go home. Before Auntie comes home," said one of the ring-ins.

I kept thinking of what Phil had said. She had hit the bloody nail on the head. No self-respecting parent

would admit to anything . . . except a royal . . . Indian.

"Should we buzz off?" asked a voice somewhere in the midst of thick beadie smoke. I heard Shanti insisting she take Wendy home, so I slipped out leaving them arguing about the method of transport: taxi, tonga, rickshaw, or, a dad's pick-up service.

Considering all things, I didn't think calling in any of the fathers was quite the wisest move. Anyway, I suddenly wanted to get home quickly. I had started feeling pretty lousy. Perhaps Bloody Marys charged with raspberry fizz, and washed down with beadie fumes didn't quite agree with me.

Fortunately when I arrived home, Dad was, as always, changing for dinner, whether he played tennis after work or not. This gave me the chance to slide into my bedroom and take off Mum's clothes. I had hardly scrambled out of them when Dad was outside my door.

"Sally . . . Sally . . . are you in? Are you ready for dinner?"

Dinner! Christ! I was going to throw up.

"No," I croaked, "I'm going to bed . . . I'm ill . . . just leave me alone . . . something I've eaten has upset me."

"Some soup," said Dad sounding like Mum, "some soup and toast." Jesus, why can't parents leave you alone.

"Starvation fixes it," I muttered and hoped it would. It felt so bloody permanent.

"Fill in the form for the Australian authorities when you're better," he said kindly, moving away, "I've left it on your desk and, oh, we'll need another photograph."

I sat down on a chair and stared at the form. Not another . . . and a photo to examine our colour. No-one was allowed to have an Indian grandparent. Those

were the regulations. I was OK, but how about Dad and Mum with their grandparents. God, how I hated the whole mess. We had won the war, hadn't we? Then why were we all running off like frightened deer to a country where colour was so important. I tore up the form and wrote my own.

TO WHOM IT MAY CONCERN

NAME:	Chee Chee
AGE:	Don't care
COMPLEXION:	Take one European
	Take an Indian
	Cocktail them
	Add an olive . . .
	then lump it or like it.
EYES:	Not blue
	Not brown
NATIONALITY:	Mongrel
COUNTRY OF BIRTH:	No man's land
OCCUPATION:	Vanishing princess
AMBITION:	To be a human being

I pushed this under the door. I knew Dad would eventually return, pick it up and stand outside, silent, scanning it. This made me feel so sad I went off to the bathroom to throw up.

Night and Snow

Alba Romano

Tonight there's cold, nothing but cold.
Deep snow and absent moon.
Just myself and the track of my footprints,
ridiculous alternating impressions.

The offensive warmth of golden light
that spills from anonymous windows
illuminates worlds that ignore me.
I walk without purpose or destination.
The night does not sense me and the trees do not see
 me.
No system includes me.

Doubting my being and my name
I look back, and existence
is confirmed by deep footprints,
ridiculous alternating impressions.

Noche y Nieve

Alba Romano

Esta noche hace frío y sólo frío.
Nieve alta y luna ausente.
Sólo yo y mis pisadas hondas,
ridículas improntas alternadas.

La ofensiva calidez de luz dorada
que desborda de anónimas ventanas
ilumina mundos que me ignoran.
Camino sin destino y sin sentido.
La noche no me siente ni los árboles me ven.
Ningún sistema me incluye.

Dudo de mi ser y de mi nombre.
Miro hacia atrás
y mi existencia se confirma ante mis huellas,
ridículas improntas alternadas.

Love

Angelika Fremd

Some were kings,
some were queens,
others common folk.
We carried home in boxes,
their royal beetle majesties,
fall-out from spring-laden trees.

Two of my court became
joined, end to end.
An illness? Love, they said,
it's the way they are bred!
Love? Walking backwards
or dragging the other along
as if dead?

She loved his uniform, she said,
the way his antlers showed
his ranking, sleek curve of his head,
his markings put him firmly
in charge. Now dead,
he was a handsome soldier,
grandmother said.

Liebe

Angelika Fremd

Manche waren Könige,
manche Königinnen,
andere gemeines Volk.
Wir trugen sie nach Hause
unsere Maikäfer-Majestäten,
Abfall der frühlingsschweren Bäume.

Zwei meiner Höflinge wurden eins.
Eine Krankheit? Liebe, sagten sie,
so ist es von Natur aus.
Liebe? Rückwärts gehen
oder den Geliebten schleppen
wie einen Toten?

Sie liebte Uniformen,
die schönen Sprossen
die Einstufung erleichtern.
Seine Abzeichen bezeugten
dass er befehlen durfte.

Jetzt ist er tot,
dieser stattliche Soldat,
den Grossmutter liebte.

Potential Cannibalism

Coren Caplan

Further proof of my love
Is hopefully not needed.
Please do count carefully my fingers
Limbs and other parts
Already in your possession.
You should find everything
Accounted for. But I meekly
Ask that I not be eaten.
I'd rather live
Another day, however much I'd like
To be a part of you.

Mal Tombée

Dewi Anggraeni

Maryati steps timidly into the house, almost hiding behind Trevor's broad shoulders. Her palms are moist and her facial muscles are stiff trying to retain a smile. They walk into the large hallway leading into the wood-panelled kitchen. But Lisa doesn't guide them there. She turns left into a cream living room where people are chatting and drinking. Standing aside to let them step in, Lisa taps a young woman's shoulder and begins introducing them. The young woman turns around facing Trevor and Maryati.

"Hello," she says. "What's your name again?"

Before Maryati has time to panic, Trevor answers, "Maryati."

The woman, whose name Maryati doesn't catch either, repeats it conscientiously, sending a warm and reassuring sensation down Maryati's spine.

Lisa continues with the introduction. Maryati, whose eyes begin to take in the surroundings, feels a flush of relief when she sees some Indonesian faces amongst them. Her face relaxes into a genuine smile and she greets them in Indonesian.

Lisa, noticing this, accelerates the process and leaves them, after saying, "Anyway, when you're ready, come outside. More people there, and more food."

Trevor begins to translate what Lisa said and looks on patiently when Maryati half ignores him and returns to the group of Indonesians near the table.

Except for a curly-haired lady of about thirty-five, the others in the group quickly lose interest in Maryati and go back to their previous discussion about Indonesia's

role in the ASEAN, which Maryati knows nothing about.

Eni, the curly-haired lady, asks Maryati if she has been in Australia long.

"No, only three months. My husband works in Melbourne, that's why I came here with him."

"What's he do?" asks Eni.

"He works in a furniture shop." Maryati says it with such pride that Eni can't hide an amused smile.

Maryati asks Eni if she's married to an Australian too.

"No, I'm a widow. I've got two daughters. They're here too. Somewhere outside."

Finally Eni understands that Maryati is wondering how come she's living in Melbourne if she isn't married to an Australian.

"Oh," she smiles slightly, "I've set up my home here. The girls are both educated here. They can't even speak Indonesian very well any more."

"Yes, I heard it is very easy to get a job here," Maryati comments.

Eni nods tolerantly and gives a non-committal grunt.

"Let's go outside and meet other Indonesian people." Eni takes Maryati's arm, glancing at Trevor who is talking to a rather seedy-looking man in a safari suit.

They both stand at the doorway, adjusting their eyes to the bright afternoon sun. An Australian man comes over to talk to Eni. Maryati looks around, squinting. Her attention is drawn toward a young woman wearing white three-quarter length pants and a bright off-the-shoulder top. She's chatting and laughing, leaning with her hand on the shoulder of a tall Australian man, who has his arm casually around her waist.

When she catches sight of the man's face, Maryati feels faint. She stops squinting, hoping to shut away the reality in front of her. "Oh, Gusti!" she moans almost

audibly. Eni turns and asks her if anything's the matter. She doesn't answer.

* * * * *

It wasn't the first time that Maryati was sent to deliver *jamu* to the Hotel Sahid. In fact, the receptionist knew her so well that he just waved her past. But she was stunned when a tall suntanned white man with hairy legs opened the door.

"You brought me some *jamu*, come in!" the man said in fluent Javanese. Clutching the bottle of *jamu*, Maryati stepped in, bowing as she passed the man. When she was going to kneel on the floor, the man stopped her. "No. Please sit in this chair." He took her by the arm and gently pushed her toward the chair. Maryati obeyed. Then the man held out his hand. Only then did she remember that she was still holding the bottle of *jamu*. She gave it to him and mumbled some apology.

Pouring a cool drink for her, the man asked her if she was born in Solo. She said yes, abstractedly.

Despite the invitation, Maryati didn't dare touch the glass. The man picked it up and brought it to her. He took her hand, opened it and was going to put the glass in it when he noticed how tiny her hand was. He put the glass back and examined her hand. Maryati felt her hand icy and burning at the same time. She had never touched a white man before. Numb, and curious, she let him caress her palm, then her fingers. Kneeling in front of her, the man kept looking at her arm, half revealed by the rolled-up sleeve of her *kebaya*.

When he was looking at her neck, he was so close to her she could smell his strange body odour. She lowered her eyes.

The way he took her was different from any Indone-

sian man. He let her come first. And he wouldn't let her dress straight away, still caressing her arm.

A short while later, he took her again.

* * * * *

Eni touches her arm. Maryati feels her flesh burn and her eyes become moist.

"Maryati!" Eni calls. "Are you all right?"

Maryati focuses her eyes on Eni. "Hmm, yes, the sun's a bit glarey."

"Your eyes look quite red. Would you like to wash your face, perhaps?" asks Eni. "Come, the bathroom's this way."

Maryati washes her face then lets the water run on her hands and arms, cooling her fever.

* * * * *

After that event, she kept looking for the man each time she went back to the Hotel Sahid. It wasn't an international tourist class hotel and there weren't that many foreigners staying there. The man never came back. When her menstruation stopped she went to the hotel even more often. She didn't know how to contact him. The hotel was the only point of communication in her scope of understanding. Through one of the cooks in the hotel who enquired at the desk, Maryati found out that the man was Australian. But where's Australia? Is it anywhere near Holland? She didn't even know where Holland was. She'd never gone to school. Four months later when her stomach began to swell, she resigned from the *jamu* shop and went back to her widowed mother in a small *kampung* near Karanganyar. There she gave birth to a boy with skin the colour of milk cof-

fee and light brown eyes. When her son was two years old, his grandmother told his mother that if she wanted her son to have a more comfortable life, she'd have to go back to work in a large town. Someone in the *kampung* mentioned that Yogyakarta was a better place to find a job. It was more popular with tourists. So Maryati went to Yogya.

* * * * *

Eni is still waiting for Maryati when she emerges. Trevor is seen looking for her too. Eni leaves her with Trevor and goes looking for her daughters. When they look at each other, Maryati feels a little reassured. Yes, she's Trevor's wife now. Yet it's a shaky sense of belonging. There's so much Trevor doesn't know. There wasn't time to tell him.

* * * * *

In Yogya she found a job at a restaurant. At first she worked in the kitchen, but because of her good looks, the proprietor moved her to serving at the tables. Though she couldn't read or write, she wasn't numerically illiterate. She learned the menu by heart by the numbers of each dish, and only made one or two mistakes during the seventeen months she worked there.

One day her employer sent her along with several other staff to serve at a barbecue at one of the guest houses in Yogya. Trevor spotted her immediately.

"Who's the pretty girl with her hair in plaits?" he asked one of the cooks. "Can you introduce me to her?"

The cook, the only one with some English, looked up in amazement at first. "Gosh, there's no need for introduction. Just talk to her." Discretion stopped the

cook from saying, "Who d'you think she is? A princess?"

That night at the restaurant the kitchen staff were chuckling behind their hands.

Trevor finally found the courage to approach her. Conversation was stiff and limited. Trevor's Indonesian was strictly tourist-oriented, and he didn't know any Javanese. He managed to elicit enough to know where he could see her again. After a while, when he didn't want any more to eat or to drink and had learned where the toilet was, they just looked at each other in awkward silence. Then Maryati had to start packing up to go back to the restaurant.

That night, Trevor and two other tourists came to the restaurant. With encouragement from his friends, he spoke to Maryati. The following night he came back alone. It was his last night in Yogya. With a phrase book in his hand, he proposed to Maryati.

Maryati, who thought Trevor was practising his In-donesian, laughed nervously at first. Then when he repeated his proposal three times, she realised, along with some other diners nearby, that he was serious.

She didn't tell him about her little son then. Neither did she when he came back to Yogya for her two months later. At first, she didn't want to spoil her luck. Then, the more she delayed, the more reluctant she became. I don't want to hurt him, she justified herself.

* * * * *

Trevor invites his wife to come out. Lisa is beckoning them to come and have some chops. Eni's there too, her plate already full. When Eni's serving her some salads, Maryati asks, "Who's that girl in the white pants?" indicating the woman with the man.

126

"That's Narsih. She used to work with me. And that's her husband Boyce. You know, Boyce Marten, the author of *Pancasila, Javanese Version*"

Maryati doesn't hear any more. "So he's married. And his name's Boyce Marten."

Suddenly she looks up and asks, "Have they been married long?"

"No, they're newly-weds, like you are."

* * * * *

The elation of being properly proposed to and married soon died down. Trevor was unable to arouse in her the feverish turning of her stomach the other white man had done. Every day she waited for Trevor's phone call around lunch time, though what they could talk about was limited to events around the house. Trevor's progress in learning Indonesian was slow and Maryati was too scared to travel to a local migrant English class. The highlight of her day was when Trevor came home. They could communicate better face to face.

Trevor rang up an Australian-Indonesian friendship organisation and was informed of several gatherings they could attend. However they missed two of these occasions because they both fell on birthdays in Trevor's family. His parents and brothers were kind to Maryati, but were frustrated by their inability to communicate, and they couldn't really accept her extreme shyness.

At first, Trevor was eager to introduce his wife to his friends. He invited them to their flat, and Maryati'd slave in the kitchen preparing elaborate Javanese dishes. Yet when the visitors came she'd sit quietly in her chair while they ate and chatted, not knowing what to do or say, except for when they needed something at the table. She preferred to stand around and serve them like a

waitress, but Trevor wanted to see her seated like a hostess. Maryati concealed her frustration and obeyed her husband. Trevor finally sensed that his wife didn't enjoy his friends' company and stopped inviting them. She longed for Javanese company. She was homesick, and missing her son.

* * * * *

Trevor comes to join his wife at the salad table. Eni walks away to get some more sauce. Maryati waits for Eni to come back. She's Javanese. Though upper class, she's still a Javanese. When she does come back, Boyce Marten and his young wife are also approaching the salad table. Maryati wants to rush away but she's too numb.

Boyce sees Eni and gives her a cheerful greeting. Maryati feels her skin contract. She puts her plate on the table. It attracts Boyce's attention. He turns to look at Maryati, who lowers her eyes.

"By the way, have you met Maryati and Trevor, Boyce? And this is Boyce's wife, Narsih." Eni's voice floats as Maryati slowly lifts her eyes and meets Boyce's.

Boyce's grin seems to freeze for a moment. As a shudder goes through Maryati's body, she sees a flicker of recognition in Boyce's eyes. As her vision blurs with the pressure of tears in her eyes, Maryati lowers them again.

"The sun gets in your eyes again, poor Maryati!" Eni grabs her arm and apologising to the group, leads her to the bathroom again.

Trevor follows the two women with his eyes, his mouth still gaping with bewilderment. Narsih looks at him, then at her husband. Boyce looks pensive.

The barbecue goes on, with children squealing, men

and women talking and arguing, a group in a corner dwelling on the consequences of love on impulse.

In the bathroom, Maryati runs cold water on her palms and splashes it onto her face, but her eyes won't stop stinging.

Jamu is a specially made herbal drink, used for health purposes, for example to enhance physical strength for men.
Kebaya is the traditional blouse worn, with a batik sarong, by Javanese women.
Kampung is a cluster of small village huts. Kampung dwellers are usually not well-off.

The Two of Us

Vasso Kalamaras

Translated by Vasso Kalamaras
and June Kingdon

They filled us with bitterness.
We shared our joys and struggles
all these years
bound together by hope.
How many times were we lost
in pain
moments when misfortune struck us
defeated by our own mistakes?
You
who came to possess to fill
the whole of my life
I know you
yet who are you?
After so many years together
you amaze me
everything about you
soul
voice
movements
every work of yours
so much my own.
The truth is bitter
we are like everyone.
Two strangers.

ΟΙ ΔΥΟ ΜΑΣ

Βάσω Καλαμάρα

Μας γέμισαν πίκρες
χαρές μοιραστήκαμε και κόπους
δεθήκαμε τόσα χρόνια μ' ελπίδες
πόσες φορές δε χαθήκαμε
σε πόνους
στιγμές που μας κτύπησαν ατυχίες
στα δικά μας τα λάθη
νικηθήκαμε.
Εσύ πο 'ρθες ολάκαιρη να κρατήσεις
τη δική μου ζωή να γεμίσεις
σε γνωρίζω
μα δεν έμαθα ακόμα ποιός είσαι.
Εσύ
μια κατάπληξη χρόνια πόσα
μαζί μου
όλα
η ψυχή
η φωνή
οι κινήσεις
το κάθε σου έργο
δικά μου τόσο.
Κι η αλήθεια πικρή
όπως όλοι κι εμείς
δύο ξένοι.

Carpet Thoughts

Coren Caplan

Roses, roses and stems underneath a hurricane of our
Own making. Of the caresses you did not speak.

Vacuuming would not go astray on this one. We
 touched
It together, felt its pile in our pores.

Carpets designed for family people who don't ever
Wish or need to inspect it at close range

Who "got their telly going" and won't hear the
 housemites
Who lift their face to nothing but a screen and never
Lower their tongue to anything but a TV dinner.

But what about us, grappling with the surface of
 regular
Patterns amidst our irregularities?
I want to make love to you, you say.

Tiny, gnawing sounds, familiar sounds. Overhead a
 stuffed
Seal in lambswool on the shelf with glass eyes,
 flowers in
Brass containers, tightly packed, tightly, into order
 and submission.

The Other Country

Chitra Fernando

After two years in Sydney teaching English to Vietnamese migrants in Bankstown, Rupa Gomez felt she had to return to Sri Lanka. The insistent "When are you coming back?" in every letter from her father, her mother and Aunty Mary, from Francis and Srini, from everyone excepting Uncle Anthony, took on the collective force behind a battering ram.

The car stopped before the familiar house in St Mary's Road. Srini, her younger sister, ran to the car and hugged Rupa. Everything was the same: the scent of jasmine in the air, the purple profusion of bougainvilleas, latticed sunlight, a strip of diamond-shaped criss-crossings on the verandah floor; potted maidenhair ferns still lining the steps; the same well-worn cane chairs. Why then did she feel that something — someone was missing?

"Where's Uncle Anthony?" she asked abruptly.

They looked at her distressed, mournful. Her mother said, a quiver in her voice, "He — he's dead." Then added, "It's so nice to have you back."

Rupa had vaguely noticed her mother's black-and-white sari, but hadn't taken in the meaning of that choice of colours in the almost heady pleasure of homecoming. "What — what happened?" she asked, her voice unsteady.

"Heart," said Srini tersely. "The funeral's the day after tomorrow."

With tears streaming down her face, Rupa heard rather than saw Aunty Mary. "Crying! People overseas must expect their relatives to die in their absence."

Aunty Mary was scrutinising her from head to toe. "You've put on a bit of weight. Not so skinny as you used to be." She looked meaningfully at her sister. Then continued, "Your cheeks are quite pink. And your hair seems thicker."

Rupa felt a premonitory qualm. The look, the comments — they meant something. She guessed what was in the air, but did she really mind? The independence, the isolation of city life — she'd had enough of that.

"So why are you still standing on the verandah?" demanded Aunty Mary. "Come in, come in. Sit down, sit down."

They went into the hall, which was also the sitting room. A wide archway separated it from the dining room. Through the open door of the dining room, Rupa could see Emmali, Nanda and Jose on the back verandah, straining for a glimpse of the returned traveller.

"Jose, Jose," shouted Aunty Mary, "take these bags upstairs. Nanda bring the tea and the sandwiches." A widow with one grown-up son and plenty of time, she came often, and always took over the household.

Rupa sank into a chair, looked around, re-knitting herself to familiar things. Opposite her was the cabinet filled with bric-a-brac, at once souvenir and public proof of the combined pilgrimage and tour her parents had made to Europe: a bottle of holy water from Lourdes, a picture of St Peters in a gilded frame, a miniature Eiffel Tower, Venetian glass animals, a London beefeater splendid in red and gold, the Little Mermaid from Copenhagen and other more commonplace treasures in the form of silver trays, ornamental bowls and porcelain figurines. On the wall above this hoard, like some special guardian, hung a large picture of Christ: flowing brown hair, a mild face, a hint of bewilderment in the up-turned eyes. The reason for this

bewilderment, which only she seemed to notice lay, Rupa felt, in the object His fingers delicately pointed to: the Sacred Heart. It lay decoratively exposed on His breast, a jewel ruby-red in the light of the wick floating in the chalice on the wall-bracket just below.

She turned slightly to look at the wall at which He gazed — the wall of photographs. Srini and herself as babies, their first communions, her graduation. Wedding photographs: her parents, Francis and Therese. Would hers hang there too? She felt a pleasant sense of anticipation as she thought of the future here at home. If Uncle Anthony had been alive, she felt she would have dared to be completely happy.

Smiling broadly, Nanda brought in the sandwiches and placed them on the edge of the coffee table. The Holy Family, complete with manger and animals, occupied the space usually taken up by the carved brass bowl and two brass vases. A reminder of Christmas just round the corner and meetings with friends. She tried to picture Florence Street where she'd lived for the past two years. Only a hazy impression of liver-coloured buildings with concrete driveways, an Italian delicatessen and Jenny's Kitchen — a place of takeaway barbecued chicken and roast lamb remained. She couldn't even clearly remember the interior of her unit.

That night, her old room, now unfamiliar, was not comfortable. Not the tiniest ray came in through the wooden windows, shut at night to keep out mosquitoes. She'd forgotten how thick this curdled darkness could be. Half-suffocated she turned on the bedside lamp and began thinking of Uncle Anthony. She'd lost a friend and ally. When she'd wanted to go overseas, only he had supported her. He'd spent five years as a private in the British army in Egypt in the World War. He'd wanted, she thought, some years away from the family, just as

she had. The war ended. He returned. For two years he worked as a clerk in the Municipal Council, retired early and came to live in his sister's household, a teller of stories, a dreamer. But he had remained part of the family. Their family.

Rupa turned off the light. The darkness pressed down on her again. The mattress felt lumpy, the pillows hard. She drifted into that state, half-sleep, half-wakefulness, a mixing of memory and dream. Old stories, Uncle Anthony's stories, came back.

A woman, fair as the moon, carrying a child, lurked in the long shadows of the bushes and trees by a gleaming river. The nocturnal wayfarer enticed into holding it, only for a minute or two, she said, waited in vain for the mother's return. What was this thing he held in his arms? One touch of the long, lolling tongue and the victim dropped dead. Despite the heat, she felt her skin prickle with goose-pimples

A beach. Uncle Anthony and she, their feet sinking into loose grainy sand, looking for shells. She was a child again, yet also her present self. They moved closer to the water. The waves lapped the firm shore. Across the water were distant boats, coming or going? The laughter of children playing by the huts beneath the coconut palms filled the air. From one cluster of fronds crowning a soaring trunk flew forth the New Year bird, the shining cuckoo, hovering a moment above the waves.

"That's what I've been looking for," shouted Uncle Anthony triumphantly.

"Yes, yes, that's what I want too," Rupa cried out. And she saw before her a flurry of white-sailed yachts and cargo ships, docile whales, beside the harbour's wharfs. Her ears were filled with the mewling of gulls flying over water a-dazzle with light so white, it broke

into a thousand iridescent black opals. Someone was shaking her. It's the man wanting his golden leg, the leg his brother wouldn't bury with him, she thought in terror. But it was only Srini.

"Get up, it's ten o'clock. You've been sleeping like a log."

Rupa sat up. Light streamed in from the open windows, crows chattered outside.

Uncle Anthony's body was brought from the undertaker's to 14 St Mary's Road the next evening. Almost immediately afterwards, condoling relatives and friends began to arrive. They went up to the coffin, looked at the dead man, then turned almost always to Aunt Mary. In complete black, and a more imposing figure than her sister, she took on the role of chief mourner with ease.

"What happened? How did he die?" was the inevitable question. Aunty Mary's narrative powers improved with practice. So the first plain, "Yes, child, it was heart. Sudden but peaceful," had, when it came to the tenth recital, turned into: "There was nothing wrong with him. Nothing. Went as usual for his daily walk on the beach. Came back with a hearty appetite. One thing, he had a hearty breakfast before God called him: six hoppers with fish curry, at least four bananas, two cups of tea. And then he g-got up" Aunty Mary's voice grew tremulous.

Srini came up and said something.

"What? What? The wardrobe keys? In a vase on my dressing table. I'm not criticising the servants in this household, but just give that tough nut Jose half a chance, he'll sell his grandmother. So why should I expect any consideration from that rascal? Now go, go child, and don't interrupt again."

Aunty Mary recomposed her features, reintroduced the tremor into her voice. It — it — w-was almost as if

he — he felt — heard the Call. He t-tried to s-speak but he couldn't. One minute alive, dead the next. Such is life!"

Her listeners nodded sympathetic agreement, then moved away for newcomers. Mourners came and mourners went. Finally, only close friends and relatives remained. They moved into the verandah, talked in their normal voices, talked of everyday matters.

"So, so, Rupa, you're looking very well. Must be all the apples and grapes you eat in Sydney. We, of course, have nothing here."

"What a na-aice sari! From Sydney?"

Other questions followed thick and fast. They knew Australian salaries were very high, so how much was she earning? She evaded the question. All right, then what rent had she paid for her flat? She gave a false figure, irritated by the lie. Did Australians keep kangaroos as pets? Sita Hapuge was living in Adelaide. Or was it Perth? Had they met? What? Perth was almost three thousand kilometres from Sydney! Was Australia really such a big country?

She could not feel sympathetic when they complained that the cost of living was on the up and up. She was quite unmoved when told that Prem Sirisena had committed suicide; that Reuben Jineris had gone bankrupt; that Lilani, still unmarried at thirty-five had had a nervous breakdown. All this had nothing to do with her. She began to long for the silence of her Bankstown flat. The hum and buzz of voices around dazed her. She preferred the roar of Sydney traffic. At least it could be ignored.

Emmalin, their cookwoman appeared and stood before the coffin. Anthony sir would never again eat any more of her yellow rice, pork curry or chicken pot roasts. Whom was she to cook for now? she asked look-

ing upwards. Not to be outdone, Nanda joined in with her own lament. The effect was that of a contrapuntal dirge, not entirely unmusical. Rupa listened, half-amused, half irritated. She wanted to say to everybody, "He was more than a mouth and a belly." But she did not. No-one would have understood anyway.

Late next afternoon, the funeral procession wound its way down the road to the church, half a kilometre away. Was I in Sydney only two days ago? she asked herself, as she watched the pall bearers, her father, Francis and two cousins, carrying the coffin into the church. The candles on the altar and those thick on the side-tables, votive offerings of the local fisherfolk, lit the melancholy countenance of Christ drooping on the giant cross above.

She didn't really listen to Father Ignatius's descant on life and death, a cover for being unable to talk of Uncle Anthony's good works. He had been neither procreative nor promotive, and so had failed to do his bit for God and for Society. Every one around her was now singing *"Nearer My God To Thee"*. She joined in mechanically. As they left the church, she was uncomfortably aware of the fisherfolk, Jose, Emmalin and Nanda among them for the occasion, kneeling on the floor, their hands clasped reverently above their heads. She was sure they resented the pews, where the rich sat, the English service which they didn't understand, though they knelt there so meekly, so reverently. These differences, these hidden resentments disturbed her. She remembered the easy informality of her life in Sydney with nostalgic pleasure.

The relatives and close friends of the Gomezes returned to the house from the cemetery for refreshments and talk. "I say, Rupa, found a nice young man with rosy cheeks in Sydney?" called out a friend of Francis's as she

passed by with a plate of biscuits and cheese. She turned abruptly away, and then seeing her parents talking to the proprietor of Lazarus Stores, the shop that sold everything a good Catholic could want, she went towards them with her plate. As she came closer, she heard her father say, "But, Mr Perera, Rupa is an educated girl, so a hundred thousand is more than enough, don't you think? My daughter's a fine girl."

Self-conscious, ashamed, she turned quickly away and almost bumped into a man standing by the umbrella stand, sipping a glass of passionfruit cordial. "Sorry," she mumbled, then held out her plate. She had an impression of someone tall and lanky, a mild face as embarrassed as her own, a shy smile, saw slightly protruding teeth, then a hand reaching out for a biscuit. Out of the corner of her eye, she noticed her parents and Mr Perera watching them, her parents with affectionate concern.

"Well, what do you think of him?" asked Aunty Mary, after all the visitors had left.

"Who?"

"Dominic Perera, of course. Who else?" Aunty Mary laughed. "Don't pretend you don't know. I saw you offering him biscuits and cheese — getting a closer look. I was surprised, I must say. But then, that's what Australia's done to you."

"I'm not going to marry Dominic Perera. I can never love him."

"Enough of this kind of talk. You have a duty to God and the Family. In my time, we either married or entered a convent."

"We do things differently now." She spoke calmly without feeling calm. She felt upset. She longed to please the family, but didn't see how she could. She

wasn't like Srini, who sooner or later would marry the man her parents chose for her.

That night she couldn't sleep. She lay in the dark, at first depressed, then terrified. What would become of her? The future that presented itself was bleak. The mornings: unravelling the intricacies of nouns and verbs, the present continuous and the perfect, declaratives and interrogatives to bored convent schoolgirls. The evenings: the occasional wedding, the funerals, but mostly reading the newspaper from cover to cover, even the births, deaths and matrimonial columns, as she'd been told Lilani, still unmarried at thirty-five, had till she went mad.

She felt a sharp longing for Sydney. A longing for its roads and freeways with traffic zooming morning, noon and night; for glimpses of the Harbour, that wrinkled expanse of slate-grey water, glinting and gleaming as you flashed past by train or car; for the Opera House, its thin white shells slicing through blue air, for the surf-riding, sun-tippling bathers at Bondi, Bronte, Cronulla . . . for the wine-bars and restaurants and the bold, impudent pigeons in Martin Place . . . All these spoke to her of progress, of modern civilisation and its freedoms.

The Christmas festivities, quieter than usual because of Uncle Anthony's death, were over. New Year came and went. Early in January, her parents wanted her to accompany them to Colombo to choose a chain from the new collection Macan Markars were advertising. A home-coming present they said.

"But why?" she protested. "Why spend so much when I don't need jewellery?"

"Well — you — you might think of settling down. We'd like to see you settled before too long," said her mother with an affectionate smile.

"No, no," she pleaded fearfully, "I don't want a chain."

Her parents looked at each other. "We were thinking of Dominic Perera for you," said her father. "He's just returned from England with a doctorate in banking and commerce. He works in the research unit of the Central Bank." They looked at her anxious, expectant.

"I'll think about it," she said in desperation. "I need time. I haven't finished my contract with the New South Wales Education Department. I've got to return for a few months and then — then I'll come back and marry Dominic Perera."

Her parents looked at her, their faces sad, mournful. After a minute or two her father said gently, "We'd like to give you the chain all the same. You have — maybe you have — have you met anyone there — in Sydney?"

"Oh no, no," said Rupa and burst into tears. "I only want to finish my contract, and then — then I'll come back home." She truly believed she would.

The Handshake

Vasso Kalamaras

Translated by Maria Koundoura

Our palms touching, I wanted
to offer you the sin of my thought
thus finding our search's end.
Yet it is conditionally lost.
A husky voice, the pulse of our life
is stifled in commonplaces.
I search for you because you dominate the spirit,
a thought which gives birth to poetry
made of our flesh.
I wish my weaknesses could turn
into an endless source of joy for you,
forbidden and emphemeral as they are.
What if you are saddened?
Circumstances never change
and our hands upon meeting,
be sure, will come together,
sinlessly, in a formal,
ordinary and typically brief
hurried handshake.

ΧΕΙΡΑΨΙΑ

Βάσω Καλαμάρα

Ήθελα
ακουμπώντας τις παλάμες μας
να σούδινα την αμαρτία της σκέψης μου,
κι εκείνο που γυρεύουμε να βρούμε
κι όμως χάνεται στις συνθήκες.
Ζεστή φωνή ο παλμός της ζωής μας
στραγγαλίζεται στις συνθήκες!

Σε ζητάω, γιατί κατέχεις το πνεύμα,
μια σκέψη που γεννάει ποίηση
φτιαγμένη απ' τη σάρκα μας.
Οι αδυναμίες μου
να γίνουνε πηγή αστείρευτη στην ευτυχία σου,
γιατί θάτανε το απηγορευμένο
και το περαστικό.

Κι όμως
τι κι αν λυπηθείς;
Οι συνθήκε ποτές δεν αλλάζουνε
και τα χέρια μας σαν βρεθούν
νάσαι βέβαιος
θ' ανταμώσουνε χωρίς αμαρτία
σε μια τυπική
συνηθισμένη όπως πάντοτε
βιαστική χειραψία.

(Concrete poem no. 1)

thalia

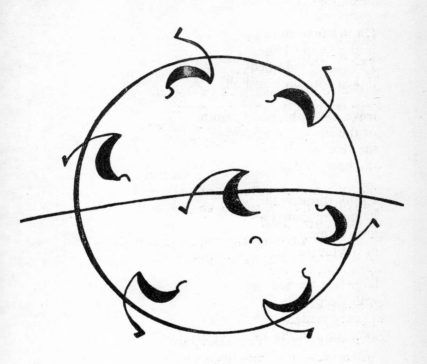

ᨒ : *I love you (in shorthand)*

⁀ : *Mother (in shorthand)*

On My First Morning

Lily Brett

On my first morning
in the Grand Hotel
I leave the twin beds
linked with an iron bolt

leave the cushioned warmth
of the smooth eiderdown
the feather bolster
the linen bedding

I walk through the huge
bathroom and you
look at me
in the mirror

large lids creased
with sleep
a crazy mangle of hair
jutting up in the air

the same thin lips
the same high cheeks
the same forlorn
early-morning expression

and I have travelled
with my fear
and my suspicion
and my anger

and I am here
on the other side
of that dark moon
with you

mother.

Foreigner

June Factor

The soft bone will not harden,
the flesh transcend
the solitary thrust.
He fights the dark mole's
bitter blindness,
the unassimilated, alien crust.

In that long night
only the lurching breath
betrays the heart's mistrust.

Diary?

Ursel FitzGerald

The past belonged to another world, a world sealed off by barbed wire and a sign: BETRETEN VERBOTEN. That, anyhow, was the feeling I had whenever I asked questions about my father and my two sisters.

Had they been blond like my mother, or dark like me? Had my father been kind, like Dr Weber, for whom my mother once worked as a nurse, or as strict and impatient as my teacher, Herr Raabe?

Yes, my father had been kind, missing, declared dead, and yes, my sisters had been blond like my mother . . . Always the same clipped answers and the same impenetrable expression on her face until, ever so faintly at first, I began to suspect something dark and hidden, something so mysterious or painful perhaps that it might always remain beyond access for me now that we lived in Australia.

"She doesn't look German at all," people would say after we arrived, and I'd watch her face and think of that sign and wish I were blond like my sisters.

"I am from the Black Forest," I volunteered one day with no longer a trace of an accent, thinking that this might explain my darker appearance, though we had lived near the North Sea as far back as I can remember . . . but then, of course, I recalled that very instant that my mother was from the Black Forest as well.

That was in the late fifties when I was nearly thirteen.

"Why did we come here?" I asked her at Christmas, thinking of open fires and the flicker of candles in darkened rooms, and longing for a snow-lit winter

world instead of its blazing reverse. I can't exactly remember her answer.

In the evening, as she lit the candles on the Christmas tree and its fragrance began to play upon our memories, I saw tears in her eyes as she swallowed hard, knowing her sadness was bound up with a time in which I had no part at all.

I lay away that night, staring into the dark until, as if by design, visions came breaking through — or dreams perhaps — of wooded slopes, valleys dark and thick with pine, of cities and towns of medieval times and one town in particular where the fragrance lingered most persistently and a silence reigned, ominous and supreme.

"Why wasn't I born in your hometown," I asked my mother on Christmas Day, "and why did you never take me there?"

Again she looked as if to say BETRETEN VERBOTEN, but I met her gaze and held my ground and she answered slowly, cautiously, I thought, that she had to go wherever she knew she could provide for us both which eventually led to a hospital in a town further south where she was promised work, and shelter even, after my birth.

It made sense and I left it at that. After all, she had lost my sisters there as well as her entire belongings and, as she told me once when I was younger, even my grandmother had died soon after the French, and with them, the Moroccans and Tunisians, left town. So there was no point in re-visiting her grief-ridden past.

We always stripped our Christmas tree in the first week of the new year. With its needles shed and its glitter and tinsel no more, its riblike aspect became a subtle reminder of the transience of life.

As we learned about war crimes and the Nuremberg

trials at school, visions of skeletons and bones suddenly began to haunt my dreams, pulling me down . . . down . . . down, into a void, where I died a thousand deaths.

* * * * *

It was cold and they were naked, thousands of women and children, and also a few old men, some of them holding toddlers in their arms. Everyone stood at the edge of an enormous pit that was full of corpses already. Sulphurous fumes mingled with the stench of death and it became an effort merely to breathe. I saw Kora and Maria next to my mother, with my grandmother a few steps to the right.

"Where are our husbands, the fathers of our children?" my mother asked.

"Don't you remember, they are fighting another war," my grandmother whispered.

I knew of course that my sisters had died in a bombing raid — a direct hit — and there were times when I'd lie awake and imagine what it must have been like for them, for my mother and grandmother, and other people in the town.

* * * * *

It was December 26, Boxing Day, and I saw my mother and grandmother start their steep climb up to the cemetery to visit my grandfather's grave. Suddenly a tremendous roar pierced the air and several enemy bombers shot past. The two had barely managed to scramble for cover near the cemetery wall when the screaming of sirens reached them from down below, followed almost immediately by a series of explosions which left a deadly silence in their wake.

"The girls," my mother cried, "the girls!"

Kora and Maria had remained home that afternoon, perhaps to play with the toys they had been given for Christmas.

It was an endless descent and the air was thick with dust and smoke as they reached the outskirts of town.

"Meiers and Schroeders und Schuhmachers und Hoffmanns . . . just razed to the ground," said an old woman who kept on shaking her head, " . . . just razed to the ground."

"Hilda Meier?" my mother whispered in disbelief . . . She had been her bridesmaid once.

" . . . and what about her two sons?"

"They found them too," the woman said, "dead, all dead . . ."

I felt cold again, so cold, as I saw my mother and grandmother approach the enormous heap beneath which my sisters were buried.

*　　*　　*　　*　　*

We lived near a railway line. My mother used to work long hours at a hospital in a suburb of Melbourne and I was alone for much of the time. At one stage, when she was on regular night duty, I went through a series of events which just came to me, as if of their own accord. It started with a vision I had of a man with steel grey eyes, who owned a violin and knew how to play a steel guitar and who, supposedly, was my father.

"I told you to look after the girls," he shouted, "how could you leave them behind!"

My mother said nothing; all she did was cry . . . cry . . . cry, even as she waved her white handkerchief and the train, ghostlike, took him into the mist. There was no end to her tears.

*　　*　　*　　*　　*

And all the while, it seemed, I didn't exist at all, which meant that no-one noticed when I went to the sideboard in the living room and opened the middle drawer, just below the silver and the table linen. There it was, wrapped in white tissue paper, directly beneath the Bible, a notebook — no, diary — all scorched around the edges. A sad remnant of an even sadder past, I thought, and marvelled at its likeness to a recent project for which I used matches to create a similar effect. What was I to do with something so personal and private? I was in a quandary. Then, in front of my very eyes, it grew larger and heavier, and soon made the Bible appear hideously small in comparison. Though some pages were missing and others charred beyond recognition, I realised that it had become transparent to me. Every word had imprinted itself upon my mind, perhaps for all time, and suddenly the silence around me was filled with the whispering of the pines that overshadowed the small town in the eastern part of the Black Forest, with which my past was, after all, quite intimately connected. As in a giant jigsaw puzzle, where I used to work from the outside in, so here too I had finally pieced together the frame, but in place of the sign BETRETEN VERBOTEN had found an invisible gap now through which to enter.

* * * * *

It was obvious that she had known about the Einsatz commandos and the mass executions in the Ukraine where Karl was stationed for a time, and where no amount of barbed wire could prevent the sounds from echoing across, as if from slaughter yards, nor the stench that followed and crept into the barracks and huts at night.

"Don't tell anyone," he whispered one drizzly

November afternoon at the station, "think of the girls."

But she may have envisaged already that they'd never see him again.

> The pines stood tall and silent as his train melted into the distance, and with each passing year the silence has grown more ominous and oppressive. How long before those demonic powers will turn back on us and the fury of the gods be unleashed upon the guilty and the innocent alike?

It seemed strangely fitting that there should be blank pages as well as those that were missing or charred beyond recognition. As in the quiet of a deserted church which occasionally forms gateways to other invisible reaches, so her silences prompted my entries into a hidden reservoir, dark and ancestral, and slumbering beneath the surface of things.

I knew she'd become a Red Cross volunteer, sooner or later. It was in her nature not to give in.

Apparently the bombers returned with insistence and, as their thunder mingled with the screaming of sirens and the valley shuddered under the alien might, there awoke in some women, my mother included, a mute strength, a numb determination not to succumb to the forces of unrestraint that engulfed and threatened to obliterate them. The day the bombs rained down upon the queues of women and children in the market square was the day everything humane and of value went underground.

> What destructiveness there is in this savage male energy, and what untold pain and suffering it engenders! I am numbed with the cruelty of it all! First the Marktplatz, empty and deserted now, except for the old shopping bag I went to collect, and a child's tiny shoe — but, oh my God, it seemed to be oozing with blood — and then Dr Weise's clinic, below ground and air-raid proof, a subterranean abode that pulsated with the spasms and moans of the wounded and was thick with the stench of seared flesh.

My mother would have been a tireless worker. I had

visions of her wading through rivers of blood, trying to retrieve shattered limbs that were floating about, or heads, flattened and caught in the weirdest expressions, all ossified, gaping, and threatening to pull her under.

"Why would they have bothered to bomb your hometown?" I asked her eventually.

"It happened to be on their flight path," she explained, "but it was an important railway link as well."

"Aha," I thought, and could almost hear them sweeping round and round in constantly-expanding circles.

"They are looking for the Bahnhof," the women whispered down in their cellars-cum-air-raid shelters, knowing the station was well covered by the Waldhang and therefore hidden from view.

"They'll never find it," they thought triumphantly.

Finally, however, the railway bridge was destroyed instead and the bombers dispersed for good.

Their legacy . . . a dismal pattern of pits and rubble heaps upon the valley and the blackened slopes, and weeping sores that will not heal upon the landscape of our minds.

But soon a strange new sense of foreboding crept in with the silence that followed and lay heavy as a pall over the town. Even the children, by now as wary as the old men, would not leave that shadow world of the cellars where, although customary potato heaps and other provisions were quickly diminishing, they may have glimpsed something of a chthonian link with the roots of life, womblike, secure, and not of the present. And on the whole, the women too remained drawn to this subterranean realm — shadowland between life and death — unwinding and savouring their retreat from the scarred surface above.

Eventually only my mother, moving between secret storage depots, still attending the bombed-out and wounded, watched them roll in one night, tank after

tank, and stop at the market square, directly in front of the Rathaus.

Ours was a beleaguered town as it awoke to a barrage of machine-gun fire and mortar shells, aimed at the town hall where the French had established their quarters that night. What a fiasco, what utter irony, being surrounded and fired upon by our own soldiers who, falling short of their intended target, ended up destroying the church!

Moroccans, a penal unit from North Africa! . . . What followed were days of drunken orgies, rape and looting, interspersed with the shelling from surrounding hills. Mothers and daughters, even small children, were violated and the old men, tied up, were made to look on. Women began to dress as men, girls shaved their heads, everyone withdrew to the darkest corners of their cellars, and still they tracked them down with predatory cunning and intent.

My mother sheltered some of the victims in my grandmother's cellar, hoping the Red Cross flag outside would protect them from further attacks. She even borrowed a handcart in which she'd wheel the more severely injured to Dr Weise's clinic for further treatment. There was the young girl, for example, who had broken her leg when jumping out of a window in an attempt to escape her attackers.

"Our own men from without and these savages from within," Dr Weise sighed when they arrived, "how much more must we endure!"

I heard a knock at the door and opened.

"Du Mutter mitkommen, my men sick, you help!" (But this dark soldier held no whip in his hand.)

"Oh God, this can't be true," I thought at the townhall, following him down into the Ratskeller below. The hell, the darkness, that sulphurous pit filled with bodies, their stench, the remains of looted rabbits and chickens, the stare of glassy eyes!

"Malaria," he said, and I, knowing there was no more quinine available, gave them Baldrian and Hoffmannstropfen instead.

"This should reduce their fever," I explained.

"Danke, Mutter, Du und ich go back now."

How clean and sweet the air as we stepped out into the open again! From then on, he became almost a regular caller, always asking for dressings or Baldrian and Hoffmannstropfen of which I still had plenty in stock.

On the sixth day, a French officer came in for an inspection. My mother had hidden Karl's violin in one of the large cupboards, behind the medicine and the bandages. The man hardly spoke a word but when he left, he took the violin with him. It was then that she broke down and cried . . . cried . . . cried; she had never cried so much before. Suddenly the Moroccan stood by her side.

"Warum Du weinen," he asked and she told him about the officer and the violin. That evening he returned with Karl's violin and his skin glowed, golden and caramel, when he saw her cry once again.

Oh you dusky soldier!

He grinned helplessly but then became serious as he heard the crying of a small child through the cellar door below, which my mother had forgotten to close. Children cried a lot now, and the town had long run out of milk. The next morning he brought a large crate filled with tins of milk.

". . . fuer die Kinder," he said in his humble way.

The war had all but ended when the Tunisians replaced the Moroccans and flooded the town with colour and life as they rode in on their donkeys. By then my mother knew she was with child and prepared to leave quietly, under cover of darkness.

And I, I went through a stage when I thought I might not follow her to the inland missions — whenever that would be — but go to Morocco where, like the Queen of Tunis, I'd dwell ten leagues beyond man's life. Ultimately it was perhaps all just a matter of biding my time.

Years later, shortly after my mother's death, I came across the notebook — diary? — again. There it was, still wrapped in tissue paper, somewhere beneath the Bible, and as I opened it I remembered that those blank pages had since been filled in by me.

Mother

Angelika Fremd

In your absence,
vines cradled the house,
bore fruit, withered,
shut out the light,
made inroads
strangling the chimney.

When you were home,
dry twigs struck green.
You left in rustling silk,
returned with butter,
spinning gold from hay.

You were allowed,
past the fence,
out the gate,
into the wood,
down the road,

to war.

Mutter

Angelika Fremd

In deiner Abwesenheit,
liebkosten Geränke
das einsame Haus.

Die wuchernden Weinstauden
warteten noch länger,
bis ihre saftigen Perlen
das Fensterlicht erloschen
und den Schornstein erwürgten.

Deine Heimkehr feiernd
keimten verdörrte Zweige.
Du gingst von uns
in Seide gekleidet,
kammst zurück
beladen mit Butter;
du hast aus Heu
uns Gold gesponnen.

Dir war es erlaubt,
den Weg, jenseits des Zaunes,
durch das Gartentor,
rund um den Wald,
die Landstrasse entlang,
in den Krieg

zu gehen.

dad

Ania Walwicz

was in siberia so cold when you blew my nose froze away drop like stones only grows four months eating garlic clover whole lot vitamins rats the most intelligent they don't need it really remember in tasmania there nob dy to speak didin't needs either only driving coutry drove into a dutch couldn't see out one eye shoul'dnt go to any cinema gets nervous what did you eat did you brush your teeth beer helps acid to my digets digetst digests only one you said don't want a father drunkard it was night near a dutch very muddy heavy trucks came and nearly drove over something saved me threwme away he said thought you'r a gonner then nearly killed can't see film gets too much i'm in it look they shot his skull right off they are chasing running to get my had a russian gun in the russian army they get st uck german ones always fired gave me a drink strong young wine in a cy cup they had to take drink it all down and after on my horse was rising to the stars like mohammed rising levitate head hurts where is street what did they say couldn't catch you tell me now my mother ghost it comes mill owner of a mill said your mother came to me last night in my film they chase had officers making sure nobody runs away had to kill no way out do you think i know i don't know then forgot polish speaking only russian army caught shaved my armpits all hair off body every bit poured disinfectatnt for lice this man came to a dance and he said did you hear that they are shooting she said what camarade to had to get up at four thirty meat keeping my place safe had lights on left you don't know who breaks in they're all bandits just tell him know why your

wife left you tell him they were spies read about that did you must watch the news why didn't you ring was waiting all the soldiers slept at an orphanage at night had nowhere else to go they said minus twenty degrees getting warmer no don't eat much and the tall soldiers slept there were no beds they slept in baby cots their lrgs sticking out lots of bugs on the same horse all war long that was a bay one they don't tell you what hurts can't i put her there and stayed all year with always fighting for her was she was like when met wanted to get married this man very old completely damaged is the beach kind to strangers went to shop and go to librarry didin't want to talk to anybody all strangers only read the papers do you go it's cold don't heat too cold to washing let me help carry on in siberia taiga such stars very bright stars they didn't want people to travel so they didin't give tickets they said all booked out and we waited they waited on the station sometimes one week and lots of seats in russia they shot them after the war if they came very back they were afraid of anybody in leningrad if they looked healthy because they eat people's meat the like killed them to keep alive it was a very good horse and followed me when i fell one night slept in a barn no hat and the head cold stay was in uniform gave me so i sett-led there wasn't any way out do you think i'm keeping used the machine cleaned i brought they bring me they had a stretcher out shot off his leg man without a chest though you couldn't see looked normal really and the chest cavity when they took off the blankets there was only bunker in mud that's where sleep i was dozing and if she still there in did shopping soldiers wer climbing and if they dropped nobody to pick up they were runn-ing very brave bog people i've read drag from peat how do you say just dry bread but enough what soldiers eat hard biscuit you soak this well didin't tins survived

The Mask

Yota Krili-Kevans

You are wearing the lion mask now
roaring his charms;
his intellectual superiority
the lustre of his white skin
the treasures of his plunders.

And yet you were a poor boy
with freedom on your bare feet.
You crossed the unknown
with giant steps
and reached the antipodes
when just a cub.
Enduring apathy in your adopted land
you gobbled the distance at night
to find the company of a friend
to speak the mother tongue.
Sneers and pretended smiles
of the anadam-papadam
you swallowed
and slowly year by year
sweat became silver.
Blacksmith, the time
forged your uniform of defence
its golden colour
charmed even the hornets.

Now your shaking hands
administer the savings,
bless your mother tongue
give relief to poverty.
Yet the wounded dreams
forgotten in the fallow of your soul
are not redeemed
and wake in the nights
whispering their heartaches:
the loss of your first love
your parched throat for knowledge
your beloved daughter
who rejected you.

With your face wrinkled by suffering
with one foot in the grave
you brag the deeds of the lion.
And if some one asks
about those early unhappy years
your bright eyes cloud
and you repel the memory.

Now your suffering heart
remains dumb.

Only the mask chatters openly.

Η ΜΑΣΚΑ

Γιώτα Κριλή-Κέβανς

Φλεβάρης '79

Φοράς τώρα τη μάσκα του λιονταριού
και βρουχιέσαι τις χάρες του·
τη διανοητική του υπεροχή,
το λούστρο του λευκού πετσιού,
τους θησαυρούς των λαφύρων.

Κι όμως εσύ ήσουν κάποτε
ένα φτωχό παιδί
κι είχες λευτεριά
στα ξυπόλυτα πόδια σου.
Με θεώρατα βήματα δρασκέλισες το άγνωστο
κι έφτασες στους αντίποδες,
όταν ήσουν αμούστακος ακόμη.
Στης ξενιτιάς την απονιά
έτρωγες την απόσταση μες στη νύχτα
να βρεις τη συντροφιά του φίλου
και να γευτείς τη μητρική λαλιά.
Τα χλευάσματα των αναντάμ-παπαντάμ
κατάπινες με προσποιητά χαμόγελα
και σιγά σιγά με τον καιρό
ο ιδρωτας έγινε χαλκός.
Ο γύφτος χρόνος,
σου σφυρηλάτησε τη φορεσιά της άμυνας
και το ασημένιο χρώμα της
μάγεψε ακόμη και τους σβούρκους.

Τώρα με χέρι τρεμάμενο
λύνεις το κομπόδεμα,
βλογάς τη μητρική σου γλώσσα
και δροσίζεις εδώ και κει τη φτώχεια.
Μα τα λαβωμένα όνειρα
ξεχασμένα στα ξεροτόπια της ψυχής σου
δε λυτρώνονται
και γροικούν στον ύπνο,
σιγοψιθυρίζοντας τον καημό τους·
τη χαμένη αγάπη
μιας παιδικής σου φίλης,
την αποσκιά της γνώσης,
την άρνηση της λατρεφτής σου κόρης.

Με σαφρακιασμένο τον πόνο στο πρόσωπο,
με το 'να πόδι στον τάφο,
καυχέσαι τους άθλους του λιονταριού.
Κι όταν κανείς από περιέργεια σε ρωτά
για κείνα τα δίσεκτα χρόνια τα παλιά,
τα φωτεινά σου μάτια σκοτεινιάζουν
κι απωθείς τη θύμιση.

Τώρα πια, μένει βουβή,
η πονεμένη σου καρδιά.

Η μάσκα μόνο, μιλάει στ' ανοιχτά.

166

Grandfathers and Little Girls

Miriam Kuna

I suppose my first memory of *those things* was that of snotty-nosed yellow-haired Janet Dawson lying flat on her back in front of the primary school in Pigdon Street, North Carlton. She lay with her legs up in the air and pants around her ankles rather like a sprayed cockroach. She couldn't have been more than five or six years old, a skinny little thing with a big head, sharp features and a lot of curly white-ribboned blonde hair. Somehow, the gauntness of her facial bone structure has always stayed in my mind, and those feet, waving about through the elastic of her grey bloomers. It was the depression year of 1931, and the boys walked past and stared timidly at her little pink fanny. A bit like Lenin's tomb.

Then, outside the synagogue, when we were about eight, there was a little peeping behind buttons and stretching of elastic, and when I was twelve, my friend Shanie and I were lying on the floor about to *show each other* when we heard my father's footsteps in the passageway. To this day, I have never seen Shanie's you know what, and he, although I'm sure that he'd still like to, has never seen mine.

My grandfather made me feel his balls when I was about seven. This was in his house in North Carlton. It was a single-fronted semi-detached drab place that I hated because it was plain and ugly.

My grandmother used to keep chickens in the tiny back yard; she killed them by wringing their necks after an undignified chase through the shed and behind the gully trap. She seemed to have no compunction in pro-

viding free lodging for these creatures, and then destroyed them in such an untoward manner, without prior consultation with the squawking victims themselves. They were cleaned there and then, and the chicken soup and "lokschen" she made was the basis for many a memorable Sabbath dinner. I remember crawling under the table, tickling my aunties' legs, while my grandfather wrestled with the "lokschen" in his beard and the plates of boring beige chicken were handed around, after the soup, for aunts and uncles and cousins to devour.

My grandmother was, however, better at cooking than she was at washing up; she never used hot water — the greasy pots were rinsed under running cold water, with a minimum of soap. The kitchen window was rarely opened, so the rank odour of grease and fat and unwashed stains on walls and stove and oil cloth covering the kitchen table took on a three-dimensional quality.

The next room was used as a storeroom for corks, as this was my grandfather's trade. He actually had a number of cork pictures decorating the walls of the house; flat bas-relief carvings of trees and forests and imposing urban buildings. There was a tussle for these pictures after my grandparents died — I came off rather badly with two of the smaller ones, and someone said that some other artist had done these anyway. My family pride was hurt at that.

We never went into the cork room because the blind was always drawn, and it was dark and musty and forbidden, although it actually smelt quite pleasant.

At the end of the corridor, the dining room spread majestically across the full width of the house, I suppose about fourteen feet, though I have never been back to measure it. The big dining table took pride of place. There was a bulky sideboard along one wall, and on it

stood a shiny brown wooden clock with prominent brass handles. I remembered this clock because it had a very jolly and determined tick and a most sonorous chime.

Along the northern windowless wall was a sofa, and this was where my grandfather used to make me lie down, so that he could fondle my pubes. I suppose the penis was there, but I don't remember it at all — I only recall the floppy rolling hairiness of those grand-paternal testicles forcing themselves into the palm of my bewildered prepubescent hand.

I remember he used to spit on his fingers before he applied them to my vaginal area. I resented being in-directly spat on, especially in a part of my body which I felt really belonged to me, and not my grandfather. Although I felt no active resentment, being trained to respect the judgment of my familial elders, I was aware that my wishes had not been considered, and that my compliance in this sordid game was being taken rather for granted.

The other thing I didn't like was the look of concen-tration that came over my grandfather's face; I felt affronted by his lack of interest in me as a person. He seemed so remote, so desperate. I suppose, looking back, he was worried about my grandmother's return; perhaps he was frustrated because in spite of everything he still failed to get an erection.

Anyway — I didn't like it much.

To make matters worse, my grandfather always relieved himself in the bathroom basin because he couldn't be bothered going outside to the lavatory, and it didn't occur to him to run the tap afterwards.

So, as the bathroom led off the kitchen, there were more olfactory horrors — the sour smell of greasy unwashed surfaces and clogged drains, in combination with the revolting odour of rancid urine.

It never occurred to me to associate my grandfather, or anyone I actually *knew*, with the Bad Men I had been brought up to fear. Bad Men were associated only with the anonymity of public places.

I used to run petrified through the park on my way home from school, convinced with nightmare panic that behind every tree there lurked a Bad Man whose sole mission in life was to terrify and attack me in as vile a manner as possible. It was never explained to me exactly why it was that these Bad Men had it in for me in such single-minded fashion. I only knew that they were fanatically devoted to ambushing me, and had, by definition, to be strangers.

It followed then that men whom I knew could not be ranked as Bad. It certainly never occurred to me to question the right of my elders to direct my behaviour, even though I may not always have actually liked it. In some ways I suppose, I felt a certain distinction in having been selected for these secretive activities; I still don't know how many others, unbeknown to me, shared my fate, and am not disposed to ask, even today.

My father didn't help much, either. I loved him and he loved me. We sort of understood each other, drawn together as quiet allies in the face of my mother's determined control of household affairs. He used to take me for rides on the handlebars of his bicycle.

I used to fondle my navel in bed — my father called this "pooking". He punished me one night by taking me into the breakfast room (our family dining room), laying me flat on my back in front of all the visitors, pulling my pyjama top up and my pants down, and with dramatic implacability covering my navel with a large piece of sticking plaster.

I felt as though I was undergoing surgery without anaesthetic. All those pairs of eyes around the table,

naked on my nakedness, all condemning me without trial. I was Dreyfus stripped of his rank, Godiva shorn of her hair. The lights were so bright (my mother liked maximum wattage) and there I was, naked to the world, well, near enough, betrayed by my own father whom I loved and who loved me.

Mr Kepler was the last man to take advantage of me in my early childhood. Under the pretext of studying Yiddish with me (I was learning Yiddish myself at Jewish school), he lured me into his room in Mrs Warr's boarding house. This was a great gloomy Victorian structure, full of large dark rooms with high ceilings and inadequate windows. Mrs Warr had a spare room empty, save for *Women's Weeklies*, which she had collected for years. There were hundreds of them, all jammed full of Mandrake and Narda, and Petrov's wonderful fashion drawings, and Weg's cartoons of bosomy women sipping their afternoon tea. Every issue featured those marvellous short stories that always ended so happily, with the romantic hero swearing undying loyalty and devotion to his ever-willing and always blushing female counterpart. There was always a picture of them kissing each other, or embracing in some suitably sexual way. I remember that the man always paled beneath his tan, and had a quizzical grin and a boyish laugh. She, on the other hand, was invariably caught off-guard, cleaning the windows or the stove, or perhaps doing the washing, just when she wanted to appear most glamorous in her corset and seamed stockings and her hair not in curlers.

Anyway, Mr Kepler got me on the chair next to him, and asked me to teach him Yiddish. This consisted of my writing down a few letters of the alphabet, while his hand invited itself into my crotch and started moving about my genital region. I had no reaction whatever to this, as I quite liked Mr Kepler, but I remember feeling

171

surprised that a grown-up man should want to do such out-of-the-ordinary things in such secretive circumstances.

I finally lost my virginity at the age of nineteen. I lost it in my mother's study with the man who became my husband a month later. Although I had imposed strict limits for all my other boyfriends — no activity below the waist, theirs or mine — I asked the man whom I was about to marry, to deflower me, as I felt this was a sensible course of action to take for a prospective married woman.

I knew very little about male genitals, even less about intercourse and conception, and absolutely nothing about contraception. At MacRobertson High, the nearest we came to sex education was a half-hearted study of amoebas and hydras. Those were the days when female teachers had to resign when they got married, so that we innocent students would avoid the taint of contact with non-virginal staff.

My mother, who laid claim to being an emancipated woman, and was president of a Jewish society with a membership of both sexes, consistently ignored my questions about the facts of life.

When I called out in shock at the sight of my first menstrual blood in the toilet bowl, a development for which I had been totally unprepared, my mother appeared with a resigned expression, bearing a homemade sanitary napkin. "That's how women have babies," she said, looking glum.

So, seven years later, at ten o'clock on a Sunday evening, after a great deal of pushing and shoving, bending forwards over the arm of the big chair upholstered in English leather and floral Italian brocade, my would-be lord-and-master finally lurched his way into me from behind. The blood gushed down my legs in great spurts

so that I had to race into the guests' powder room like a fugitive from the Russian front. (This was just after the war.) I turned to face my future husband, at whose penis I had not yet had a good look, and for whom I had no sexual feeling whatever, only admiration because he drove a Ford V8 and looked handsome when he flicked his cigarette ash out of the car window. "Good," I said, wiping up another three globules of blood that were threatening to spoil mum's carpet. "Good, I'm glad that's done," and got dressed.

For Leo

Nora Krouk

1 Shanghai — Hong Kong

Grey-eyed and stammering
three-year-old
asking one morning
"Is he my real Daddy?"

And clinging, once,
through the intimacy
of red-hot measles,
through growing up with
unanswered questions.

Should we confront him
with all his lies?
Suggestions advice:
take him to bed,
above all, love him.

At twelve, we gave him
a Spanish guitar
then grudged its
possessive powers:

a sensuous interplay
of the polished wood,
nylon strings, strong
competent fingers.
The blond hands.

2 Tel Aviv

He did not want to see us
that year. Reaching again
for a new life, swayed
on the fringes of a striped
tallis, murmuring
in the first light
 Sh'ma Yisroel
 adonoy elohenu
 adonoy echod
Her swelling belly. The cord.
A knot, tying his fleeting
love to cold boredom.

3 Eilat

Now the setting is golden and blue
Eilat blocked from my view by the walls
of his friend's sandstone, filled,
as ever, with music and smoky talk,
each to each, Chan to Leo, a stay,
a rock, listening to the rich stories
even into the small hours, listening,
never once saying:
"Hey, hold it there, Haver!"*
Fingers pluck at the strings
echoes fill his world:
Cloudburst** honoured, once,

*Haver (Hebrew): friend
**Cloudburst: name of an army group in which
Leo's voice and guitar backing were an integral part

by a silver disk.
The applause the lights
the perceptions blur
and his skin is clammy
Spilling ashtrays, beer cans, on
occasion, Scotch. Never drunk,
big and sweaty and pale he talks,
but the things he says are live
coals burning holes in reality.
Smoke is acrid. He is hurting,
red-lidded and heavy eyed and his
throat is clogged with hard
stories and his chest feels tight.

4

Cloudburst — what better name
in a land of flowering deserts
and salvaged souls? His
sheltered behind a waiving
hand with stained fingers.

They wrote:
 "dear Leo, I can still hear
your voice. I love your songs!"
 "Leo, Eilat Is your songs
in a cloud of smoke . . ."
 "Leo, I will never forget
your music. Why does it hurt so? Please,
please, look after yourself. Don't drink so much!"

Family History

Antigone Kefala

Satin in Mother's room,
mirrors, alabaster boxes,
Black Sea shells, water singing.
I went around the bed chanting:
Do you hear the sea inside me?
Stopped at the new cot
oyster head, crayfish tail,
as in the zoology books,
I picked it up and swallowed it,
horrified,
yet the thing had no taste.

When I found myself I was weeping,
beating the ground with my fists,
the wet nurses were there,
all in grey, and his face
with the dark handsome eyes
slipped away from my reach.

Evelyn's Eighty-ninth Waltz with Summer

Barbi Wels

This will be Evelyn's eighty-ninth summer. In the clutch of her vacuum cleaner, she waltzes across the floor of her apartment. Time, ever the wallflower, perches on the end of the sofa and fidgets with the engraved clasp of Evelyn's tapestry purse. Time has a beerbelly which he attempts to conceal with well-cut business suits and strategically-placed ties. His profession is best described not as land agent, for he presides over the domain of all land agents, but as space agent. He divides, deals and retracts the space in which each person exists, according to whim and the demands of anxious seeds and embryos. It is rumoured that he owns the world, and indeed, if you look you will see his trademark bound on the wrists of most people. Time fidgets and Evelyn waltzes, recalling gloves that grazed elbows and taffeta gowns with matching dyed pumps. She suddenly senses the wrinkles spreading across her face like spider webs, unfurled under the eye of a time-lapse camera. Time smiles, rubbing his hands with plans for the space Evelyn carries as she waltzes and she's smiling too, her head tossed back in yester-glamour. But do not leap to conclusions about senile morbidity here. Evelyn's not disturbed or even seduced by her observer, she is just weary of Evelyn Oldham and ready for something else.

Lately, Evelyn has been feeling a little frail, but not being one to seek definition of herself in mirrors, the frailness first came to her through the touch of others. At first she thought it was an outbreak of politeness —

people offering her seats on the tram, strangers appearing at her side when she crosses Jetty Road, and several times now, the tram has even paused between stops to let her cross. The politeness theory has waned as Evelyn notices new things, like people bending down to talk to her, and worse, bending over her to yell in slow monosyllables. Her name has evolved to "Mrs Oldham dear", and is rapidly contracting itself to a simpler but anonyfying "dear". Just the other day, some probably quite well-meaning lass from meals-on-wheels rang up saying she'd got her name from young Doctor Good. Obviously she couldn't have been a local lass or she'd have known about the dinner parties Flat Three, The Mansions, is famous for. Well, *was* famous for, until Time acting as landlord went on a rent-collecting binge, and most of the more regular guests (and one of the hosts) were buried in quick succession.

Flat Three, The Mansions, is neat, quiet, standing brave in the front line of suburbia marching into the sea. For a long time, the flat seemed too big for one. It has not changed much since two first inhabited it. Ah, the newly-wed Mr and Mrs Oldham, the tall shy mister carrying the tiny laughing fresh missus up the stairs and across the threshold. That was in nineteen-twenty when the apartment block had just been built, just after the Great War, and they were very stylish. The new Mrs Oldham was very stylish also, and she had a more than respectable inheritance. Bert Oldham adored her. He used to say that her letters had kept him alive in the trenches. Evelyn would laugh when he said this, but it was the sort of laugh that made people suspect that she wrote poetry.

Just recently, when Evelyn realised it was not that she had forgotten how to dream but she had lost the ability to sleep, she went to see Doctor Good who gave her a

pat on the arm and some Mogadon. She spent four nights staring at the pills and resenting the power they had and she didn't. On the fifth night, she was looking out of her window and across Colley reserve to the amusement park, where the ferris wheel turned in its sleep with the wind, and she was thinking. The lounge was filled with clock ticks and echoes of the town hall clock's ode to midnight. The streets were empty. The streetlights burned like stars with indigestion and Evelyn realised that what she had was something extra — another life while other people slept. Suddenly she was powerful and from then on she read at night, all night, while Beatrice the ginger cat dozed.

Each day at noon, Evelyn crosses Colley Terrace to visit the rotunda where she feeds the gulls and the more daring sparrows chunks of bread. The shadows of a wiry old lady with flailing arms, hurled pieces of bread and swooping birds make dark kaleidoscopic patterns on the sunnily green grass. Evelyn enjoys this ritual; she is satisfied by the justice her feeding of both Beatrice the cat and the seagulls constitutes. Beatrice knows to mew with jealousy as her keeper leaves each day armed with loaves of bread. The birds know where to gather when the Town Hall clock chimes twelve through daylight. Over the years, Evelyn has learned to recognise a few of the more distinctive beaks and squawks, yet each day the flock seems bigger and more demanding. Perhaps this is really so, or perhaps Evelyn is shrinking, as some old people do.

Evelyn has a fantasy that one day, the wailing gulls will overcome her and carry her away over the kiosks and Magic Mountain to a clifftop palace where they will honour her gifts of bread by crowning her queen. She will sit on a throne made of rare shells and padded with the downiest feathers, wearing flowing designer clothes

that the seagulls shall steal for her from rich people's washing lines.

Evelyn also has a terrible fear of the birds. One day, there may be just too many of them to feed. They will grow angry and form an army of a thousand and burst through the leadlight windows in Flat Three and take Beatrice as their hostage. Evelyn has visions of herself opening endless cans of sardines and tuna (and maybe even caviar) in the middle of Colley Reserve, while Beatrice, haggard and blindfolded, is guarded by twenty of the largest gulls.

There is something else. Since these nights of her extra life began, Evelyn has started to suspect that she and Beatrice are exchanging lives. Indeed, she has started to crave liver and fish and has quite gone off the idea of vegetables which she's always had such a taste for. Recently, when she'd finished eating, she caught herself licking her fingers clean of crumbs and meaty juices, and observed an amused expression on the pointy face of Beatrice. The cat has taken to snoozing the nights away on the big bed. Evelyn is finding it harder to concentrate on her books and ends up pacing around the flat or pressing her face against the flyscreen, longing to take sly, wicked walks through the streets of Glenelg, or across the reserve to explore the empty fun park. Each day Evelyn feeds the birds with more zest, and with a funny laugh, as if the life she's saving is really her own.

Apart from reading at night and feeding gulls every day, Time busies Evelyn putting her life into boxes. Evelyn has never written a novel. She has not been immortalised in any work of painting or sculpture and has never been featured in the newspaper (except in a crowd photograph taken at Luna Park when it first opened across the road, in 1930). She has lived a good and quite happy life and has seen much in and out of

eighty-eight summers. Now she sets about dismantling her life and putting it into boxes, labelled, of course. Since Bert died (in a most disorderly fashion) Evelyn has collected boxes, covering each in brown paper with her deft hands and sticky tape. Shoe boxes, hat boxes, pill boxes, jewellery boxes, notepaper boxes, electrical appliance boxes — all have been gathered with dedication.

The labelling is difficult. How does one, quite literally, sort out one's life? At first, Evelyn considers labelling the boxes alphabetically. She discovers this means deciding whether a photograph is simply a photograph (and belongs in the "P" box) or whether because it is a photo of Bert it should go in the "B" box (and perhaps into the "A" box, even). Then again, because it is a photo of Bert on the morning of their wedding, it could go in the "W" box or maybe in the "M" (memories) box.

Evelyn spends her eighty-ninth summer making, shifting, breaking-up and re-arranging piles of objects on the apartment floor. Her attempt to give her life some final order gives Flat Three its only brush with anarchy in sixty-six years. All through December, lists are made and a kind of chess is played on the chequered kitchen floor with crystal glasses, piles of letters and other things not normally seen on a chessboard. Evelyn tosses back colour, size, shape, year of origin, importance, weight, material, value (sentimental), value (monetary), country of origin, disposability, beauty, usefulness and rarity as possible criteria for dividing the things that represent her life.

New Year's Eve arrives. As midnight hurtles through the streets, the sky outside Evelyn's apartment is filled with the coloured shrieks of fireworks and the alcoholic cheers of a thousand throats. Evelyn labels the fortieth of forty boxes (a hat box circa 1951) with an indelible red texta. She is surrounded by a wall of labelled boxes.

Beatrice can't sleep tonight and yowls to be let out. She is released into the streets by Evelyn who returns to Flat Three to sit in her favourite chair and admire her boxes in their neat stacks. She is satisfied. Four hours before Time rolls up at The Mansions, drunk and in a white porsche with the usual interchangeable blonde on his arm, Evelyn's lips kiss a whole summer's portion of Mogadon.

New Year's Day is without a breeze and the air is blurry with heat. A ginger cat lies vacant in Jetty Road, a tyre mark through its head. At noon, seagulls and sparrows flap screechingly around the rotunda in Colley Reserve. Within three minutes, not even their shadows tinge the littered after-party lawns. In two minutes, designer clothes have vanished from every washing line in the district. And there, at the end of Glenelg jetty, the chubby left hand of Time tosses a tapestry purse into Encounter Bay, catching with the other hand a blue piggy bank falling out of the air to the tune of a new mother's sigh.

Communion

Ana Irene Cummins

Hand round this piece of bread
 this law
 this silence
 this slow living without reckoning

Give your friends
 this smile
 this wide space
 this continuing dance
 singing along the way
 whistling at midday
 and with this sun inside
 this rising sun

Cordoba, Argentina, 1975

Comunion

Ana Irene Cummins

Reparte este pedazo de pan
 esta ley
 este silencio
 este vivir despacio y sin cálculo

Da a tus amigos
 esa sonrisa
 ese ancho espacio
 ese continuar bailando
 en una línea cantando
 silbando al mediodía

 y con este sol por dentro
 amaneciendo

Cordoba, Argentina, 1975

Part III: "English plus . . ."

Marginalia

Sara Dowse

An American Abroad

In the late fifties, when I emigrated from the United States to Australia, there was a term that was used ad nauseaum whenever anybody raised questions of ethnicity. "Marginal man" had been coined in 1937 by E.V. Stonequist, but by the fifties, it had acquired the markings of that pernicious era, and can be counted among the reasons for my wish to escape.

The problem was that the concept, while having the ring of authenticity, was wide of the mark, singling out as it did the individual as deviant. It turned whole populations — Jews, blacks, Chinese, Japanese, Mexicans — into deviants, and conjured up the rather unwholesome image of a haunted, dispossessed creature lurking in the shadows of two houses, never to find rest in either. Stupidly, we deviants mostly believed it. Take me, for instance.

I had tried very hard to conform. I had made an (unsuccessful) bid for University High School Hot Rod Queen, and been thrilled to have even been nominated. I had been voted, in my senior year, president of the school's most exclusive club. To present my bona fides, I had got drunk on six-packs in the alfalfa fields interspersing the suburban outgrowths of that mushrooming West Coast city — *La Cuidad de Nuestra Senora la Reina de Los Angeles*. Dreamtown of the Mayers, the Selznicks, the Goldwyns.

How to describe that place, that time? The city's

architecture, like that of the rest of California from Sacramento to San Diego, was Mexican-Spanish, as was most of the urban nomenclature. In Los Angeles, Jews ran the movie industry, second only to aircraft and oil in the profits it brought to the city. Its siren song had drawn people from all over in the biggest post-war boom in the US. Yet its dream was white, Anglo-Saxon Protestant, apple-pie American.

In high school, my friends were Japanese, Mexican, Jewish and, though we hadn't a name for them then, the golden WASPs. Apart from the absence of blacks (this was West LA: the blacks, crowded in the eastern, downtown ghettoes, were another story), the school spanned a multiplicity of ethnic and racial minorities. But still, in the classrooms, we were taught a watered-down version of Stonequist's Marginal Man.

Leaving aside the use of the word "man" (it was to take many years before I was to realise that there was another, deeper form of oppression than the ones I smarted from in the conformist, Cold War fifties), the idea of marginality is revealing. For, even then, the combined populations of all the minorities in the city would have been greater than that of the dominant WASPs. Yet the alienation of the Jew, the Latino, the Nisei, the black, was very real.

Throughout the LA megalopolis, there were "zones" — shorthand for certain neighbourhoods where gentlemen's agreements served to keep out minorities. In LA, blacks, Chicanos, Japanese and Jews were denied membership in most of the city's golf clubs; no-one thought it outrageous, only perhaps, sad. Anyone from any ethnic background could attend the University of California at Los Angeles, the local state (as opposed to

private) university, so long as she or he met the academic entrance requirements. Jews made up over forty per cent of the student population there. At the other end of town, where the blacks lived, the University of Southern California was a bastion of WASP privilege, a university where rich but academically unimpressive students could be groomed for their rightful place in society.

There were many colleges like that. They could, of course, be sneered at. But what of the prestigious centres of learning such as Stanford, Harvard or Yale, where there were known to be admission quotas for Jews? Quotas also applied in most of the graduate schools, schools of medicine and law. Two of my closest high school friends, both excellent students, were refused admission to Stanford, which accepted less brilliant but more ethnically suitable candidates from the same leaving year. Having once been excluded from a local teenage dance club because I was Jewish, I stuck to UCLA.

As we left what, looking back, was the multicultural Shangri-la of my high school, every one of us came face-to-face with the harsh realities of our racist society. For blacks downtown, it was undeniably the worst, but the Frank Rodriquezes and the Emi Hayashis had a bleak time too. The Jew's predicament was to come too close to realising the dream, having one's fingers burnt by the flame but finding the torch forever out of reach. All the folksy ethnicity of the Jewish youth organisation, Hillel, or the clannish preoccupations of my family with marrying me off to one of my kind, could not compensate for that loss.

For the obsession then was with "passing". We Jews had an edge on the others here — a name change, a religious conversion, might just do the trick — but this didn't mean that passing was an exclusively Jewish

business. Margarita Carmen Casino dyed her hair and became Rita Hayworth. The 1949 movie, *Pinky*, posed the dilemma of the fair-skinned Negro. Black magazines like *Ebony* were filled with advertisements for skin-lightening creams, hair straighteners. The richer Jews went for rhinoplasties, which were as common in my high school years as orthodonture. A whole sub-culture was predicated on the paring down of the prominent Semitic nose, involving as much subterfuge and expense as the removal of unwanted pregnancies (a procedure fraught with equal danger at the time). An aunt of mine had submitted to so many of these operations in search of the perfect proboscis that she was left with a bag of putty instead of her God-given cartilege. Horror stories abounded, but did nothing to abate the rush to the plastic surgeons' doors.

Worse than being a Jew was to have had Left connections. Often, the two went together. In those days, to be on the left basically meant voting Democrat, and all the Jews I know voted Democrat; I was nearly shocked out of my olive skin to discover, at university, that there were Jews who had actually voted Republican.

The Left was tamed then. I spent much of my childhood in the shadow of loyalty oaths, deportation orders, the House of Representatives Un-American Activities Committee and studio blacklists. Liberal protestors against these purges would defend the victims with a pious tolerance of their "errors". Socialism was a dirty word. Rarely were the notions entertained that a Marxist analysis might have any bearing on the contemporary American scene, or that racism (or discrimination as it was then known, the fifties being a heyday for euphemism) had any thing to do with class. The real

Left, of socialists and communists, was practically a gerontocracy, their meetings convocations of greyheads. I.F. Stone wrote in December 1953, "It is as if those with their lives still ahead of them are too cautious or cowed to appear at such affairs." And with reason.

The currents of a troubled national psyche erupted with the Rosenberg trial. Julius and Ethel Rosenberg were set up as scapegoats as if Nazi Germany had never existed. *Their* guilt or innocence was in a sense irrelevant: the trial of the Jewish communist-atomic-spies served excellently as a catharsis for a massive national guilt that perhaps had something to do with America's bombing of Hiroshima and Nagasaki. The case was a tragedy of our age, the Rosenbergs being the only convicted spies executed in the US in peacetime; to see it through my narrow, egotistical eyes smacks of irreverence. But I must risk that to say that one of the most amazing things about the Rosenbergs for me was that I defended them. In formal high school debates, in arguments with my peers, I, lily-livered, self-loathing anti-Semite, child of a Democrat-voting ex-communist (divorced and in showbiz to boot), defended them. I don't know where I got the nerve or the honesty, but I do know that it was one of the few episodes of that time of my life that I can look back on with any pride.

The fire within me was quickly doused by ostracism. After that, I directed my efforts to becoming a slightly interesting Barbie doll, nursing my marginality like a neurosis, for effect. The resolution of my dilemma is interesting, if only because it brought me here. I met an Australian who was very un-American, but also a Gentile, a goy. Americans then didn't know much about Australia. We knew about the swimmers and the tennis

193

players and the sheep. We knew about the White Australia Policy, and I naturally assumed Australia excluded Jews. I believed that if I married this Australian, I would have trouble getting into the country — a belief that lent a piquancy to the romance. Then I discovered the reality.

I found that I could get into the country, that my fare would be paid, that I could live anywhere I wanted, join (if I had the money or inclination) just about any club, that a Jew had been governor-general and another a leading military commander, that Jews were tolerated, even at times admired, because there were so few of us. The biggest surprise was the ill-disguised Australian antipathy for Americans. Having spent so much energy trying to become an American, for this I was little prepared.

I had been told how Australians regarded Americans as their cousins, how grateful they were to the Yanks for having saved them during the war. The reality, again, was quite different. The Australian film director Gillian Armstrong has been quoted as saying, "I couldn't stand talking to a person with an American accent, they used to irritate me," and this was the kind of attitude I met. Even among people who held me a little in awe because I was from Hollywood and had known movie stars, there was at best a grudging respect. The vast majority of my acquaintances, neither impressed with American films nor anxious to emulate Americans in any way, treated me with curiosity and contempt.

I decided to continue my studies, although it was not easy to transfer between the two systems and I lost credit for all but my first year English and history. For the first few weeks I walked around Sydney University in a daze.

Everything about the place seemed quaint and Dickensian: the high wooden desks in the freezing tutorial rooms where we perched on stools, the chalk-coated robes of the lecturers that made them look, I thought, rather like dusty swallows. Even the bus that carried me from the Quay to the university was inscribed with such antique instructions as "Please do not talk to the driver whilst the bus is in motion."

One day while (whilst) in such a state I bumped into a long table in front of the Fisher Library. The table was covered with leaflets and pamphlets openly espousing socialism. The *word* was used — again and again and again. Nothing like this had appeared at UCLA. There I had been campaign manager for a candidate for editor of the *Daily Bruin* and was immediately labelled "pink" because he had dared to discuss something else in the student newspaper besides the social events of fraternities and sororities. At one stage the university authorities had cancelled a speaking engagement of President Eisenhower's — it would have been too political. It didn't seem possible that here, in White Australia, where boxes of Nigger Boy soap pads could be found in almost any grocer's window, here they allowed socialist literature on campus.

"Can I help you?" A woman had been watching me. "Uh. No thanks, I was just looking." All I had to do was open my mouth and I found myself surrounded. There were three men and this one woman, and they lunged at me as if they had found an enemy agent who was willing to talk. And willing I was: I was desperately lonely. So the five of us went down to Manning House cafeteria for a chat.

What happened next became a watershed for me. The United States of America was attacked and I spewed forth all the rhetoric I'd picked up in my high school

civics class. My homesick back to the wall, I became a fulsome apologist for Uncle Sam's imperialism and the free enterprise system. But I knew as I spoke these lies, outrageous even then to my ear, that I could never go home again, that I belonged no more there than I did here. Nine thousand miles from Dreamtown, I was confronted with my marginality. The truth was that I had lost the heart to make myself into an American; the struggle had been too bitter, too hard.

That was an interior change, a tremor so close to the core of me that it barely altered the surface. On the outside I remained a Yank, speaking a certain way and wondering why no-one understood me, aspiring to what I considered a minimum amount of comfort, seeking out American food, American music. But the damage had been done. I found myself drawn inexorably to the range of anti-American sentiments. Owing to the times and my experience, this didn't take long.

What makes Americans so disliked? There is a simple answer, simple and justified — something akin to what had sent me adrift in the first place, the fact of US global pre-eminence, imperialism if you will. Among the many surprises on my arrival in Australia were the familiar brand names. Colgate, Kraft, General Motors, they took the edge off my loneliness. I hadn't realised the extent of American penetration of the Australian market; nor could I have known that Australians no longer made their own movies because the American and British distributors had squeezed them out; nor was I aware of the degree of American control over strategic or security matters, although given my confused state at the time I might even have endorsed it. My encounter at Manning House, however, was the start of a gradual

awakening to these injustices and the resentment they engender.

In the twenty-five years since I came to this country, the antagonism towards the US has increased. The spur was Vietnam, and Americans know it. The war there revealed the weakness in the overly technocratic military machine, the hypocrisy in the gung-ho ideology. It was the war that made me finally renounce my US citizenship.

My Australian experience has amounted to a political re-education. My view of America has taken on new shadings. At the same time I have had to adjust to the disjunctures in Australian political thinking: the paradoxical combination of sassy iconoclasm and a deep-seated need of authority. Like many non-British migrants to this country, I found not only the Whitlam government's dismissal inexplicable, but its acceptance of dismissal even more so. How could a properly-elected government be dismissed? How could any nation allow another to dictate to it in such a fashion? Americans would never have stood for it . . . if it had happened to them.

For all the hypocrisy, for all the inequality, for all the injustice that occurs in that country, the US has a democratic tradition. In our time, the American people have removed US troops from Vietnam, prevented one president from seeking re-election, forced another to resign. For all its parochialism, the American press has teeth. Inadequate as it is, the American judiciary has been one of the country's most progressive forces. American culpability in Vietnam led to my renunciation of US citizenship; the events surrounding 1975 served to remind me of the serious defects in the Australian body politic.

There are things in oneself that don't change. Culture is childhood. Nations are different from cultures, but certain nations allow certain cultures to grow, shaping them like plants with heat and light. As a national entity, the US is often unappealing, and if there are aspects of its culture I would prune (if I had that power), there are others I would want to flourish. For today I see that although the pain of marginality was part of that culture, the ability to express that pain, to do something about it, is part of it too.

Soon after I left the US, there was an efflorescence in Jewish-American literature. Jewish actors stopped changing their names; Yiddish enriched American English so that now words like *kibitz*, *schmaltz*, *boo-hoo*, *dreck* are so common that few are aware of their origin. The same thing has happened with Mexican words: *tacos*, *gringo*, *honcho*. I'm told that Koreans now run local business in LA. Arabs and Iranians have moved into prime real estate, those "zones". Beginning with the freedom rides down south (escapades in which a number of my hitherto quiescent contemporaries took part), the gelid conformism of the fifties thawed. With the thaw came Alinsky and Sesame Street, Martin Luther King and Cesar Chavez. In 1964, the first US Civil Rights Act was passed, and with Titles VII and IX which introduced affirmative action into American corporations, schools and universities, the term "quota" took on an entirely different meaning.

When I visited the country of my birth in 1975, and again in 1981, I found that the social fabric had changed out of all recognition. Blacks and whites walked down the street together, each sprouting Afro hairdos; everywhere it was all right to have *curls*. WASPs ate bagels for breakfast. There was poverty, filth, violence, anger but there was also this: a kaleidoscope of culture.

It was as if I had walked into the corridors of my high school, where the Garcias dated the Hoffmans and no-one gave a damn, no-one, that is, except the bigoted parents. But the bigoted parents were either dead or cowed — or enlightened. The oppressive hegemony of the white middle class had been broken. Who could call all these blacks, Hispanics, Jews, marginal? Who would dare?

Astute observers of the American scene note that there is not one America but many, and if they take this observation further they might recognise the effort it has taken to turn all these disparate entities into a nation. America has been faced with the quintessential task of nationalism: to wear down and blend into one. Both the process and result can be frightening, but frightening in different ways to differing sensibilities.

The mass media have been significant. Through them American culture has permeated other cultures. Few remember what work it was to shape that culture to begin with. The mass migrations to the US at the turn of the century provided both the talent and the predicament: the struggle of diverse, often antagonistic groups to find a place in the adopted land. Out of this grew a cinema, sensitive to the needs of that audience. There were tensions in such a relationship. As the cinema evolved into an industry, these tensions were contained. Rare was the Hollywood studio that would risk offending any part of its audience by dealing with specific ethnic groups. Conformity was substituted for cultural exactitude. And even if the conformity tended to worsen the underlying racism, that risk seemed preferable to bringing the differences out in the open.

This dialectic operates today but on a more sophisticated plane. The precise contributions of the various ethnic cultures are held as positive virtues, as is

the hybrid product. But the more this is so, the greater is the pressure for cultural diffusion. The greater the ease with which individuals negotiate their differences, the more cosmopolitan, varnished and seemingly inauthentic the society becomes.

The relevance of these considerations to Australia should be more apparent than it is, as we acknowledge the 200th anniversary of European settlement. A nation is essentially an artifice, something which entails conscious shaping. Australia now is a multicultural concoction. Rather than pretend that the mixture is bland, or merely encourage a peaceful co-existence between groups, we can look to the conflict between them as fundamental to the process of nationhood. It is a different notion altogether from the concept of the racially pure fatherland, involving as it does a creative tension between human life in all its flavoursome diversity, and the application of human will. The end result of all this rubbing together may indeed be something rather polished — so many plastic faces and nose-bobs, as bright and depressing as an airport lounge anywhere in the world. But it may also constitute the first step, a toddler's lurch, towards the melting away of national borders. And there is nothing marginal in that.

People with Pallid Faces

Lily Brett

People with pallid faces
limp hair
and lank expressions

stare
at
us

they
turn
in the streets

nudge
each other
in bus queues

point
in the foyer
of the five star hotel

I feel
like a recent arrival
from Mars

though
I'm wearing
cautious conservative clothes

and
have removed
my jewellery

maybe
it's my
clean hair

and curious complexion.

Among the Boyds and the Fairweathers

Maria Pietroniro

Gianna stood back from the art gallery window. At last her work was there, with Max Boyd's and Ian Fairweather's. In the corner perhaps, not very prominent, but there nonetheless.

She went into the cafe, ordered a capuccino and thought over what she would say to Debbie. Debbie was the coordinator of the local Ethnic Communities Council. She had asked Gianna to take part in an exhibit of ethnic artists and they were to meet to talk it over.

What was an ethnic artist, anyway? Was it a separate school like impressionism? Gianna thought she didn't "feel" like an ethnic artist.

When she had first arrived in Australia she could not paint for many years. The light was too bright, nature too sparse, too overwhelming. When she tried to paint the trees she found they looked like broccoli with white stalks. The mountains all ended up looking like her beloved Dolomites and her work had the soft haze of the Lombardy plains. The people were too sullen to capture in strokes of charcoal, their expressions vague and unyielding.

It was clear a transformation was needed on one side or the other. Gianna held back and waited. Waited for what? To be met half way, perhaps? While waiting she had fallen back on what she knew, what she felt sure of. The occasional painting had the sickly hue of nostalgia. She was feeding herself, her loneliness through

memories. Her work, like her life those days, lacked substance, lacked vitality.

And still the land, its people did not budge. The vast expanses of red soil left her feeling so small — like an ant that can neither burrow nor fly away. The people remained impassive, embarrassed to the point of ignoring what she hoped was the poetry in her work. Dissatisfied, she had stopped painting altogether.

Slowly, slowly, like the turning tide she had begun to yield, to surrender. She had allowed it all, accepted it all, unable to even say what "it" was.

The colours of her palette began to surrender too. She found they were not so alien. The mimosa turned to wattle, less delicate, more vibrant and robust. The shopkeeper she sketched was truly from Bondi, not Milan. She had earned her place beside Boyd and Fairweather.

Consider the ferns, the coconut trees, the rain . . .

Devika Alfred

"No religion, no culture," his mother had warned, crunching the last chicken bone on her plate. "Yes," Ravi replied, "I saw another one today". He never did have the guts to tell his mum that the native who made him choke on his Coke was a woman. He kept thinking about her but in quick reply to his mum, in order not to get her going on "the topic", he said, "It was another young boy again". That was many years ago.

Today life is still green, alive and always moving. Ravi stopped his taxi for the only traffic lights in a country town set high in the mountains of Malaya, twelve thousand feet above sea level. He had grown up here in the highlands and had witnessed the tiny town change into a tourist resort. Most of the people who'd come to the three towns in the highlands, especially Tanah Rata, came from the neighbouring states to escape the hot equatorial climate. To them, the highlands were cold. Temperatures dropped to 20°C, which never happens on the rest of peninsula Malaya. While his tourists sported cardigans, Ravi remained in his cottoned short sleeves. He knew the jungly shortcuts from the town up the very top via the waterfalls to the foot of the mountains at Tapah.

"No religion," Ravi explained, reiterating his mum's words. "They eat everything, pigs, monkeys, dogs", he told the two new tourists in the back seat of his cab. He added, "But these days, many of them wear clothes." Just like the Malays he thought.

The natives of the highlands are known as the Orang Asli which in Malay translates into "uncivilised people". They are a negroid race who stand in the background of the growing world image that the Malays were the first inhabitants of Malaya. They are short, have deep set black eyes and thatched wiry hair.

Ravi had seen many of the shy natives — men, women, children and some elders. He recalled the incident before his tenth birthday. He was sharing a can of Coca-Cola with his three mates when he did see one of them: clothless, with grinning pink gums, the native ran back into the over-abundant greenish jungle. The picture of the agile native girl was not easy to erase. How those black eyes shot past as she ran into the green! As usual, Ravi started off telling his passengers the negative traits of the natives the way his mum would say over and over again, though he found himself padding the description with increasing positive qualities. Sometimes he lied.

He did other things as well. At five o'clock from Monday to Friday, he stood waiting at the Village School for Natives to carry his two teachers home. One, a man teacher named Zanid he dropped off first. The other, a lady teacher, whom Ravi realised he was intensely attracted to, he dropped off later. Today he decided to take the plunge and to ask her if he could accompany her along the path from the tarred road to her home.

So as the school bell clanged, Ravi's taxi appeared and after Zanid left, he offered to walk the woman teacher (more of a girl) along the dirt path home. He had picked up a few native words but by then discovered he didn't need to use them, as the teacher spoke excellent Malay and a few words in English.

She did not say "yes" or "no" which could only have meant she did not mind his company. He parked his taxi

by the road and walked into the thick rainforest. Huge ferned palms sprouted right off the ground and lanky coconut trees stood tall in clumps here and there. Beautiful, Ravi thought: consider the ferns.

As they walked in silence, his mother's voice echoed in the back of his mind. "No religion." "Maybe they are just different," Ravi argued. His mother would stand confirmed and announce to an invisible congregation, "But they are afraid of death. No higher beliefs of an after-life. As soon as a person dies, be it child or adult, the body is flung over the roofs and all families evacuate, just leave. They take some cookware and flee." At this point, the native teacher looked at Ravi and smiled. He went on this jaunt the next day and the next. Before the weekend broke, the native girl, Hanifa, asked him what his name was.

"Ravindran. You can call me Ravi for short." "What kind of name is that?" she continued. Another question? "An Indian name," he said, noting her interest in him. "What are Indians?" Umm, how could he have explained the world, a map, the atlas to her. He stopped himself and answered, "They are not Malays or Chinese." Logical elimination of the other races seemed a simple enough description of what Indians are.

Perhaps, he could ask a question: "How do you know which hut belongs to you, they all look . . ." "Mine's the one facing the big clump of coconut palms," Hanifa butted in. Just then, Ravi almost slipped into another mud pool when Hanifa grasped his hand to give him support. Soon they held hands until they were within sight of the huts.

He was doing very well for himself lately, changing various accounts as his passengers enquired about "the natives". January, Feb., March and now June was turning into July. Heavy blistering showers which never

seemed to abate. Ravi propped up the umbrella as they huddled to ward off the storm and never-ending water.

Then something happened. One mid July evening, another storm had passed and Ravi waited by the school but there was no Hanifa. By this time, the male teacher had decided to take the bus home. Ten past five, still no signs. Ravi got into the taxi and raced to the communal *attap* huts where Hanifa stayed. Roofs were lifted by the continuous pouring. He returned to the school which lay flooded. Not a trace.

He tried to concentrate on everything else as he hurried home. What was the matter with him? He managed to stall all talk of being matched with a young Indian girl and live happily ever after. He knew exactly. He knew exactly what is mum would say while doling out the rice onto his plate, "See Ravi, if you were married, my daughter-in-law would be doing this and would give me some rest." On and on, to escape the spiel, he thought of having a shower and cleaning up, i.e., to shave.

When he cut himself the third time, he mopped up the lather and called it quits. Yes, his mother opened her mouth again. This time, the woman concerned was someone he knew — Radha, his cousin's neighbour, whom he had met on their holiday in India when he was twelve.

He wanted to say, "Stop Amma! Please don't make me skip dinner just to have some peace of mind." His mother rambled on. Did Ravi know that he wasn't a teenager any more and that he should think of settling down? All he could think about, oblivious to the conversation, was where Hanifa could be.

"So, what do you think son?" his father asked getting into the picture as well. Ravi stopped eating. Heading straight to the sink to wash his hands, he said, "I've told you both so many times. I'm not repeating myself." Next, he found himself in bed, and slept, very confused.

The next day, there she was. Ravi peered into the open schoolyard. Short and compact, Hanifa wore a long shift and was teaching students, sitting on the concrete floor of the gazebo-like structure. He was surprised to hear her enquire about him being at the school that morning. Another lie buried that question, "Well, you see, sometimes . . ."

"When the rains are heavy like that," she softly continued, "we often leave for another village for the day. Water was coming in from everywhere. Our windows don't have doors or curtains." How silly of him not to think of the practical side and get upset. Now he thought, of course — the rains!

August came around, the rains ended. The native students managed to see themselves in photos for the first time, courtesy of Ravi's little Instamatic. School was to break soon, so Ravi bought Hanifa an Indian bangle as a gift to present on their last trip before the break.

But on the last day of term . . . it happened again. No trace of anyone at five o'clock. It was not raining. Ravi waited till half past five, fingering the silver bangle in his shirt pocket. This was a bit too much. He became depressed. What should I do now, don't even know if I feel like crying or what?

He pulled himself together and rethought the scene. Hanifa had mentioned wanting to say goodbye to the final year students. Perhaps she was trying hard to give him the cold shoulder and thought this to be the opportune time. He remembered when she laughed and said it was easy to recognise her hut because it faced the most number of coconut trees. You only had to look to see how obviously more trees there were just next to them. A whole series of scenes ran through his mind. Maybe, he'd got it wrong. The school may have broken up the

day before. It couldn't have, he saw the last lot of students leave as he pulled up at the gate.

Ravi started the engine and made his way to the path he had become used to for the past six months. He couldn't believe his eyes; he knew what this meant. Panting after sprinting the usual ten-minute stroll, Ravi stood still. His eyes stung with hurt. Hot tears touched his lips and he tasted the salt in them. He squeezed the bangle in an effort to change things.

The sun blazed through the windscreen while his tears blinded him further. He recalled the tone his mum would use, "But they are afraid of death. As soon as a person dies (in this case, an old man) the body is flung over the roofs. Evacuate, they evacuate and flee . . ."
He knew he'd never see her again. Hanifa's group may have moved to any part of the vast Malayan jungle. Consider the ferns, the coconut trees, the rain.

Cold Times, Warm Times

Vilma Sirianni

It's dark outside, but dry. And the lighting moon looks cold, but the cold is good. My sister and I sit on pins. Waiting long in short spurts. Adults open and close the doors. Lights are low. Whispers too. Corrugated shed walls heat up with the fire and sweat drips drops. We wait for, "Si, you can come." And we squeeze through closing doors that hush our entrance. We become witnesses again to the winter world of slaughter: reds whites and pinks.

The pig is still. Enclosed by quiet cages of people criss-crossing his skin with sharpness. Each knows his work. And the sense of ritual is strong. Something I can feel in spite of youth. Mists of steam wet our skin. Knives flash. Big ones. The pig, dead and patient, jerks with each scrape. Bristles pile in little hills on wet cement and hot pink water rivers its way to the back of the shed.

In spite of the work and the fear and the pressing time, there is joy, contentment, a building to climax. The women wash the offal, squeeze water through intestines till they run clean and transparent in fragrant, lemon-wedged water. The men skin the pig, then cut the flesh in done-many-times movements. Like priests at mass. And meat is separated. Salami meat, prosciutto meat and a pile of fat. And naked bones that will be boiled in a witch's copper cauldron over a tripod and roasting potatoes. The women stir, kerchiefed heads to protect against stray hair.

Men and women separated in labour yet joined in some faint, thick harmony. There is much talk. Yes, the pig is good this year. Yes, the fat will be white and pure.

211

The soap will be good. Men argue kindly about the size. How many kilos? They talk of the kill and the movements of the pig. And they love the pig and sympathise with it. Especially Papa. He would wash them with soap every day. Wash down their cement pen and feed them good fattening food. But still, he too is caught up in the ritual at hand and takes the congratulations well. He raises fine pigs. The salami from his pigs are the tastiest.

Breaks are taken. Espresso coffee aroma mixes with the thick smell of fat. The face of the pig, still attached, just waits, understanding the greatness of the occasion. He is more to them now than he ever was in the old country.

He was a boast then, a measure of affluence. How big was your pig? And how many salami have you hung this year? And "Comma! I just brought you some meat. Not much, you understand, just so you can try." And if you didn't have a pig to kill, you kept indoors. The next year if you didn't have a pig to kill, you never received again. The rules were strict; social rules that grew over generations.

But here, the pig understood he was something else. Here, you couldn't hang your best salami at the front window for all to see. Here, your pride was silent, fearful. Here, they didn't understand. Health regulations. And there were butcher shops. But everyone knew if you bought meat, odds were you ate kangaroo. Here, the pig knew he was a link in a chain that was long and thinning. A chain that held on to custom and sacred social laws.

The salami were red with pepper and long, and pricked with a mangled fork to let out air, and they smoked in our shed for days. Hanging from rods neat and regimented, but as exciting as Christmas balls to us. Our

eagerness was hard to control. Mamma would cut two down and we would roast them dripping red and gold into our fire, and soak up the taste on bread, letting ourselves indulge in long taste-bud fantasies. Mamma and Papa loved to see us enjoy. This was a special offering, a gesture of identity, a part of Italy that they had brought with them. And the warmth was in them, in the fire, and in us.

The landlord knew but he loved salami too.

Reluctant Degustatrice of an Aussie Pie

Denise Pochon

Smells in the car.
The crust looks crisp, inviting.
A child's hunger bites with furtive glances.
I agree to taste the vanishing pie.
　Whose minced carcass am I gnawing at —
　Appeasing grumbling gastronomics?

It does not taste like Quiche Lorraine,
Or Pâté de Foie Gras Trufflé,
Goose Perigord laced with a touch of brandy —
　In fact it tastes mighty peculiar . . .
Dried lizards and mice boiled à l'Anglaise?
Who cares? I'm famished. C'est délicieux,

The witch in me, chicanery in glee.

My child, sucking her fingers, wants some more.
A cold wind slaps my face as I open the door,
Then lifts my tartan behind my back.
I've always sensed nothing was safe down-under.

"Years ago, I couldn't eat those pies . . ."
"Yeah, but now they're loverly ain't they?"
An oldie, ghostly under the neons grins
Exuding nippy aether-beatitudes.
"Yeah, and you must have sauce with it;"
Fanning my face, pleased with the world.

Vaguely I ponder — What is in that pie?

Peas Make the Man

Silvana Gardner

Every second year, the cadavers are distributed accor-
ding to the customary ritual. We leave our homes to
gather in a specific place on a specific date and we must
all wear white. I take it very seriously and think of
myself as an Initiate into the Mysteries of the Human
Body, though the idea sometimes frightens me.

I can't forget the pregnant cats and rats. The pregnant
prawns, dogfish, cockroaches and toads were already
dead when I began training.

The rats and cats were still alive.

Sometimes toads were still alive, but eggs aren't as
shocking as kittens or pinkies.

My colleagues didn't appear to be affected by the ex-
periments. They never said how terrible it was. I never
said how terrible it was, either. Scientists don't say these
things to each other. I trained to be unshockable and
passed the small animals' test with a fair ability in hand-
ling carving tools.

Some students speculate whether they'll get a male or
female cadaver. I'm above this chicanery and don't
think at all.

We were briefed, brainwashed and threatened that
dissection of human cadavers, despite its common prac-
tice, is of enormous importance, not only for our learn-
ing but also for the exorbitant cost involved. I can't
remember whether each cadaver cost twenty dollars,
two thousand or two hundred.

But even at twenty dollars, the cost seemed extrav-
agant and I scientifically deduced that I was very
important or very expensive.

El Supremo (the secret name of the Chief) doesn't trust us at all. He looks at us as if we repel him. Suspicion is written all over his face. I try to avoid his presence as much as possible because he's suspicious of me, more than anyone else. I always try to hide behind my colleagues. Somehow he singles me out for one pretext or another and questions me scientifically. This makes me feel a fool which I disguise with a serious demeanour.

He knows and I know that I don't know anything.

Otherwise, why would I have suffered for the rats and the cats?

He knows my weakness and I bluff my constant embarrassment with outer coldness.

On the first day of the roll call he addressed me as *Madam* would you be so kind as to leave the room? Two hundred and fifty faces turned to look at who dared to arouse his wrath. Intimidated, I nervously stubbed out my cigarette. Prolonging the public humiliation, El Supremo accused me of being a deviate contaminator of the social quota of oxygen. Worse still, I had no self control.

Some people thought it amusing (El Supremo smoked in secret) but I was crushed as a potential scientist. The lack of self control doomed me. From that time onwards, I officially felt apologetic for even daring to enrol.

Total inadequacy had already begun unofficially with the cats. I was no good. But who was going to throw the bad apple out? Certainly not me!

On the day of the cadaver initiation, I steeled myself to act scientific. I didn't joke or laugh like everyone else. I was suprised at my coolness.

The laboratory rat I smuggled away from an electrical experiment often told me I was a misfit. (He learnt to speak my language in gratitude for saving his life.) I told

him in the depth of one midnight, when no-one could hear us, that I was going to be a scientist. He wrinkled his nose in disgust. He was most offended that I could lie so blatantly to him. I confessed that maybe I was a bi-scientist? He said I was wrong but wouldn't say what I was.

I challenged him that I would succeed as a scientist and if succeeding meant chopping up a cadaver, I would do it!

A slice here, a jab there, slap, slap, turn over. Meat is meat!

The dissection room is very beautiful. It shines with chrome and stainless steel. One could say it's made of silver. Everything is very clean, polished and tidy. We wear white to match the decor.

It's like living in Paradise except for the odour and huge refrigerator doors. They're like bank doors to the mint. As high as the walls. No one is permitted to go near them except the attendants. They told us it's a crime to open the vaults ourselves. They're probably thinking of our professional ancestors: once a body snatcher always a body snatcher! Maybe our ancestry will make us dynamite the doors and run off with the bodies. They really don't trust us. The odour is pungent. No-one seems to notice it and I make a foolish mistake to ask what the smell is. Formalin, of course, with raised eyebrows.

I keep forgetting what the smell is and have to train myself not to ask what is the foulness in the air that makes me want to stop breathing.

On the first day the cadavers were laid out on stainless steel tables. Unusual tables with a hole in one corner. I asked another stupid question regarding the function of the hole. For drainage, of course. Drainage of what?

Everything was covered with white sheets. Snowy

mounds set out neatly in rows, about fifty of them. If one was inclined to be happy, one could have said it was like a Swiss snow scene. I didn't feel happy or sad. I felt numb.

Properly identified, I looked for other identifications to show me the number of my snow mound.

I wish I could remember that number (four kittens in the ginger cat, two kittens in the black, six pinkies in the rat), they have a bearing on one's life but I suppress such notions in fear of El Supremo's disdain.

I remember his number, too. It's fifty because he was fifty years old and I feared these years I would spend in science. I also feared him when he could spend fifty years in a dissection room. But to be fair: he must have been a child, once.

As a proper fifty-year-old chief, El Supremo stood near the vaults and sententiously informed us we should all have our numbers (how I cringed!) For I hadn't, never had, refused to keep identity numbers and I didn't know where to go and all the mounds looked alike and my redness must have blazed like a beacon in all the whiteness and no. 50 knew it, knew it and smiled sardonically to watch how lost I was becoming, lost in the snow of cadavers, lost in a snowstorm of dead bodies, spinning, spinning till I hit a table. I was diseased. He knew it.

Everyone grouped into fives and circled their mound. The blizzard was still raging when someone told me my number.

I've lost that number . . . it must have been below zero to freeze my memory to perdition. I wish I could remember the number as well as I remember the cadaver.

It's a male because of the genitalia. Otherwise it could be an Egyptian mummy. I'm amazed how indifferent I've become to our dry mannequin. Even his dagger tattoo doesn't conjure a personality. He's a thing. He's a doll. A dessicated, acrid doll. There is no fear whatsoever that I'm touching a defunct human being.

My rat will be shocked tonight. He was wrong about me.

I *am* a scientist and my scalpel is the first to be raised for the slicing of the hand.

My colleagues are impressed with my businesslike manner and a little envious of my eagerness to learn. They look at me in disbelief when I say that to sell one's body to science is the most honourable act a human being can do.

And I will sell my body when the time comes.

No. 145 sniggers that I might need the money a lot earlier. He's well known for such uncouthness. I tell him he has no soul.

And we bend over our dissection like five white vultures over precious carrion.

Weeks go by. You can tell how quickly time goes by the degree of dissection on the corpses. Of course, some keen students like to work in advance and they're already up to the head when we still dawdle on the arm.

One arm is alloted a couple of weeks and when the blood vessels are identified and learnt, the peelings are

padded back around the bone. The torso takes four weeks. The more tattered the body is, the more they know you've been working.

I never flinch at the weeks. The head, neck, arms, the torso. But I shower a lot.

I can't wait to get home to wash, wash. Scrub, scrub, The formalin must have crystallised in my nostrils because I smell it all the time.

I've stopped eating corned beef. The colour reminds me too much of the cadaver.

One night I vomited after dinner when I realised I hadn't been scrupulous enough to lift bits of flesh from under my finger nails. I ate an infinitesimal bit of him and I spewed months and months of dissection.

I find it difficult to touch food with my hands. I'm never sure if my hands are clean enough.

But I am hardy. I keep going back to sharpen my scalpels.

My group decided to give our cadaver a name. Like his number, his name is a total blank. It could have been Tom, Or Dick, Or Harry.

Maybe his name varied from Tom to Dick to Harry.

I resented their silly sentimentality because he's a thing. And the reason I get nauseous is that he's fast decaying. Rotten meat. That's all. Anyone can be made nauseous by something rotten.

I pretended not to hear when I was asked if I would work some more on Tom-Dick-Harry. I made up my mind that "he" was an IT.

Till we reached the anatomy of the stomach.

Half of it is nearly cut off. Degrees have plummeted

below zero and I wash obsessively. People ask me if I'm sick.

The stomach laid bare looks like a shrivelled chicken gizzard. Everyone is getting a little bored by the monotony of it all. After the stomach it will be the reproductive system and after that, the legs . . . No. 145 asks me whether I'll go to a Scottish dance. No.

El Supremo stalks us. He's getting more and more suspicious of me every day.

And . . . and then . . . then . . . I found peas in the stomach. PEAS. Formalin hardened peas. Eight of them. I counted them in the palm of my hand. I counted them again, in disbelief.

I don't know where I am except in a vast silence. I can't even hear my own heartbeat. The silence is oppressive.

My colleagues' lips move but I'm deaf. I am dumb. Deaf and dumb.

With eight peas in my hand I look at the remains of a great Egyptian pharaoh who ate a last meal of peas.

In the silence, there are thoughts. Peas take a short time to digest, so he must have died soon after eating.

Was he happy? Where?

Was it sudden? Was he alone?

Why do I see him falling over on the waterfront?

The dagger tattoo.

Was it night? Is he alone? Silently eating peas and silently dying. A sailor

When sound slowly crept in my vacuum I heard laughter. Laughter at his last meal of meat pie with peas. An Aussie, right to the very end.

And then the laughter became a scream, a rage to wipe an army out.

To kill, kill the disrespectful ones. To annihilate myself for having dismembered a man. A person.

Who ate peas shortly before he died.

And the peas were eight in number.

And they sent me home. Someone took me home.

It could have been El Supremo's orders. Did I hear him say *I knew she would crack!* But I wasn't afraid of him anymore.

He was only No. 50 and what's fifty years compared to eight peas?

Bonjour Brunswick!

Rosa Safransky

When my father arrived in Melbourne in the European suit with the narrow lapels, he had his first vision: he would starve.

"How do you make a living, tell me that my learned philosopher? All she does is read and think. She'll give herself pains in the head. Any fool can read, but how do you put bread on the table? How do you survive?"

"What good was philosophy in the camps?"

Torrents of words pour over my head. If he spends any more time talking, the business will sink and we will all starve!

He rushes out the door. A black cloud hovers over his head, my mother's bees. Insects in the house were the property of my mother. In summer, the walls buzzed and the rooms smelt of honey.

I put a Polish tango on the radiogram. Scratchy music fills the room. I glide over to the window with the lace curtains.

"What are you doing in there?" my mother frowns. The music stops. Another lecture starts on responsibility, obligation, on the cares of the world, all of which weigh so heavily on my mother's shoulders, they stoop.

"What would happen if we were all like you? You know how hard everyone works. I haven't even got time to sit down and have a cup of tea. All you know is how to be lazy, how to do nothing, P-R-I-N-C-E-S-S M-A-R-G-A-R-E-T!" (Princess Margaret is the patron saint of the idle and the lazy.)

The final insult she saves till last.
"You're just like your father!"

My parents hadn't planned to come to Australia. They hadn't planned to go anywhere. My father lived on the Russian Polish border. The revolution swept over him, hardly making a dent in his cynicism, and my mother lived in a high ceilinged apartment, next to a concert flautist. She heard music through walls which were paper thin. My mother lived near the old marketplace, my father near the new. Lubicz was a small town, everyone knew everyone else, but it was not till after the war that my parents met.

"But where did you meet?"

"I met your mother in a room. Your uncle Emil was with her. It was after the war, they had nowhere to go."

A room? He met her in a room? Poland was full of rooms. There must have been something to distinguish that "room" from all the other rooms. A dark street with an open doorway, or my uncle Emil in a cloth cap, chain-smoking on a doorstep while my mother sits on a chair on a bare wooden floor inside that "room", waiting for my father to come in and marry her and carry her off to a back street in the Antipodes behind a butcher's shop, a shoemaker's shop, a paper shop. And here we are in front of the weatherboard in Watson Street.

But let's go back further. The wedding present. A suitcase with cans of Tom Piper and a jar of vegemite arrived in Poland. My father sniffs the vegemite. Why would his friends send him shoe polish? They know there is no food.

And now the wedding. An American GI jacket. My mother is married in it. Her passport shows its astrakhan collar. And now me. Where? When did they have me?

In a Chagall landscape, the Eiffel Tower leaning through an open window. The stork brings me in spring.

"Tell me about Paris, about what we did there?"

"We went for walks in Montmartre. It was quiet, everyone was in the Metro."

Only two people on the street, my mother and me.

"And then what happened?"

"The wheel fell off your pram and half a dozen people ran out from nowhere and chased it."

"But where was my father?"

"On a transport ship to Melbourne from Marseille, with six shillings in his pocket."

On the back of a postcard of the Longchamp Palace, a masterpiece designed by the architect Esperandieu, he writes,

"The ship is big. Don't write yet, I'll send my address when I know it."

My father and Uncle Leon arrive in Melbourne, two weeks apart. Neither know the other is still alive. One night there is a knock on the door. His friends crowd into the room.

"Who was your father?"

"Who was your mother?"

"Which town were you born in?"

He tells them.

"Get in the car, you've won the lottery!"

"But I didn't buy a ticket."

They push him into a car and drive to a house in Mozart Street. Inside, he finds his brother Leon. They embrace and cry. They tell and retell their odysseys. Auschwitz, Belsen, an UNRAU refugee camp in Italy.

"You don't have to live here, come and stay with me." My father puts a deposit on a house and awaits our arrival.

My mother arrives in Melbourne with a bag of goosefeathers, a tapestry of a lion, my uncle Emil and me. I meet my father, the face smiling at me in photographs. He picks me up and hurls me in the air. I howl louder than a ship's horn, turn redder than a field of beetroots.

"Europe will explode," my mother warns and he puts me down. How did we all fit? Emil has the front room, I sleep in the same room as my parents, Leon sleeps in the spare room and the living room doubles as a workroom.

My father found his vocation at fourteen. The way Fred Astaire sings and dances. Tailoring, you either have it or you don't. My father had it. He threw a final plate of his grandmother's hated noodles behind the stove and walked into his first sweatshop.

Au revoir Europe, bonjour Brunswick! "Brunswick Creations", a two-storey shopfront, stands next to a surgical appliance store with a dismembered leg in its window. The doorbell rings and Emil's patterns jump from the wall but we go straight through to the back where my father stands ironing. My mother puts saucepans of food down on the sink, near the cracked Solvol soap in the wire rack. My father sits the iron down hard on the ironing board and holds the dress up to the light. He tests the zipper to see if it works. It does.

Good, now he can eat! I go out into the backyard to look for the cats.

"Have you forgotten your father? What about a kiss?" He calls out and points to his cheek.

The backyard is a concrete path bounded by a high corrugated fence. A fuchsia tree stands in the corner and every few months, the butcher's cat gives birth to a new litter of kittens in its shade. The toilet stands just behind the fuchsia tree, so my father and Emil often cross paths out the back, my father clutching his newspaper, Emil a saucer of milk. My father glares at Emil caught red-handed feeding the wild cats. The exhausted butcher's cat is a savage Bengal tiger, waiting for me to open the door of the lavatory and run back into the factory. I peer through a crack in the wall and when everything seems safe, I throw open the door and run for my life, reaching the factory just in time to slam the door in its face.

Emil works in the cutting room upstairs and on the living room table at home. He is always surrounded by clouds of smoke.

"We live in a Turkish steambath," my mother complains. Emil shrugs, throws a switch and rips through a mountain of sleeves. Emil, the "shneider", the cutter; pinstriped suit, slick-backed hair, gangster looks, a "papyross" in the corner of his mouth; his pale green complexion can be attributed to a diet of cigarettes and Coca Cola. Emil's coughing spasms and chain smoking provoke a worse reaction than the wild cats.

"If you want to kill yourself, kill yourself! You know what you're doing, but we need air!"

It was called "the beach", the "fresh air". There was only one beach — St Kilda. A train starts, billboards move backwards. "Huttons is best!" A man in a bowler hat pushes his hand into another man's face. Pink-faced

children smile, wrapped in Dickie's towels. The train stops. We stroll past Luna Park filling our lungs with "fresh air", my father, mother, Emil and me. This is not St Kilda but the Black Sea, a Chekhov summer. We are dressed for it, my mother's jet black hair and classical European profile, my father in his panama hat and open-toed shoes, me in a pink nylon frock with pearl buttons down the front.

"Hold on tight," my mother whispers, gripping my hand, "or the wind will blow you away."

A breeze wraps itself around me, goose bumps appear on my arms and legs.

"Rozi is cold," my mother's watchfulness has been rewarded.

"What do you want from her? You can't leave her alone for one minute. You think this is still Poland?"

Yes, my mother thinks that and worse. I find myself weighed down by my father's jacket. At last, we go inside. Luna Park! What I've been waiting for. My mother and Emil are not excited. The great slide, dark tunnels, the mirrors in the giggle palace, the floor falls beneath our feet. My mother turns pale when she sees it. Amid gasps of horror, my father and I get on the ferris wheel. I look down and then up. The beach stretches for miles and I can almost touch the stars.

Wrong Accent

Olga Novak

The Majestic Private Hotel in Fitzroy Street, St Kilda, was only walking distance from the boarding house I lived in. The hotel was run on the model of a gracious, English-style establishment. It was a costly haven for retired professionals and wealthy older people, some middle-aged working professionals, an occasional younger guest. Except for the permanent guests, some casual guests, mostly country people on holidays, frequented the hotel.

The dining room was spacious, the tables covered with starched, white damask tablecloths: an impressive background for quality silver and cutlery. Working as a waitress in the Majestic was fairly easy. First breakfast service. After breakfast: changing table linen, tidying-up, polishing silver — all in an unhurried manner, in my own good time. Then luncheon service . . . not all guests came down for a midday meal. After lunch: a couple of hours free. I used to spend my free time in the backyard of the hotel, relaxing on the lawns, under the shade of trees or warming myself in the sun.

In the last decade I'd lived in Melbourne, I never actually realised that the sun also shines on weekdays, and that lucky people spend their mornings and afternoons in backyard gardens inhaling fresh air and soaking in the sunshine. So far, all I knew were neon lights over machines, factories filled with industrial dust of nylon, cotton, wool: dust settling in my lungs, my nostrils, penetrating every pore of my skin, of my being, of my very life Now, I too had the privilege, at least for a couple of hours daily, to breathe fresh air

from the nearby sea and bask in the much-lauded Australian sunshine. Relaxed and refreshed, I served dinner. The guests used to dress up, making it a social occasion. I fitted into the refined atmosphere of the hotel immediately. The guests showed their appreciatin by striking up polite conversation and by generous tips.

The hostess-cum-manageress was a proverbial two-faced creature. Dripping with kindness, bowing into the dust before the guests, she was abusive and nit-picking to the staff. She decided that my accent was a blot on the imitation Old-English-style of the hotel. She started, on occasional days initially, to take me out of the dining room, substituting me with an Australian waitress. She made me work in the kitchen: mopping up floors, scraping dinner plates and feeding them into the dishwashing machine. One Friday afternoon, handing over my pay envelope, she declared: "You are not going to work in the dining room anymore. You'll start working in the kitchen from next Monday!"

Physically it was, of course, easier to work in the kitchen than as a machinist in some clothing factory. Emotionally, the trivia and boredom of a kitchenmaid-dishwasher's job was spiritually poisonous. At least in the factories I had the satisfaction of seeing some productive accomplishments! In the dining room I was meeting people. Meeting Australian people, and learning about Australian people were some of my vital interests at the time.

"No, I came here to work as a waitress, not as a kitchen maid!", I answered. "Look at *her*!" the hostess started screaming in front of my co-workers. "Who does she think she is? Some sort of *princess*? You don't want to work as a kitchenmaid? You should kiss the hands of people offering you such a job and such good food! You never had enough to eat till you came to Australia. If

you don't like the jobs we are kind enough to give you, why don't you go back where you came from!"

Next morning I did not report for work in the kitchen of the Majestic Hotel. Saturday's *Age* advertised job vacancies for waitresses. I landed a job as a waitress in the Hotel London in the city.

Colonialism

Jeltje

mama and papa
were nursed
by *babus**:
young Indonesian women
who spent their youth
coddling the colonialists'
sickly children.

as a child
i often asked
what my parents did
when they were
little.

my mother said,
that when the European Ladies
came for afternoon tea,
the children
were summoned
to greet them.
Mrs Q. asked the eldest
to say something "nice" . . .
"Poop!" said my mother
& ran out the door!

**babu*: maid, servant

my father remembers
playing with my mother
on the lawns
of the colonial estates
("they were
wild games!"
my mother adds.)
he also remembers
sitting around
with *koki**
around the fire
outside in the *kampung**

watching him cook,
after *koki*'d served
& washed up
inside
(my father
still likes
cooking *sajurs**
& improvised
sates!)

my father's mother
died when my father
was still young
she seems to have had
more contact with her children
than the other colonial mums.
she talked soft
with my dad,
& taught him
how to massage

koki: cook
kampung: village
sajur: soup

her aching head
(it's been hinted at,
that my paternal grandmother
was of Indonesian
descent.)

i think
both my parents
have been homesick
for Indonesia
for a very long time!
they were shipped
"back to the mother country"
in their early teens.
my mother says,
they didn't like
what they saw.
she blames it
on thē cold.

i blame it on
the early years spent
in Indonesia:
they just couldn't cope
with Dutch Burghers
& the money-pinching
attitudes . . .

i think
my mother & father
came to Australia
with a dream
of finding something
they'd left behind

in Indonesia.
how their faces
lit up! when
the migrant-ship
crossed the
Equator!
(my father
greeted the
Southern Cross
like a long-lost
friend!)

Kuala Lumpur Story

(an extract from the novel)

Beth Yahp

In the heart of Kuala Lumpur's bustling Petaling Street, amidst the sweetmeat sellers, and the man who twirled umbrellas above his head with energetic cries of "Special offer! Special offer!", and the blind beggar woman with her yellow eyes cocked half open in constant lookout for kind donations, there sat an elderly man in a small rattan chair. He looked for all the world as if the people around him, so wholly engaged in their separate business transactions as they were, were actors in a comedy which, although absorbing, was not quite amusing and of no real consequence. He sat there looking a little superior, in fact, and he was of course, my father. He was doing what he loved best: nothing.

"Well it's not injurious to anyone," he defended himself, constantly.

And mother would sigh.

My mother could never just do "nothing". In my father, it was inborn: he did nothing whenever he could, and he had it down to a fine art. My mother, he told us, was the type who, if she ever ceased doing whatever she was doing without having something else to move on to, would collapse into a jelly-blob of hysteria. This was hard to believe as my mother was always calm and pragmatic, especially under stress. However, as my father pointed out, she had never stopped doing anything without having first secured something else to move on to.

Thus our home, which was situated inconspicuously among Petaling Street's many shop-houses, was an eternal hive of activity. My father, who abhorred strangers in his living-room, escaped with his rattan chair into the middle of the street.

"To be in the thick of things," he explained caustically, and would add: "Your mother, however brings the 'thick' into the living room, regardless of all propriety."

With that he would march off, his back straight, his head high, one hand gripping the arm of his chair.

Mother, of course, paid him no heed and continued to invite the "thick" into our house. Eric, my brother, just rolled his eyes.

"I saw Dad give old man Lau five *ringgit* yesterday," he said, but only when father was out of earshot.

Unlike my father, Eric and I enjoyed the company of the desolate, often-moaning and invariably interesting mixture of people who visited our living room. Father merely referred to them as the "thick", and so dismissed them. Anyone who wanted to spend time in our living room had to be thick, he said.

The "thick" in today's case happened to be three aunties from across the road, several skinny street children munching on shelled groundnuts, and my maternal grandmother, whom my father abhorred above all the other visitors who invaded his living room.

Grandmother was a fine lady whose set ways and ideas, and remarkably biting tongue, proved to be our undoing — Eric's and mine. We were a sad trial to her, I fear, all the more so because we could neither of us speak nor understand much Cantonese, which was all that she could speak and understand, other than a smattering of market Malay. Nevertheless, we both sat very still whenever she gave us one of her energetically gesticulated sermons, in Cantonese. Mother would

translate whenever and whatever pleased her, and this made them, in all, well censored sermons.

My mother could be a gem, at times.

Grandmother was thin and frail-looking, and had come all the way from China in 1909, a fact she never let us forget. At our ages in China, she said, our parents would have been seeking Eric a wife and I would have been one. As it was, I was past the desired age of the Chinese bride, rather an old maid so to speak. Eric, however, was at just the right age — but he preferred table tennis to courting and car magazines to girls.

Today, Grandmother delivered none of her elaborately eloquent speeches (which neither of us could understand). She sank into one of our cane chairs instead, sighing and looking a little sad.

"Your Grandmother's oldest friend has left this world," Mother told us gravely.

"It is God's will," Grandmother sighed.

"Actually," said Mother, as if it was an afterthought, "it happened to be an extremely wealthy friend. Gastronomically wealthy."

"Gastronomical" was my mother's favourite word of the moment, and she used it whenever she could. Eric and I waited patiently for her to elaborate. There was no use in rushing my mother: she ran at her own pace, and to her own tune.

"Please be kind to your grandmother," she merely said, closing the subject.

This meant that Eric could not skulk around the house doing Darth-Vader-on-the-look-out-for-victims impersonations, which made Grandmother nervous; and he couldn't do disco demonstrations to the tune of the music which drifted in from the pirate cassette-tape vendors outside, either — his spinning made Grandmother dizzy.

Today, we poured tea for my grandmother. We brought her peeled mandarins and spoke to her in what Cantonese we knew, American-accented as it was. To this she merely remarked: "You watch too many white devil programs," which made us more worried, as Grandmother was not one for brevity.

When Grandmother was sad, she looked old. Her cataract-filmed eyes lost their particular light and her usually animated face grew disconcertingly still. Her shoulders seemed to grow more bent and her samfu hung loose on her, losing her in its dull floral pattern.

"Was it a big ship?" Eric asked, to distract her.

Grandmother sighed and looked at us, sitting at her feet.

"It was a big, wooden ship," she said, "and the sails were as high as two houses, placed on each other."

The crossing from China, Grandmother said, had not been easy. The junk had been tossed on an angry sea, and in the hold, where passengers crowded, the stench of vomit had mingled with the moans and cries of sick men and women.

Grandmother had come to Malaya with Grandaunt Sehu, whose family had not owned enough to feed her, and whom no-one had wanted to marry. Although Grandmother could not remember, we imagined them dressed in coarse cotton samfus, with Grandmother in red, perhaps, for she had left Kwantung a promised bride, to be the second wife of a mining *taukeh* in Kuala Lumpur, my Grandfather.

Grandmother staunchly believed in the Confucian ideals of filial piety and the perpetuation of the family name. Thus obedience to parents and ancestor worship were the most important of all virtues, and the sons of a family were to be treasured. Eric noisily supported Grandmother in this, but only when I was not around,

as my direct reaction was to clout him on the head — but only when Grandmother was not around, as this upset her. My father, a self-proclaimed man of the future, saw no logic in the exaggerated worship of dead people or the over-importance given to a name.

My father, too, could be a gem, at times.

I left Grandmother and went upstairs to my room where I sprawled on the bed, flicking through my journal and chewing on the end of a pencil. Today Grandmother's gastronomically rich friend died, I wrote, and he must have been the secret lover from China because Grandmother isn't usually disturbed by death.

I remember a story I had once been told, and wrote: "When my mother's eldest sister was shot in the head for stealing a chicken because everyone was starving during the Japanese Occupation, Grandmother did not cry. When the soldiers came for the men and boys, she hid them in a secret well under the house, and when they were found and taken away, and she thought she would never see them again, my grandmother's eyes were dry, although my mother wept. Grandmother, my father said, was like the finest of Chinese jades, whose heart was made of ice."

When I was twelve, I announced that I would make records for posterity, which caused strange looks but few comments.

I was still at it. Everyone and everything is in this book, I told Eric once, to which he replied: "You're insane."

My brother was not very intelligent, I liked to think.

Mother came into the room and sat on the edge of my bed.

"What are you writing?" she asked.

"The usual," I said.

Mother was silent, and she had on her "deep-thought"

look, which could either be good or bad. There was something on her mind which I knew she would tell me, in her own time. Meanwhile, I wrote: "My grandmother's life has not an easy one and she suffered tremendous hardship from the day she was born. In China, there was never enough to eat and her village was plagued by roving bandits and tax collectors. Grandmother's family sent her to Malaya to become the second wife of the rich *taukeh* to save her from starvation, and also because he pledged a dowry which would feed the family for several months. They promised the heirless *taukeh* that Grandmother carried sons in her, it was written in the shape of her head and the curve of her belly."

Mother sat at the end of my bed regarding me rather curiously, but as she still said nothing, I wrote again: "Although Mother and Grandmother both have very strong personalities, Mother has always bowed down to Grandmother's wishes, out of a deep respect, if not love. It is hard to imagine anyone actually loving Grandmother, and this in spite of the story of the secret lover from China."

I stared at the last sentence, thinking. The story of the man from China was one which hung in the air in my family — it was whispered in the kitchen and in the hallways, but only when Eric and I were not around.

"Is Grandmother's gastronomically rich dead friend the secret lover from China?" I wanted to ask, but could not, because it was something I was supposed to know nothing about. And Mother, in any case, would say nothing.

"It is the writing that makes things clear," I wrote, "as it is the naming that makes things exist, even the things that do not exist, perhaps."

The personal curse of the Chinese is to be surrounded

by a myriad unnamed things, which peek out of corners in old photo albums or drift out in whiffs of sandalwood and old camphor from long-forgotten boxes.

"What's this?" I would ask my mother, digging deep, my hands full. "Whose was this?"

And she would look up, and say: "No-one's", or "You wouldn't know who," and nothing would make her say more.

Ghosts dwell in our living room, and shades wafted about the stairway, with long straggly hair and their mouths wide open, hungry ghosts, perhaps, wailing to be named. Even the ghost of the secret lover from China, unnamed and non-existent, had crossed the waters following an invisible trail, to haunt my grandmother.

I decided to continue writing, impatient with puzzles, and with not knowing.

"My grandmother loved him," I wrote, "for things unseen by others."

The Gecko Cure

Uyen Loewald

I used to be scared of looking at Mrs Dao. She suffered from a constant twitch in her left arm, which made her resemble a trembling crow, an impression reinforced by the black hair which covered most of her face. She also used to wear black clothes with wide sleeves which her half-folded arm spread into the shape of a wing.

The thought of people making her swallow a live gecko to cure her disability frightened me even more. I had never seen, or even known, anyone who had swallowed a live gecko the way Vietnamese folk medicine prescribed. I tried not to look at Mrs Dao just to avoid the possibility of seeing her swallow the gecko if ever her twitch went out of control.

As the years went by, many stories were told about Mrs Dao, and when I became a teenager, burdened by morality and justice, I felt compelled to understand her. Mrs Dado was a kind and gentle woman who unhesitatingly took in all the children of her husband's mistresses and treated them as if they had been her own. She came from a good family, but when her opportunities for marriage had receded, her parents had married her off to Mr Dao, a poor, small-town clerk who was many years her junior.

She gave her husband three sons and one daughter. Bearing in mind the Vietnamese proverb "three sons never bring prosperity", Mrs Dao withdrew from sexual duties to a purer life according to Buddhist teaching, hoping to leave happiness to her children when she departed for the next life.

Mr Dao could not afford second wives on his modest

income; his mistresses left him when pleasure faded and sent him the infants instead of bills or souvenirs. The children grew up knowing no-one but Mrs Dao as their mother.

Trung was her oldest step-son, an idealist who joined the revolutionary forces to liberate the country when the Vietminh movement became popular in the Mekong Delta. Xuan was her oldest step-daughter, loud and fat; she worried Mrs Dao most of all, not because of her lack of ability but because of her aggression. Mrs Dao married her to the first man who asked. Soon after the marriage, the couple went to live in Hue, almost a thousand kilometres away to the north of Saigon.

Mrs Dao's own children joined the Vietminh movement right after the French were vanquished in the battle of Dien Bien Phu. On the day they left, she burnt incense and prepared a tray of food "to offer to the gods for their protection," she explained. But her neighbours knew better. "She did it just in case they die; their souls would not have to wander, to starve or be homeless," they said. Mrs Dao did not hear from her sons after their departure.

But she had more children to worry about. Her second step-son, Hung, was a practical boy and healthy, while her step-daughter, Lan, was delicate. Lan was sensitive and affectionate; like her husband, Mrs Dao could not help being partial to her. It was said that Mr Dao loved Lan best because her mother was his favourite mistress; she was the only one he ever loved. But despite all their special care and concern, Lan developed rheumatic fever shortly after she entered high school, and the illness left her with a damaged heart.

Mr Dao died suddenly, but Mrs Dao's twitch never went out of control. I began to think the gecko cure was a joke, despite many people's efforts to convince me:

"It's true. I've seen people doing it, and they've been cured for ever." Some even tried to impart further wisdom: "The gecko is a terrible creature. In its previous life, it was a very stingy man. A curse transformed him into a gecko in the next life. The gecko has to live in pain; it cannot die. When its tail is broken off, it keeps twitching, just like Mrs Dao's arm. If Mrs Dao swallowed the gecko, it would calm down. It would rest and be able to free its soul from the miserable gecko body. Mrs Dao would be blessed by becoming free from twitching too."

But Mrs Dao suffered on, caring for her husband's children not only because she missed her own and wanted to gain blessings from the gods, but because it was part and parcel of her tender nature and the goodness of her heart. Only sometimes, when sadness overcame her, would she cry: "Dying is an escape from this wretched life. Oh, why didn't you take me along with you, my husband?"

Her step-children reciprocated her love. To support her and the rest of the family, Hung, her second step-son, joined a special branch of the US Navy. He was trained and paid by the Americans to perform secret tasks. Mrs Dao made every effort to dissuade him. Only the thought of starvation could make her concede to fate: "Buddha, love him; may he never have to shoot his own brothers," she prayed.

Regularly, Hung sent home money; not only did the Daos' standard of living surpass that of the middle-class families around them, but Mrs Dao was taken to American hospitals to be diagnosed and treated. Though her disability was never removed, it was greatly reduced.

One day, a telegram arrived from navy headquarters. Mrs Dao could not read English; Lan opened it. As she

finished reading the last word, Lan fell to the floor, like the twitching tail of a gecko. Mrs Dao and Thu, her youngest step-daughter, took her to the hospital. But Lan's heart ceased to beat before arrival. Mrs Dao consoled herself: "You have been kind and innocent; you'll have a better life next time around. Your soul can join your father's. He has always loved you." She never learned the contents of the telegram.

So Thu, who had barely entered her teenage years, had to go and identify her half-brother. Alone she went to Cam Ranh Air Base to see Hung's body, burnt beyond recognition in an air crash. She buried him with the help of strangers. And alone she had to bear the horror. To reward the living, the US government generously continued to support Mrs Dao and her daughter.

Then came the communist Tet-Offensive of 1968. People lived in fear instead of celebrating the Vietnamese New Year. The capital cities were attacked, and many families lost their children. Instead of displaying red flowers and offering good wishes, people wailed; they wore mourning bands around their heads. Mrs Dao learnt that her step-daughter Xuan had died with her family in Hue. Mrs Dao cried: "Poor daughter, I wish I hadn't married you to that soldier. You wouldn't have had to live in Hue. But there were other people who also died. They did nothing wrong, either. Perhaps war makes it too difficult for the gods to protect us from danger."

For seven years, Mrs Dao waited for her own children to return in glory; she turned down the American offer of evacuation when the Vietnam war ended. "I am going to stay right here and wait for your brothers and sister," she said to Thu. "You can go ahead and leave. You'll have a much better life overseas. I am sorry I have not been able to live without you all this time. Now the

country is reunited, it's your brothers' and sister's turn to look after me."

Thu could not leave the only woman she knew and loved as her own mother; her heart feared the uncertain future. There had been no contact with her half-brothers and sister for twenty-one years. She was afraid of what would become of her horrible secret, which she hid within the sentence, "My brother has joined the others." This is what she said to Mrs Dao every time she was asked, "Why hasn't Hung come back to visit me?" Instead of having seizures at Thu's answer, Mrs Dao was always satisfied. She read a different message in Thu's words. Often she would add: "I know Hung will come back to visit me sooner or later. Brothers should be together in these times, and he has done the right thing, joining the others."

Then Saigon was liberated, and Mrs Dao received word from her daughter. She was ecstatic; her mind echoed her sons' marching songs of glory. She went to temples and pagodas to thank Buddha and the gods for their protection. She unpacked her treasure to take out shiny brass trays, red chopsticks, and precious china. Carefully, she emptied her piggy-bank for the feast of reunion. The table was heavily laden with her children's special favourites: abalone sautéed with chicken breast and snow peas, bird's nest, jellyfish salad, "dragon's beard", chicken braised in coconut milk, barbecued veal with homemade soya bean sauce, and many other dishes she had expected not to have been able to afford because of the war.

Her daughter returned in black clothes, her hand holding a packet of sugar, the rare and expensive gift from the north. "When are your brothers coming home?" Mrs Dao asked her anxiously.

"They did well for our nation." Pride shone on her

daughter's face. "You must be really proud, mother, to have been able to offer three sons to our country. Dung sacrificed himself in the battle of Khe Sanh; his unit gained glorious victory. Long and Dong almost took over the city of Hue in 1968. My brothers were very proud to save our country. We were highly commended by our leaders. We contributed to our national victory. From now on, you are living in a free nation. . .."

Mrs Dao heard no more; her seizure came. Then she lay lifeless. The gecko chuckled throatily as if to say it preferred not to become human in the next life.

Micho: 1941

thalia

Micho vrika to maherisou, in my mother's
cosmetic case i found your knife,
and with it her crys as she told me of your
kindness in the depression of 1941.

Micho the miller's helper, who brought a bag
of flour to my grandmother once a week in
secret, in fear of being caught.

Micho the *antartis* was caught by the enemy
and tortured for hours, days, until the day
of ordered murder was released:
"We hold respectable executions!", so a
barber was sent to groom the prisoners.

Aristidis the closest barber was ordered to
groom,
into the steemed hot dimness he went pushed
and silenced.

Micho recognised his friend, "*Aristidis, kita
pou mesa ime*; look where i am, green stinking
water dripping around me in a small cemented
square; *Aristidis pou ine ta kala pou ekana,
vouthame Aristidis*, Help me!"
the soldier's rifle butt swung down on the
barber, "No speaking!"
the friends glanced at each other.

At home *Aristidis* knelt by his mother,
muna yati, yati:
the next day Micho was shot by the firing
squad, all that remains is the knife.

I asked my mother what was his last name,
she looked at me saying, "We never found out."

The Tiger

Sophie Masson

We were inside, exchanging stories about tigers. Malaysian tigers, with their big wide fierce faces, and the curled-up ferocity in their very name. Soft paws in the jungle, insistent clawing at wooden houses. Six o'clock curfew in hill villages, because after dark, the tiger is waiting, waiting, with his great lamp-yellow eyes and his soft paws.

We shiver in delight. The night outside is soft and warm, we are safe, we are in Australia, no tigers here, we were frightening each other's imagination into visions of tiger and the torn flesh of Soraya's uncle.

Soraya's hair is clean and soft, it falls to her shoulders, and I remember the long black tresses that the family brought back from Indonesia. Real wigs of real human hair, cut off the heads of corpses. They always made me shiver when I put them on. I had prickles in my scalp, feeling the warm soft heavy dead black hair that hung from my alien head.

We wore those and the Balinese ceremonial sarongs, one red and gold, one green and gold, and the heavy gold paste ornaments and glass jewellery which lived in the red snake-charmer's basket most of the time. I remember my sister, dressed up, childishly thin in the green sarong, the belt twisted pitilessly around her, her big kohl-rimmed black eyes, those long dead plaits hanging off her face, the crown wobbling, making her slow and regal way down the staircase where the *wayang golek* grinned from their earthenware pots (we'd mixed up our continents: the pots were African). She looked like a princess, and we held our breath. But hubris had

its fall, and she tripped on the second last stair, and fell sprawling, a thing little girl in borrowed finery. We children cried with the desperation of children: nothing would ever ever be the same again.

So many years since I saw the staircase, so long since I held the *wayang's* putty-coloured hands. As children, we listened to the nightmares and the dread, we digested the raw pieces of experiences our parents fed us, we saw ourselves as strange, different. We listened to stories of Saidjah, the Communist guerilla who'd waited peacefully like the tiger for Dutch army stragglers in the rice paddies. We knew the smile of Asia, we bathed in mythology and heard the heartbeat of the jungle temples at Borobudur. Oh to come upon them still virgin, still hidden in the depths! We touched the pink stone sculptured head in the living room, the proud Javanese face that stared from the sandstone, the hair horned like a mediaeval headdress. We stared in fear at the wicked blade of the *kris*, that beautiful deadly snake-thing that insinuated out of its silver scabbard; its beautiful handle, ivory, green stones and the carved oiliness of its sharp edges! We imagined the serpentine thrust — ahh, like so — into the gut of frozen-faced Javanese warriors. We read *The Ramayana* in three translations: old Javanese, Indonesian, and English, in a cheap graph book where a Javanese soldier had noted it down for my father. We saw the princes and the demons, Hanuman's monkey hordes fighting in flat bare ornamented feet on the long banners that hung in the hall.

My passport said: place of birth: Jakarta. Squalid and sprawling, smelling of evil canals and fragrant *warungs*, Jakarta remains as a hot humid memory of hospitals, rooms without airconditioning, cockroaches as big as your fist and porters who stole luggage.

And everywhere, Sukarno's face, his skullcap, his

stick. His sexual *chansons de geste* filled everyone's mouths. He was a magician, they said, Soraya said. He rode around the country in splendid cars, he lavished gestures and sculptures. My father recalls him briefly passing near the port where he and Saidjah and the others were working, while far at sea, Malay pirates prowled murderously, their descriptions like balm to my childish soul starved of wonder and miracles: bandannas, single earrings, scars. But how much squalor, emptiness, indifference they hid under their ferocity and their tiger-yellow eyes, how much throat-choking horror they, the sea tigers, unleashed on boatloads of refugees.

But children, Soraya and I laughed. Cruelly, we conjured pictures of cheap old bicycles lying forgotten on jungle paths while far away the tiger prepared to sleep, belly swollen pregnantly with Soraya's uncle. Had he tried to run, man from beast, had he tried to escape? Had he panicked forgetting *Boys' Own* recipes of outstaring those great lamp-yellow eyes? Had he leapt off the bicycle and tried to run into the jungle? Or had the tiger waited with heavy jowl and evil breath while the sole foolhardy human made his slow crunching way up the jungle path?

Man-meat is not supposed to be pleasing to the delicate palates of our feline friends. Surely the tiger would have preferred a nice monkey, marinated in a thousand herbs and spices? Why pick Soraya's uncle, who was so thin, who never ate pork and who awoke at four in the morning to tend his rubber plantations? He was a Moslem, he would not even have been flavoured with rice wine.

The horror of it was just too baroque; we laughed as if it were "Monty Python". But what of Soraya's uncle, who dragged with him all that day, WITHOUT KNOWING IT, his own skeleton, his own pitiful epitaph: "I'll

be home tonight." It was the man's fate to be mourned with uneasy laughter. The fearful laughter of the alien, the death which had no business to happen — the heavy paw of the tiger on the bicycle wheel.

The mind's eye becomes the eye of the day, *mata hari* rising above the humid tiger-haunted Malay night. The eye of the day, the sun, sees the last remains — one hand on the jungle path, the bicycle twisted and overturned. Soraya's aunt blinks at the eye of the day in her weeping and her shame, when she discovers the bit of him for human burial, the rest of him buried prematurely in the tiger's swollen belly. We now see the tiger. Do we forget our own fail-safe recipes, do we become nonexistents, creatures of shame in the face of the eye of the day? We take the lamp-yellow eyes to be bright with hunting passion, we let the tiger burn too bright too close, and close ourselves to the grotesque indifference, the comedy of death.

Wyang golek: wooden puppets used for shadow plays
Kris: Indonesian weapon like a long dagger with twisted blade
Warungs: street stalls in Indonesia
Mata hari: the sun (literally "eye of the day")

A View on Europe from My Mother's Window

Lolo Houbein

"Put your feet up, Ma,
I'll do the dishes."
 And afterwards
 I wipe the solid plastic tablecloth
 with design of Aaron's lilies
 and bang red plastic roses
 in tasteful imitation urn
 just off-centre for
 maximum artistic effect.
 We never cared for symmetry
 or centredness
 in our family.

 Negroes walk along
 my mother's street
 as if they were at home . . .
 which they are.
The newspaper delivery boy
she says is Turkish —
as if that explains anything . . .
 Mother knows all there is to know
 about the Turks.
 Their offsprings flourish delightfully
 in our family,
 although she thinks
 they're Dutch!
Today she decides
the Turkish boy will probably forget

255

to bring her stale world news —
 He's training brother number two
 to do the paper round.
 All the Turks think of
 is earning money, growing rich
 beyond the ordinary dreams of people
 born native to this land.

In tight anticipation she stands
girthed in late life's knowledge
behind the fishnet curtains
which allow full vision
while preserving privacy.
 Tousle-haired boys race on bikes
 down the one-way street —
 it's brother number two
 training brother number three
 and they do not disappoint her:
 they fail to bring her paper.
 She rushes out the door
 calling "Uhuuu!"
 Every culture grows its own
 peculiar noises
 to demand attention —
 the Turks surely grew others.
She sharply claps her hands in the crisp air
and because they go to school in this cold land
the cultures briefly overlap
and number two comes wheeling back
all smiles and no apologies.
"I knew it beforehand,"
she declares triumphantly about her
self-fulfilling minor prophecy

and I reflect that she is
— culturally at least — secure.

It is passing strange
to view the changing world
from my mother's window
after twenty short years.
 Ten long years ago
 my brother enlarged the frame
 to let more light in —
 Now they can watch so much better
 the progress of the immigrants
 from south to north —
 there is no turning back
 along this one-way throughfare

The Motor Car Works

Mavis Yen

The following is part of a sequence of stories set in China from the 1950s onwards, and thus incorporates the turbulent period of the Cultural Revolution. The setting is an imaginary foreign language publishing house, and the present story, the fourth in the series, deals with the heady days of trying to catch up with the West. The publishing house decides to set up its own language school to meet future staff requirements. Members of the translation department are asked to teach in a rotation, but the students demand short cuts. The visit to the motor car works proves that hard work is the only answer.

"Some people say the best English is in the Bible. What about Sha Shi Pi Ya, the author of *Hamlet*? Do we want to study Shakespeare? Of course we do. But not just now."

The speaker was Chang, the most senior student at the Four Seas new language school. He stood in line for a vice-directorship of the publishing house, and was now student representative on the school committee. Chang was delivering the main speech at the school's opening ceremony.

"Did you hear that?" Tiger whispered to his neighbour, Chen.

Tiger, in his early fifties, was the translation department's most senior translator. Although his surname was Hu, it was not synonymous with the character *Hu* for tiger. But because he had a sharp tongue, he was dubbed *Lao Hu*, Tiger, anyhow. He had a reputation

for being able to translate ten thousand Chinese characters into English in one day.

Chen was in his mid-twenties. He aspired to become a translator like Tiger. For this reason, Chen had volunteered to teach at the school when Tiger was borrowed from the translation department. The school's senior class comprised leading members of the publishing house who insisted that Tiger should teach them. They would accept no-one else.

Speaker after speaker rose at the meeting to assert their determination to master the English language. "We might even contribute to the English vocabulary," suggested one. "There must be some words they don't have in English for Chinese things. We can create them!"

"Two thousand words, five thousand words, ten thousand words, string it all together and you know English! I've been studying English all my life and I still can't claim to know it. Who do they think they are?" asked Tiger.

"But it's their spirit that counts," said Chen. "With a spirit like that we can do anything."

"Reaching for the moon," said Tiger.

"At least the refreshments are up to standard," Little Jade whispered to Barbara at the reception after the meeting. "It looks as if they are going to respect the teachers in the traditional way."

It had all begun with the news that the first motor-car factory had started producing trucks. Until then, all motor vehicles were imported and most of the petroleum was imported too. The news of the first motor cars had electrified the whole country. The leadership of the publishing house had felt spurred on to new goals. They quickly decided to run their own language school.

"This way," Madame Yu had explained to the transla-

tion department at a staff meeting, "we can train our own personnel in future. Instead of relying on the colleges for graduates each year and then having to retrain them, we will teach the skills we need."

The idea was that everyone in Four Seas working at a desk should try to master a foreign language. Young school-leavers, or middle-school graduates, would be trained to do ancillary work. At the same time, staff members would be sent to the school on full pay to study English or some other language that was required. In order to meet running expenses, paying students from other organisations would also be accepted.

Where would the teachers come from, asked the translators?

From self reliance, replied Madame Yu, the head of the translation department. Hadn't Four Seas one of the best translation forces in the country? Wasn't this the most likely source? The translation staff would be invited to pass on their skills at the school in rotation. Teach for a while and work for a while.

"Will we get holidays like in the colleges?" asked Lim, who was born in Indonesia and made the best coffee in Four Seas.

"Of course, I can't speak for the school," said Madame Yu. "So far, only schools and colleges have annual holidays, I don't see why the teachers at our own school shouldn't be treated the same way."

"Wishful thinking," said Tiger. "Just wait and see."

Besides Tiger and Chen, also to teach at the school were Barbara Lee, valued as a native speaker, and Little Jade, a new college graduate. Virginia Green, the Australian expert, would be invited to give talks, she was told, but meanwhile she would continue to work in the translation department.

"This is the life for me," thought Barbara when the

dean told his audience that the school would show films in English and other languages on Saturday afternoons. There would be monthly excursions to places of interest. "Just what I've been missing all this time," she concluded.

The school was located in the Peking suburbs where Four Seas had started an ambitious housing project. Eventually, the plan was to rehouse every member of the staff. Meanwhile, the school occupied an entire block of unfinished apartments and the students took over the task of caring for the environment. Once a week, they turned out in force to tidy up the grounds.

At their first meetings, the students outlined their hopes to the teachers.

"Give us the keys to the English language," said one.

"Think up ways so that we can master English quickly," said another.

Barbara's class wanted to learn to speak English. "But we are not imitation ocean-devils," complained a male student. "Why can't we speak the way we speak in Chinese? We don't feel comfortable saying 'would you mind?' "

Did they have to learn English grammar? The tenses baffled them. Filling in blanks was torture. Idiomatic English was their greatest enemy. They felt foolish.

"We shouldn't say the Yangtze river," said a fee-paying student from another organisation. "The river's proper name is the Long River."

"You can say anything you like," Barbara argued. "No-one can stop you. But don't you think it's important to be able to understand English-speaking people and they you?"

The teachers had to draw up long lists of vocabulary to go with each lesson. The students said they didn't want to waste time thumbing through dictionaries.

"I can't stand it any more," Tiger told Barbara within a few weeks, as he nibbled a steamed bun and picked at a plate of shredded pork and *wongbok* cabbage for his lunch.

"They insist on learning English by doing translation. They suggested I should learn from Little Jade whose students say she's such a good teacher. Actually Little Jade's students are using a proper textbook. So I countered that we should invite Little Jade to give them some classes in English grammar. Do you know what they said? They said they weren't primary school students. They didn't come to learn grammar. They came to learn how to translate. If you didn't know Chinese you'd never understand what they are trying to say. It takes me two hours to correct each person's homework and they want it returned right away."

Chen was luckier. He was assigned to teach staff members of a much lower status. They, on their part, were only too glad to have the opportunity to study. They had less complaints.

But Chen, too, had his ups and downs. The dean accepted a proposal by the students. This was to ask the teachers to give up a Sunday to compiling and typing texts. This way, there would be no danger of their study program lagging behind. Chen was upset the whole day. When Tiger found out the reason he immediately phoned his French wife, Louise.

Chen always spent Sunday with his girlfriend, Mei Mei. With everyone working six days a week, Sunday was precious. Parents looked forward to sharing the day with their children, particularly if they spent the week in nurseries. Young people sought out friends of the opposite sex.

"Louise is putting on a French dinner tonight," Tiger told Chen, "so bring Mei Mei round for supper."

Louise preferred trying her hand at Chinese cooking, but Tiger knew young people liked Western-style cooking. To them it was exotic. It made all the difference in the world.

Chen recovered his equilibrium after that.

Of all the new teachers, however, it was Little Jade who made the greatest progress. Because she was a new and untried member of the staff, she was assigned to teach the school-leaver recruits, Class A. Little Jade was not long out of college herself. She was modest. Besides having no airs, she had the knack of being able to dispel the trainees' problems. They felt at ease with her. They willingly rose early every morning and could be heard twisting their tongues around strange sounds in the out-of-doors.

"I'm a new student . . . Let me help you . . ."

But generally, the students were dissatisfied with their progress and they blamed the teachers.

Then suddenly, the tension that had steadily been building up relaxed.

"We're going to visit a motor car works this afternoon," Little Jade told Barbara during the mid-morning exercise break.

"A motor car works," said Barbara. "I didn't know they had one in Peking."

"Oh yes," said Chen. "This works has succeeded in making a car, right here in Peking. The student rep, Chang, knows the manager and arranged our visit."

"Do you mean to say that cars are being made right here in Peking?" asked Barbara.

"It's been kept a secret until now," said Chen. "Just imagine, if we can make motor cars we can do anything!"

That afternoon, everyone was on time to catch the buses assigned to deliver them to the motor car works.

The students saw to it that no teacher went without a seat. It was late spring and the lilac was in full bloom.

One of the managers met them at the entrance to the works, which was plastered with posters and notices.

"We hear you've succeeded in making a motor car," said Chang, the student rep. "We'd like to hear how you did it and we'd like to see the car too, if possible."

The manager smiled modestly.

"We just thought we'd try and see if we could produce a car," he said. "Yes, you can see it, but you mustn't expect too much."

The students pressed after the manager as he led them on a tour of inspection.

Little Jade caught up with Barbara.

"I've just been reading the posters at the entrance," Little Jade said. "One was a criticism of a woman worker for not turning up at the night school. It seems that it's compulsory to go to night school here."

In the first workshop they visited, young women in white jackets sat on benches. They made adjustments to the same types of small parts that kept stopping before them on a transmission belt.

"What are you making?" Chen asked the girl in front of him.

"These are bearings," she replied. "We're just checking them."

The belt stopped again and she busied herself. Chen escaped in search of the motor car.

The manager led the visitors through shop after shop where similar scenes were repeated. Some of the senior students professed interest but the trainees showed impatience to move on.

"When are we going to see that car?" Tiger asked Chen.

Class A was almost through the door of the first building they were in, when the manager halted.

"Before we leave here," the manager said, "I'd like to show you the canteen."

"I thought we came to see a motor car," Tiger whispered again to Chen.

"This way please," said the manager as some of the students hung back at the exit, anxious to move on.

"Nobody has to wash their dishes in our canteen," he announced. "This is because we have a dishwashing machine. The canteen provides all the bowls and chopsticks."

A dishwashing machine! Now that was an innovation. The best Four Seas could do was to provide the hot water. Everyone who ate in the canteen had to wash their own container and chopsticks.

The students surged towards the kitchen while the women staff eyed the visitors curiously. The staff wore white jackets and caps and were stacking dishes onto a moving belt. The belt travelled along a giant tunnel that was filled with steam.

"By the time the dishes come out, they are sterilised as well," the manager said.

"Where did you get this machine from?" asked Tiger, his mood mellowing. "This is what we need in Four Seas," he added to Chen.

"We built it ourselves," the manager said proudly. "Our engineers designed it."

"Ah, self reliance," said Chen.

"They're working on a dumpling machine now. Everybody likes dumplings but we don't have the manpower to wrap them. Once we get this machine, we'll have dumplings every day."

"I like dumplings too," said Chen, "but we never have them in Four Seas.

"Our plan is to eliminate queueing in the canteen within a year," the manager said as they left the building.

They entered another building and climbed a flight of stairs. It was already four o'clock and they were due back at the school by five.

"I don't want you to miss seeing the evening school," the manager said.

Classes were already in session.

"I thought you said it was an evening school," said Tiger.

It's our habit to call it the evening school," said the manager. "We have classes in the afternoon for our nightshift workers."

"What subjects do you teach?" asked Tiger.

"Everything from primary school to college level. Some of our older workers haven't had much schooling, so we encourage them to go right through to middle school."

"Where do you get your teachers from?"

"From the staff. The engineers teach college level subjects."

"Are we going to see the car you made?" ventured one of the trainee students.

"Oh yes, we're on our way there now," said the manager. "But I didn't want you to miss the evening school."

The manager led the Four Seas visitors some distance across the compound, away from the main workshops. They stopped before a low garage-type building.

"I must remind you," said the manager, "that we aren't operating under ideal conditions. After all, we are only a repair works."

"But you've built a car," said Chen.

"Well, we thought we'd see if we could," said the manager. "None of us had any experience. We were afraid we might fail. At times we even thought of giving up."

"But you didn't and you succeeded," said Chen.

"Please enter," said the manager.

Three well-preserved vintage cars stood at one end of the workshop. One was black, another maroon and the third green.

"Ah, the models," Barbara said to Little Jade.

"And where is your car?" asked Chen.

"Three of them," said the manager, trying to hold back his pride. "It is very hard work. It was all done by hand."

"By hand," was the shocked whisper that rebounded among the visitors.

English as a Sekon Langwidge

Anna-Maria Dell'Oso

As wattle dusts the air, the scent of spring's changes tickles people's imaginations. You can almost hear the sawing and buzzing of new life-plans being built. Spring is a warm-up for summer's self-improvement courses. Already the WEA is in the thick of its new season's evening classes. Soon the literary sections of newspapers will start to sprout ads for the summer language schools.

The formally-acquired Second Language has always enjoyed an aura of worthiness. A "Sekon Langwidge", as the middle-aged ladies who chatted with Mamma outside Woolworths would say to me, was a "Good Thing To Have" — along with a clean handkerchief, name tags sewn to my uniform and blotting paper for when my Osmiroid pen squirted ink into my paws.

I'd scuff my heels into the pavement and scowl as Mamma worriedly confided that, yes, Anna-Maria's English was good now, but the family had difficulty getting me to speak Italian these days. I'd kick Mamma's ankle and bite her arm. Mamma did not seem to understand that the vocabulary of my seven-year-old world was rapidly dividing into two cassette tapes, one labelled "Useful" and the other "Useless".

The language of "Useful" was getting so huge that it was threatening to spill into another tape by the end of the year. "Useless", however, was shrinking. More and more was being erased from it, a disturbing phenomenon for which I could not account, seeing I had started out with hundreds of "Useless" words and only a few "Useful" ones. It made me feel guilty and sad. Mostly, however, I felt rebellious and frustrated.

Survival in the schoolground demanded a precise command of a bewildering vocabulary of insults. At last, I was mastering them. Yet why did my parents persist in caring more about "Useless" than "Useful?"

My mother always seemed close to tears as she talked about my diminishing Italian tape, as if I simply wasn't trying to stop the erasures. It wasn't too much to ask why, was it? she'd say, warming to the injustice. It would stand me in good stead later, wouldn't it? The ladies outside Woolworths would nod sagely at my mother's eccentric English, saying, "Ooh, yers, yers . . . always good to 'ave a Sekon Langwidge, ooh, too right, yers . . ."

It never occurred to me that this Sekon Langwidge was the domestic word system I quarrelled and refused to eat silverbeet with, the phrases I sobbed in, the language of my tantrums, my chats to my siblings and the stories I told to Papa. My inner language tapes had turned an ironic full circle so that my native tongue was reduced to a hobby. Yet, when I started school, English was my Sekon Langwidge. There was no attitude of the WEA summer school or self-improving growth about learning it. No, in 1960, "English as a Second Language" did not exist. The reality of the two tapes jamming inside the heads of thousands of migrant children was ignored.

I remember my early attempts to fiddle with the new cassette of "Useful" without any instructions, when I read that, despite the outraged lobby from both teachers and parents, the federal government has stood firm on its decision to cut funding to the English as a Second Language (ESL) programs. It reveals a cynical set of social priorities. Migrant parents cannot be blamed for seeing the $30 million slash as a government policy to keep their children educated for nothing but the factory line.

Strangely, the ESL cuts have prompted a spate of gruff praise for the good ol' playground system of Aussie language-learning where "children are thrown in the deep end — like the children of the first wave of post-war immigrants". The writers of this bizarre drivel couldn't have hung around the back of the shelter-shed at my school or, if they did, they must have been my tormentors. They wouldn't laud the Deep-End system so glibly if they'd been humiliated by drowning in the swill of cultural dumbness themselves.

Writing is now perhaps my revenge for the years I squinted at infants' picture books when the rest of the class was using readers. I developed a fear of questions that was rivalled only by the class dyslexic who shared the same predicament at being "sprung" by the English.

Later came the burden of being assigned the newly-arrived Italian children who would dog my heels for months. Upon these hapless Marias and Giovannis I would practise all cruelties that had been taught unto me and, in my blindness, I led them further into the academic darkness. My mother was so upset by the plight of one of these children that she rummaged in her old blue trunk for one of her childhood books, a yellowing tome with no cover, written in archaic Italian. I presented it to the child who took one look at it, politely put it down and burst into tears.

If the Shelter-shed System of Osmosis Learning is so successful, why not further slash the education budget and let the kiddies pick up biology and maths from each other at the monkey bars?

No, the assimilation of the 1950s and 1960s was a savage process which forced us to choose between the brutalities of "Useful" and "Useless", and no matter which cassette tape we identified with, we were losers, either culturally or academically or both.

The most bitter irony of all was in high school, where the official Sekon Langwidge was French. If we wanted "community languages" (which never had the status of French and German), we had to travel miles to study on weekends. We migrant students were failing to communicate with our parents but we could conjure the verb *"entre"*. I sat HSC French while being illiterate in my native language.

I would be as hopeless at my Sekon Langwidge of English if it were not for the efforts of an eccentric teacher, a Mr Geoffrey A. Jones, who in the 1960s ran his private version of the ESL program. During the holiday, he rounded together all the non-English speaking children of our primary school and coached us without pay.

Mr Geoffrey A. Jones (as he'd scrawl it for us on the blackboard) is perhaps an old man now. If he should by some chance read this, he may be disgusted to realise that the more things change the more they stay the same. As the blocked ESL program brings us back to the cultural wars of the 1950s, I'm enrolling in Italian lessons.

This summer, I'll be playing back an old language tape that is all but totally erased.

Tell Me a Fable

Olha Terlecka

Please, tell me a fable, so one can forget sorrow
Let's pretend that I am back home, not here,
Where the cuckoo bird foretold us of tomorrow,
Where cornflowers bloomed in the field each year.

Music in the cornfield, meadows full of flowers,
Song of nightingale, that rang so true,
Mornings in the springtime, washed in dews' showers,
And periwinkle's bloom in glorious blue.

Darkness of the night, that covers a girl's fast
 running,
In the woods she sings a song of spring,
And mysterious moon, from behind the clouds
 shining,
Puts a romantic spell on a young girl's dream.

Because of the fable, I might break all boundaries
And go, where I was born a long time ago.
But please, continue the story, let the reminiscences,
Remind me, that it really was just so.

Don't take any notice, when my heart starts crying,
And is full of sorrow and misery.
For I am so longing to see the orchards swaying,
And the nests of daws on forest trees.

Perhaps dreams of homeland, will come to me always,
Where a girl with garland on her head
Singing the song of summer, walking in the
 cornfields . . .
But please, continue the story, go ahead.

Bygone it is all now, only the fable flowers
In my heart. Forever it will stay.
Even if it still is crying, hour after hour,
I will not let the fable fade away.

My heart is still breaking and I feel a deep sorrow,
How can I in a strange country not grieve
Back home forget-me-nots bloom now, and will
 tomorrow,
But fables will give me strength, so I can live.

РОЗКАЖИ МЕНІ КАЗКУ

Olha Terlecka

Розкажи ту казку – горе, щоб забула.
Щоб здавалось вдома я, не тут.
Як зозуля в лісі, там колись закула.
А в житах, волошки, як цвітуть.

Ниви, як шуміли піснею, весною.
Соловейко, як в гілках співав.
Ранки там вмивались свіжоюь росою.
І барвінок синьо розцвітав.

Чорнобривка в ночі в гай, як вибігає,
Свіжу там оспівує весну.
Місяць так приємно з хмарки випливає,
Чари дівчині снує до сну.

Може в казці тій полину знов до краю,
Де жила я, дуже так давно.
Лиш продовжуй, прошу, хай я пригадаю
Все, що доля кинула на дно.

Не зважай, що в мене навернуться сльози.
Певне, серце притиснуть жалі.
Я так хочу бачить сад і верболози,
І гніздо галок, там на гіллі.

Хочу, щоб країна снилась та ночами,
Де з колосся житнього в вінку,
З піснею верталась дівчина полями,
Казку все послухаю таку.

Все те десь минулось, казка ще зосталась.
В серці буду все її носить.
Хоч з очей, з куточка і сльоза скотилась,
Все ж ту казку буду я любить.

Знов кажи, хоч серце ще зомліє нині,
Як в краю чужому не тужить?
Пригадай ту землю, незабудьки сині,
Бо тут казка та, — поможе жить.

Concrete poem no. 4: Migration

thalia

⌐ : *Multicultural
(in shorthand)*

~ : *Migrate (in shorthand)*

Notes

The very process of compiling an anthology involves making a *space* for certain writers. But writers, through the very act of writing, already claim a space. An anthology works only to make those claimed spaces public, and to define them in relation to other such public spaces (other texts and anthologies).

There are many ways of ordering an anthology, ranging from an alphabetical organisation to a host of arrangements somehow relating to ideas of what the writing may be about, and how the ideas may be interpreted. While an alphabetical arrangement might be the most democratic, we've chosen to pursue an arrangement which allowed us some exploration of the spaces that individual writers claim, and the positions from which they choose to write.

The anthology falls then, into three loose sections. The first, from thalia's "Camouflage" to Jeltje's "Jeltje", pertains, at its most simple, to varieties of writing. The second, from thalia's "Tides" to Cummins's "Communion" relates to notions of identity and woman, and how these are constructed. The third, from Dowse's "Marginalia" to thalia's "Migration" is linked mainly to perceptions of culture and cultural difference.

It is important to note that this arrangement aligns only with our own preferences as editors. Its shaping in this way is merely a loosely-ordered reflection of the many exciting challenges *we* find within the writing, challenges to firm and fixed notions about writing, women, and cultural diversity.

Part I: "Writing, rather than confession . . ."

"Camouflage", by thalia, makes a provocative beginning to the whole anthology, as well as to its first section. In its defiance of comfortable assumptions about "writing" and "meaning", this piece prefigures many that follow. While the piece is entitled a poem, can we be sure whether we see (a sketch) or read (some language that is and is not English)? Words in an alphabet are mere drawings, after all, to those for whom the alphabet is unknown. Where is the "voice" in this poem? How do we pin down a "speaker"? How, indeed, can we determine meaning with any confidence at all?

We do know what it is not. It isn't a documentary-like record, or even a narrative commentary of the kind most associated with those writing from a multitude of diasporas, hungry to tell of their dispossessions. This piece makes a much larger claim — a leap for a witty, punning, visual space that refers back to a strong European tradition of concrete poetry (as well as to other more local ones), while making a new space, one which appropriates the shorthand of a dominant language and reduces even that to a new and individual statement. In this, and not only in the naming of the poem, thalia's "Camouflage" declares that its maker is acutely conscious of, taking charge of, the process of making.

Many of the pieces in the volume's first section offer explicit, even blatant refusals to follow traditional writing forms and themes — perhaps most particularly those traditions judged to be most fitting to the "woman" or the "migrant" writer: confession, diary, autobiography, oral history. One of the ways through which this refusal can be discerned, is in the deliberate

insertion, by some writers, of a fully aware, writing "self" into the text. This "self" is a quite consciously-constructed subject, aware of the many shifting positions and powers exercised through the act of writing. So, we find, for example, Irene Vlachou in "night": ". . . he's not the subject of my story. not tonight. i'm still searching for the subject. it constantly eludes me . . ." Not only does Vlachou insert an "I" (or "i"), a writing subject, she also plays with the common practice of reading the meaning of a story as "character" (no, it is not the "intruder"). And, she confronts ideas about interpretation directly, within the text, reminding us that meaning is far more likely to be chaotic, even frightening, than static and sure: ". . . just when i put my finger on it & say yes, that's it, some new explanation, some new thread of a theme, pops itself into view & shatters my well being." Her refusal to conform to accepted practices in English punctuation and typography reinforces the disruptiveness of her refusal to conform to traditional "realist" narrative practices.

In "The Headlines That Never Made It", Sue Kucharova also inserts an intrusive, writing self, but her use of that self, and its power, is markedly different from Vlachou's. Kucharova's story at first seems to align more with traditional narratives in its illusions of realism, its formal syntax, its evocations of the thriller genre and conventions of suspense. Her resistance to convention is displayed, however, in the role given to the I/writer, that very knowing subject — it is to rescue the "she", the other subject, the one who does not know. The "I" re-shapes, quite overtly, another discourse (a newspaper headline, story, photograph) to a different conclusion, a more satisfactory closure. Without the "I", that "she" of the story is as powerless as the "she" of the headlines. (And, no I/writer, of course, can save the

"she" implied by the newspaper headline, the real woman who died.)

Kucharova's challenge is twofold: to a social ideology that places "woman" passively, powerlessly subject to violence (a woman will die rather than act), and to absent authors creating unknowing subjects — "now I want her to wake up. She has to. I've put an intruder in her house." Kucharova's intruder, unlike Vlachou's, can only be routed through the combined aggression of the unknowing and the knowing subject: "she and I hit once more." The danger of not taking charge of the intruder hinted at by Vlachou, is spelt out by Kucharova: "I would like her to realise that waiting turns the hunted into the hunter and her only way to survive is to wait and act."

Francoise Chaimbault's "Pages Volantes" takes the insertion of a writing self far beyond a textual reminder that every text is shaped, by someone, who can, if she chooses, declare her interest directly. The whole focus of Chaimbault's piece is to explore what it is to be a writer, and a feminist one at that. Chaimbault's I/writer is in the process of, not so much searching out a tradition as, seeking a place in a tradition of which she is fully aware. She does this through her questioning and quoting of published feminist writers and writings, and her delightful eagerness to blur the generic edges. Would you call this piece an essay? a narrative poem? a diary? an acadamic article? That we cannot say precisely, indicates a writer who knows exactly where those "edges" have previously been placed.

Inez Baranay, on the other hand, reaches for a different kind of space. With a narrative approach that is breathless and wry, bursting through the formal demands of written language, she chooses a more collective position from which to speak. Baranay's writer/sub-

ject is more "we" than "I", a collective voice in exuberant debate of whose and what "Australia" is. "B", writes Baranay, "had been asked to write about growing up migrant so let's remember what we're here for and she takes up her pen. And we all go 'black bread and salami' and laugh because that's the only way a migrant childhood story can start." Baranay has already, in fact, begun Part 2 of "You Don't Whinge" with the collective statement: "We've all got a black-bread-and-salami-story."

The confidence that many of the writers in this volume display towards taking over and playing with traditional forms and subjects, can be found not only in the declaring of a writing self, but also in the camouflaging of it.

Rosa Cappiello's narrator, for example, seems more the clown in a mask, using the dramatic voice of a salacious, rakish old man to test notions of cultural "others" and outsiders. Her work, "10/20 Dogs Under the Bed", refers back, not to Anglo-Celtic traditions, but to a long Italian tradition reaching from Rabelais, to Pasolini, a tradition which uses the positions and perspectives of those at the bottom of the social heap, its outcasts, to question social margins and inequities. The old man's crude treatment of his "bitches" (both dogs and women), the narrative's humour, provoke questions about who Cappiello would suggest rests at the bottom of the heap — women? migrants?

Refusing, disrupting, interrogating not only traditional forms, but also traditional mythologies, provides, for some of the writers in this section, other ways of situating multicultural writing. Margaret Diesendorf's "Taronga Park Zoo" sequence, for example, gently and humorously probes a cherished "Aussie" entertainment (the zoo) only to produce . . . an ululating goldfish

perhaps in need of a "marine psychiatrist". Jo Jarrah harnesses that fearsome national archetype (endlessly exported), the saltwater crocodile, to outrageously satirise the absurd suspicions a dominant culture can form towards its intruders, its alien immigrants:

A lot of exotic plants have been brought here and they've escaped out of gardens.
they will come to people's soft fruit trees and they will do considerable damage.
Do they widdle on you?
No, they're very well behaved in that matter.
Do they eat you?
?

The intricate games of Vavere's "Ultima Thule", on the other hand, remind us that the mythologies invoked will not necessarily be what Baranay terms "the imagined tradition" of Australia, nor even the dominant, western European line from Ancient Grease and Rome. The more numerous and diverse the roots of a multicultural society, the more diverse the cultural and literary traditions to be measured, questioned and reshaped.

PART II: "What makes a real woman . . . ?"

Much of the writing in this second section explores the cultural spaces given to women, or made and remade by them. These spaces seem most to seek to fit "identity" and "woman" together, or to endeavour somehow to transcend them.

Ruby Langford's, "My Names", invokes one of the more recently controversial debates about the ways in which identity is constructed for and around women (although not in all cultures and societies). Identity can be given or taken away through names, the receiving and the changing of them, and all in the name of relationships of blood, or alleged affection. Langford, through an "I" who offers her own version of her naming, strongly reclaims some separate space, some identity. The reclaiming returns to Langford's protagonist the power to decide what she will be named, the power to give, at last, permission: "*You can think of me* [our emphasis] as Ruby Wagtail Big Noise Anderson Rango Ando Heifer Andy Langford. How I got to be Ruby Langford. Originally from the Bunjulung people." Langford's last sentence is a poignant reminder that naming and oppression are linked, not only in the marginalisation of woman, but also in the subordination of marginal societies to dominant ones. There is very little left in Langford's anglicised names to represent her Aboriginal heritage. Her story also, inevitably, evokes the experiences of many generations of non-English-speaking migrants to Australia who anglicised their names in order to gain acceptance.

That trying to shape and reshape identity is painful, is

undeniable. Alba Romano's narrator in "Night and Snow" makes no attempt to hide that pain:

"Doubting my being, and my name
I look back and existence
is confirmed by deep footprints,
ridiculous alternating impressions."

On the other hand, Patricia Pengilley diverts us from the pain, through humour. Her teenage Sally, in "The Case of the Vanishing Princess: Sally's Tale", is trying to construct not only a "female" identity acceptable to her pressuring peers, but a cultural one, too, acceptable to "bloody white Australia". Sally's rewritten application makes a bravely defiant attempt to rewrite (as Kucharova's I/writer does) the rules, to lay claim to spaces that could not exist, except in fantasy.

Silvana Gardner's "Assyrian Princess", with its generic echoes of science fiction, exploits the fantastic deliberately, in order to explore the constant limits, the inhibitions imposed on any woman trying to self-construct an identity. Her older, wiser princess remains, like Sally, misunderstood, and powerless.

Love in its diversity of guises, has traditionally constructed "woman". But coupling, as any kind of path to identity, does not go unchallenged here. Angelika Fremd writes sardonically:

"Love? Walking backwards
or dragging the other along
as if dead?"

Vasso Kalamaras may mourn, but is clear:

"The truth is bitter.
we are like everyone
Two strangers."

In "Mal Tombée", Dewi Anggraeni obliquely reexamines a more brutal stereotype — the white, rapacious male, and his non-white victim. Here, the vic-

tim, rather than hating her seducer, remembers her other-cultural encounter only with longing. She longs for the moment, and the man, no matter how exploitative both he and his culture have been, or how that longing may threaten her present.

Blood relationships have provided another space in which women have sought to define identity, although it is only more recently that women have examined for themselves "mothers" and "daughters". Many pieces in this section (e.g., by Brett, FitzGerald, Fremd, Walwicz and Kuna) explore and question the patterning that comes from family links. Chitra Fernando's "The Other Country" qualifies, however, the notion that one who has made a cultural shift is nevertheless forever fixed in the first culture, in those first, filial affections. Fernando's Rupa, on returning to Sri Lanka, finds that this country, and not Australia is "the other country" — that she longs for Sydney. Evasive with her parents about a proposed marriage, Rupa can only question the cultural spaces allowed her as a woman. Neither family, nor the possibility of marriage, can reflect or encompass the Rupa she has been able to shape in another (but not *the* other) country.

"In "Evelyn's Eighty-ninth Waltz with Summer", Barbi Wels tenderly and wittily explores a different, often taboo space — "old woman". Her Evelyn of the eighty-eight summers, alone, and independent, chooses to dismantle her life, outwitting Time ("with the usual interchangeable blonde on his arm") by choosing to die when *she* is ready.

Wels, like many of the writers in this volume, is unafraid to sift through cultural ritual and conditioning, to challenge any stereotypic notion of "real woman".

PART III: "English plus . . ."

It is the focus of much of the writing in this last section which demands that we reconsider the distinctions between "migrant" and "multicultural" writing, between those whose displacement is recent, and those who have either been in Australia for much of their lives, or whose multicultural links are inherited. For the latter, any dialogue with "culture" or "place" has very little to do with the tensions between any "old country" and this, new "Australia". Both "culture" and "place" become usable constructs, moveable feasts. Where, for example, should we situate Mavis Yen's mysterious "China" in her piece, "The Motor Car Works"? How would we interpret the ending of the story — is the joke against the narrator or the Western reader?

Sarah Dowse's "Marginalia" illustrates the dangers of simplistic assumptions about cultural difference: Dowse's narrator, already practiced in testing margins because of the place assigned to her as a Jew in America, at first finds a shift of geographical place liberating, only to find, of course, that every society has its marginalised groups and places.

Devika Alfred, in "Consider the ferns, the coconut trees, the rain . . ." places the clashing of cultural expectations, not, as we might expect of "migrant" writing, between East and West, but within an eastern place whose dominant group projects the burden of the "primitive" onto its own forest tribes.

It is the ease with which many of these writers invent "place" that suggests a position not at war with any new place, but incorporating it, and fashioning others.

Sophie Masson, for example, uses a non-Anglo cultural archetype, "the tiger", with very subtle humour,

to question notions of cultural belief, even superstition. Uyen Loewald in "The Gecko Cure" offers, in a narrative pacing that is itself "unwestern" (things come together in a rush at the end), a "Vietnam", a place where familiar European distinctions between superstition and belief would seem impossible.

While Dell'Oso's "English as a Sekon Langwidge" would remind us that "multicultural" is the end product of immigration, thalia's "Migration", if we read it as we read in English, from left to right, would suggest that "migrant" is the small "eye" of the larger "multicultural", thus emphasising the strength and potential of a society made up of cultural diversity. Such "eyes" must remain open and all-seeing.

It is because of this larger view, or focus, that much of the writing in this anthology deserves to be examined in any consideration of what "Australian writing", "Australian literature" may be.

Sneja Gunew
Jan Mahyuddin

Biographical Notes

Alfred, Devika
"Consider the ferns, the coconut trees, the rain . . ."
 Born Singapore, 1959, and emigrated to Australia at the age of twenty-one. Completed degree in journalism at the Canberra CAE, and moved to Melbourne in 1985. Current interests include multicultural issues and feminism.

Anggraeni, Dewi
"Mal Tombée"
 Born Indonesia. Currently assistant editor *Indonesian Studies* and employed as an ESL teacher, as well as being the Australian correspondent for *Tempo*, the main news and current affairs magazine in Indonesia. Her novel, *The Root of All Evil*, has recently been published.

Baranay, Inez
"You Don't Whinge"
 Born without nationality in Italy of Hungarian parents. Became a rootless cosmopolitan by being brought to Australia as an infant. Became an Australian by travelling abroad as an adult writer and journalist. Lives alone in Sydney.

Brett, Lily
"On the Way to Lodz"
"On My First Morning"
"People With Pallid Faces"
 Born Germany, migrated to Australia, 1948. Has contributed articles, poems and short stories to Australian magazines and reviews. In 1986, she won the Mattara Poetry Prize for her poem "Poland". Her first book, *The Auschwitz Poems*, won the C.J. Dennis Prize for Poetry in the Victorian Premier's Literary Awards, 1987. Her new book, *Poland and Other Poems*, was published by Scribe in 1987. Married to the painter David Rankin, they live in Melbourne with their three children.

Caplan, Coren
"Potential Cannibalism"
"Carpet Thoughts"
 Born 1944. Grew up in West Berlin and studied music and fine arts in Europe. Emigrated to Australia at the age of twenty-four, worked in factory jobs, then studied in Melbourne, completing a Ph. D. Lecturer at various universities. Publishes in English and German. 1977 prose writing award by IADM (International Assoc. of German-Speaking Media); 1987 prose and poetry awards by SWAG, Western Australia. 1984 first book of collected poetry *Seiltanz* (Tightrope Dance). Numerous contributions to representative and feminist anthologies in West Germany and in Australia.

Cappiello, Rosa
"10/20 Dogs Under the Bed" (Italian)
 Born Naples. Published two novels, *Semi Neri*, 1977, Edizioni delle Donne, Rome; *Paese Fortunato*, 1981, Feltrinelli, Milan. The latter was

awarded the Premio Calabria prize and was published in English by Queensland University Press. In 1982, writer-in-residence at the University of Wollongong.

Chaimbault, Francoise
"Pages Volantes"

Born 1942, Poitiers, France, of a Polish mother and a French father. Spent childhood in Poitou and the Loire region. For economic reasons, could not go to university, so married and moved to Paris where she worked as a secretary for nine years. In 1969, emigrated with her husband to Australia and has lived in Brisbane, Perth, Noumea and finally Sydney. In 1980, was accepted at Macquarie University as a mature-age student and studied part-time for a Bachelor of Arts. Completed this in 1985, majoring in philosophy and sociology. Presently living in Sydney with husband and two daughters, and is learning Polish.

Cummins, Ana Irene (nee Gioino)
"Communion" (Argentinian)

Born in Cordoba, Argentina where she graduated in journalism, modern literatures, English and French languages. Worked as a teacher and journalist, especially in a humour magazine, writing satire on social and political issues. Had her first "one woman" exhibition of paintings in Cordoba, Argentina, 1978. Worked in England from 1978 until 1980 as an interpreter/translator/journalist and teacher. Studies music and singing.

Married an Australian in Greece and migrated to Australia, 1982. Here she has worked as an interpreter/translator/teacher/co-ordinator for the Migrant Women's Artists Group, and broadcaster for Radio Station 3EA on Hispanamerican poetry, children's poetry and other topics. Participated in collective exhibitions, and has had her work published both in London and Melbourne. At present, studying visual arts, which holds the attraction of not requiring translation, and is the mother of a son.

Dell'Oso, Anna-Maria
"English as a Sekon Langwidge"

Born Collingwood, Melbourne, 1956 of Italian immigrant parents. After studying arts at Melbourne University and music at the Victorian College of the Arts, travelled to New Zealand, where she worked as a journalist for the *Christchurch Star*. In 1978, she joined the *Sydney Morning Herald* and has since worked for a variety of Sydney newspapers and magazines as a columnist and film critic. Has written short stories, an opera libretto, *The Pirate Moon* (with composer Gillian Whitehead), and a play, *Tinsel and Ashes*.

Diesendorf, Margaret
"Taronga Park Zoo"

Born and educated in Vienna and experienced two language changes before the age of seven. Arrived in Australia, 1939, and worked as language teacher and translator. Became well-known for her radio, television work and magazine publications. Associate editor of *Poetry Australia* 1967-1981. Her major publications include her volume of poems *Light*, 1981, and the double issue on Australian women poets of *Creative Moment*, Poetry Eastwest, Summer, S.C., USA, 1980.

Dowse, Sara
"Marginalia"

Was born Dale Sara Rosenthal, 1938, in Chicago, but spent most of her childhood in New York and Los Angeles. Came to Australia, 1958; ten years later graduated from Sydney University and was naturalised in 1972. Has worked as department store salesperson, bookkeeper in a missile factory, caterer, editor, academic and public service journalist. In 1974, joined the Department of the Prime Minister and Cabinet to head its first Women's Affairs Section, and resigned four years later when the unit (then the Office of Women's Affairs) was removed from the prime minister's portfolio. Her first novel, *West Block*, was published in 1983, and she has recently adapted this for the ABC. Her second, *Silver City*, based on the film script by Sophia Turkiewicz and Thomas Keneally, was published in 1984. She lives in Canberra with a biochemist and the youngest of her five children.

Factor, June
"Foreigner"
"Shadow 1"

Born Poland and arrived in Australia at the age of two. Spoke Yiddish and studied Yiddish literature. Educated Melbourne and London, has worked as a teacher and academic. Vice-president of the Victorian Council for Civil Liberties. Well known for her publications in children's literature and folklore, particularly, *Cinderella Dressed in Yella* (with I. Turner and W. Lowenstein) and *Far Out, Brussel Sprout!* Best known for her much anthologised story "The Wedding".

Fernando, Chitra
"The Other Country"

Born Sri Lanka, 1935, and educated there and in Australia, to which she migrated in 1968. Has published one collection of short stories *Three Women* (Sri Lanka, 1983; India, 1984), individual stories from which have been reprinted in anthologies in Australia, Holland and the USA. She has also published several books of children's stories in Sri Lanka. A selection of these was recently republished in India (*Kundalini and Other Stories*, 1986). Her radio play for children (*The Firebird*) was performed on the ABC in 1973 (December) and again in 1976 (May). She has also written the libretto for a children's operetta (*Dinty Blom*), performed in Hong Kong (1987). She teaches in the School of English and Linguistics, Macquarie University.

FitzGerald, Ursel
"Diary?"

Born Wilhelmshaven on the North Sea. Grew up in postwar Germany. Spent three years in the US. Migrated to Australia in 1964. Lived in Geelong since 1968, and graduated from Deakin University with a Bachelor of Arts (Hons) degree (majored in literature and philosophical studies). Has published stories, poems and critiques in *Mattoid*. Currently employed at Deakin University as a part-time assessor.

Fremd, Angelika
"Mother" (German)
"Love" (German)

Born 1944, Berlin, Germany. Migrated to Australia in 1956. Arts, Masters Qualifying degree from Queensland University, Secondary

290

Teacher's Certificate from Mt Gravatt CAE. Teacher of languages, english and history, in Queensland and PNG high schools from 1966–86. Writer-in-residence at the Migrant Resource Centre, West End in 1986; recently Writer-in-residence in the ethnic community in Tasmania. Currently Multicultural and Community Literature Officer in Queensland. Mother of five children. Co-founder of Phoenix publications and *Outrider*. Writer of school textbooks, novels, poems and stories.

Gardner, Silvana
"The Assyrian Princess"
"Peas Make the Man"

Born in Zara, Dalmatia. As migrant refugees, she and her parents settled in Brisbane, where she is an author and artist. Her fifth volume of poetry, entitled *The Devil in Nature* was published by the University of Queensland Press, February 1987.

Garolis, Jolanta
"To Virginia Cuppaidge"

Janavicius by marriage. Born Lithuania of a Russian mother and Lithuanian father, and migrated to Australia in 1949. Lives in Sydney where she is well known for her ceramics. Published poems and illustrations in *No Regrets 3* for which she also designed the cover.

Giles, Zeny (*nee* Zenovia Doratis)
"Telling Tales"

Born Sydney of a Cypriot father and Kastellorizian mother. Her writing explores the clash and mix of two systems. Has written a short novel *Between Two Worlds* about her mother's family settling in Sydney in the 1920s. In 1981, she won the *Age* Short Story Competition. In 1984, she had a play workshopped at the National Playwrights' Conference. Recently completed a book of short stories about the hot bore baths at Moree, *Miracle of the Waters* (Penguin, 1988).

Gunew, Sneja
Born 1946, West Germany, of a German mother and Bulgarian father. Emigrated to Australia at the age of four and has lived in the western suburbs of Melbourne for most of her life, with forays to Canada, England and Newcastle, NSW. Has worked as an academic in literature and women's studies since 1971, and is currently writing a book on multicultural writing in Australia. Speaks and reads (but does not write) German.

Houbein, Lolo
"A View on Europe from my Mother's Window"

Born 1934, Holland. Arrived in Australia, 1958, and lived for a short time in Papua New Guinea. Her interests are cultures, crafts and the environment. Her collection of short stories *Everything Is Real* was published by Phoenix Publications, Brisbane, 1984. Is well-known for her important bibliography *Ethnic Writings in English from Australia*. Won the 1988 ABC Bicentennial award for an unpublished novel, *Walk a Barefoot Road*.

Jarrah, Jo
"To Trap a Big Saltwater Crocodile"

Born 1952, to a Polish/German father and an English/Welsh mother. Migrated here in the 1950s. Grew up in the outer western suburbs of Melbourne, population eighty per cent non-Anglo migrant. Most of her

friends thought she was terribly British. Her few Anglo friends thought her terribly "foreign". Always, anywhere, feels slightly out of place, slightly wrong. Still.

Jeltje
"Jeltje"
"Colonialism"

Born 1951, Amsterdam. Came to Australia, 1963. Is a political poet who believes that words, particularly when close to everyday reality, can change society and that poetry belongs to everybody. Was involved in *9.2.5*, a poetry magazine about work, and was the editor of *Migrant 7*, a literary magazine for and by migrants. Anthologised in *Off the Record*, Penguin, 1985.

Kalamaras, Vasso (*nee* Papayiannaki)
"The Handshake" (Greek)
"The Two of Us" (Greek)

Born Athens. Now lives in Perth where she lectures in modern Greek at PTC. Has Associateship in Fine Art, WA. Institute of Technology, and Graduate Diploma in Education, Curtin University, WA. Has published numerous stories, poems and plays in Greece and Australia. Has won numerous awards here and in Greece, including ones from the Literature Board, Australia Council. Her work has been much anthologised and Con Castan's biography of her work and life (*Conflicts of Love*) has recently appeared. In Australia, has published volumes of poetry, "Twenty-two Poems", bilingual (English and Greek), "Landscape and Soul", (English and Greek), WA. Has also published two bilingual books of short stories, *Other Earth*, Fremantle Arts Centre Press, WA, and *Bitterness*, by Artbook, Perth, as well as a bilingual book, a play, *The Breadtrap* by Elikia, Melbourne.

Kefala, Antigone
"The Wanderer"
"Family History"
"Suicide"

Born in Rumania of Greek parents. Spent childhood there, left with family at the end of the war for Greece. After three years, the family migrated to New Zealand in 1951. Continued schooling in Greece and New Zealand. Obtained B.A. in 1958, and M.A. in 1960, from the Victoria University of Wellington. Came to Australia, December 1959. Has worked in a library, taught, and as an arts administrator with the Australia Council. Has published two volumes of poetry, (*The Alien; Thirsty Weather*); novellae (*The First Journey*); a novel (*The Island*) and a story for children (*Alexia*) as well as translations.

Krili-Kevans, Yota
"The Mask" (Greek)

Born Greece. Arrived in Australia, 1959, as a migrant worker. Poet whose work has appeared in various publications. Has a B.A. and a Dip. Ed., University of Sydney. Teaches with the NSW Department of Education. Writes both in Greek and English.

Krouk, Nora
"For Leo"

Born in China. Education at a Russian high school and College of Languages. Journalist in Russian and English (Shanghai/Hong Kong/

Tokyo/Sydney). Translator of poetry into English. Originally wrote in Russian. Published a book of poems *Even Though* in 1975. Anthologised in *Australian Women Poets*. Teacher of ikebana. Migrated to Australia, 1975.

Kucharova, Sue
"The Headlines That Never Made It"

Born in Czechoslovakia and lived there until the age of twenty. Left for England in 1969, and English became her third language. Arrived Australia, 1973 and accepted at Macquarie, 1974. Finished B.A. (anthropology), 1977, and since then worked mainly in community work. After fifteen years of unsuccessful assimilation, writing became a tool for coming to terms with her own ethnicity. Although her writing was temporarily disrupted by the arrival of a baby, she is back. Has a strong commitment to the ideals of feminism and non-tokenistic multiculturalism.

Kuna, Miriam
"Grandfathers and Little Girls"

Born to Jewish parents who migrated to Melbourne from Lodz, Poland, in 1913. Spent her childhood in the closely-knit Jewish community of pre-war North Carlton. Educated at MacRobertson High and Melbourne University. Has had careers in education, tour leading, and fashion importing and retailing. Enjoys writing short stories, verse, and one act plays, and is working on her first full-length novel.

Kunek, Srebrenka
"T.V."

Born Zagreb, Croatia, Yugoslavia. Came to Australia at the age of five and lived in Melbourne until the age of eighteen. Returned to the University of Zagreb where she gained her B.A. and M.A., while working as a translator and interpreter as well as a teacher. Returned to Australia in 1984 and is doing her Ph.D. on *The Image of the Greek Female Migrant in the Visual and Literary Text in the Post-World War II Period in Australia*. She is a visual artist, and had her first one-woman show, *Compilations*, in 1985. Exhibited *The Brides* with installation in 1987. Is working on her aural-visual installation *50 Greek-Australian Women*. Writes short stories and critical texts.

Langford, Ruby
"My Names"

Born on Box Ridge Mission in Coraki, on the north coast of NSW, 1934. Raised in Bonalbo and went to high school in Casino, finishing second form. Apprentice clothing machinist in Sydney and raised nine children, mostly by herself. Lived in the bush and the city, and is a grandmother of seventeen, last count. Lost three children, the two eldest within eight months of each other, and another one later through drugs. Decided to write her autobiography because she felt that white Australia doesn't have any idea how hard it is for halfe-castes who live between two worlds. And also because she wanted to help reconstruct black culture.

Loewald, Uyen
"The Gecko Cure"

Born Vietnam, 1940, and studied literature and mathematics at the University of Saigon. Arrested during the Diem regime in 1962, and spent six months in gaol without trial. Married an American diplomat in 1964 and left Vietnam to become an American citizen. Has lived in Australia

since 1970 and has worked as a chef and caterer. Her autobiography, *Child of Vietnam*, was published by Hyland House, 1987.

Mahyuddin, Jan

Born Griffith, NSW, 1948. In her working life, she has tutored in English at universities, taught English as a foreign language in Athens, Greece, and worked in community and women's education for TAFE, NSW. While working in the Riverina, she scripted and produced dramatic readings, presented by local Italian woman, of Italo/Australian writings. She lives and teaches in Wollongong, NSW and, in the last few years, has been writing short fiction.

Massala, Haitho

"The Pethi Mou"

Born 1959, Orbost, of Greek parents. Full-time teacher currently enrolled in Deakin University's off-campus B.A. program.

Masson, Sophie

"The Tiger

27 year-old writer and freelance journalist born in Indonesia of a French father and mother from the Spanish Basque region. Lives with partner and daughter and son in New England. Her first novel is titled *The Canadian*, and she has just completed her second novel *Prodigal*. Is currently working on a non-fiction account of Caesarean operations in Australia.

Novak, Olga

"Wrong Accent"

Born in north-eastern Poland. Lived for six years in the USSR and, for shorter period, in Germany. Migrated to Australia as a young adult. Worked hard for little pay in the garment industry's "sweatshops". Writes creatively in English only — poetry, prose, plays, film scripts.

Pengilley, Patricia

"The Case of the Vanishing Princess: Sally's Tale"

Born 1926, India. Migrated to Australia as a young adult. As a teacher of the deaf, she wrote a textbook on hearing rehabilitation for adults. Much later, she became founder and director of the HEAR Service of the Victorian Deaf Society, and was granted a Churchill Fellowship to survey rehabiliation techniques overseas. In 1986, she was awarded the inaugural Australian Association for Community Education "Community Educator of the Year Award". She has recently completed a novel, and a book of short stories.

Pietroniro, Maria Angela

"Among the Boys and Fairweathers"

Born Rome. Family moved to Montreal, Canada, 1953, where she grew up and worked mainly as an ESL teacher. In 1978, she met her Australian husband while in the Middle East on a UN assignment. She has been living mainly in Australia for the last six years and is very interested in multicultural issues. She has recently completed a graduate diploma in Multicultural Studies from Armidale CAE.

Pochon, Denise

"Reluctant Degustatrice of an Aussie Pie"

"The Definite Article"

Born 1940, Lausanne, and studied commercial law at the University of Bern. Arrived in Australia, 1961, and began writing, illustrating and

BIOGRAPHICAL NOTES

translating in 1983. Speaks French, Swiss dialect and German. Her first book of poems *Impromptu* appeared in 1985.

Romano, Alba

"Night and Snow" (Argentinian)

Born and educated in Argentina. In 1966, resigned her professorship at the University of Rosario in protest against the military regime. She accepted a teaching job from the Classical Studies Department of Monash University where she has spent most of her time in Australia. A specialist in Latin literature, she also teaches comparative studies. Along with her academic pursuits, she is involved in university politics and in the Aborigines' struggle for justice. She has taken Australian citizenship.

Safransky, Rosa

"Bonjour Brunswick!"

Currently completing a novel on a grant from the Literature Board. Won *Age* Short Story prize in 1983 and is included in *Australian Short Stories*, and *Coast to Coast*, 1986. Also won ABC Bicentennial award for short story, 1988.

Sieverding, Jutta

"I.C.U."

Born in Düsseldorf, West Germany, 1958, and came to Australia in 1960. Has been writing poetry for many years and has appeared in small magazines and newspapers. She also writes prose and has had a book of children's stories published (*Sunshine Stories*, Reed, 1981). At present, works as a freelance book editor in Sydney.

Sirianni, Vilma

"Cold Times, Warm Times"

Born of Italian parents and migrated from Italy to Australia in 1954 at the age of four. Has always written of the tension between two cultures. Married an Australianised Italian, and has two sons. Works part-time as a bank clerk and is enrolled part-time at university. Is catching up on her freedom.

Terlecka, Olha

"Tell Me a Fable" (Ukranian)

Born 1921, West Ukraine, and escaped from the Red Army to Austria, 1944. Displaced persons' camp 1946–49 where she worked as a typist-clerk. Arrived Bonegilla in 1949, and sent to fulfill work contract in Tasmania wher she stayed four years. Is currently completing her third book of poetry and prose in Ukranian. Many of her poems have been set to music and she has published widely in Ukranian journals and newspapers.

thalia

"Concrete poem no. 1"

"Concrete poem no. 2: Tides"

"Concrete poem no. 3: Camouflage"

"Concrete poem no. 4: Migration"

"Micho: 1941"

Born in Greece, 1952, and migrated to Australia, 1954. Lives and works in the inner suburbs of Melbourne, and started writing poetry in the seventies. Is particularly interested in "concrete" poetry.

295

Vavere, Aina
"Ultima Thule"
Born Latvia, 1924, arrived in Australia, 1950. Studied agricultural science and drama, and currently teaches science. Has published stories, poems and plays and essays and currently lives in South Australia.

Vlachou, Irene
"Night"
"the front room"
Born in Sydney of Greek parents. Has published several short stories.

Walwicz, Ania
"dad"
"translate"
Born Poland, 1951, arrived Australia, 1963. Works in the visual and performing arts, as well as writing poetry. Published *Writing* (Rigmarole Books) 1982, and her play, *girlboytalk*, was performed at the Anthill Theatre, Melbourne, 1986. Her work has appeared in numerous anthologies, and she is currently at work on her second book, *boat*.

Wels, Barbi
"Evelyn's Eighty-ninth Waltz With Summer"
Born in Australia of German parents, and is currently completing a B.Ed. while working part-time at numerous occupations. Unsure of her multicultural authenticity, she reveals that she was born on Mars and abandoned here at six months by both parents. Her pyrophobia is the result of repressing these origins. She also writes stories.

Yahp, Beth
"Kuala Lumpur Story"
From Kuala Lumpur, Malaysia. Completed her B.A. (Communications) at NSWIT, 1986. Of Chinese-Eurasian descent, has lived mostly in Malaysia. Writes in English — mainly because she thinks in English! In Sydney, has performed at numerous public readings. Has published stories in several anthologies of short fiction and literary magazines. The "Kuala Lumpur Story" is an excerpt from a novel in progress.

Yen, Mavis
"The Motor Car Works"
Born in Australia, but has lived in both China and Australia, travelling back and forth five times. The longest spell was in China, after the Second World War up to the Cultural Revolution. During this period, taught English and corrected English translations.